Material Noise

Material Noise

Reading Theory as Artist's Book

Anne M. Royston

The MIT Press
Cambridge, Massachusetts
London, England

This book was set in Stone Serif and Stone Sans by Westchester Publishing Services. Printed and bound in the United States of America.

Library of Congress Cataloging-in-Publication Data

Names: Royston, Anne M., author.
Title: Material noise : reading theory as artist's book / Anne M. Royston.
Description: Cambridge, MA : The MIT Press, 2019. | Includes bibliographical references and index.
Identifiers: LCCN 2018059567 | ISBN 9780262042925 (hardcover : alk. paper)
Subjects: LCSH: Artists' books. | Art and philosophy.
Classification: LCC N7433.3 .R69 2019 | DDC 709.04/082--dc23 LC record available at https://lccn.loc.gov/2018059567

10 9 8 7 6 5 4 3 2 1

For Robert

Contents

Acknowledgments

This book simply would not have been possible without the people and places it encountered along the way.

Thanks first to MIT Press, especially Doug Sery and Noah J. Springer.

An earlier version of chapter 3 appeared in *Camera Obscura* 97 (2017), published by Duke University Press.

People at the University of Nebraska Press enthusiastically welcomed me and spoke with me about designer Richard Eckersley and his work, as well as providing me with a much-appreciated copy of *Remembering Richard*. Thanks especially to Ann Baker and Weston Poor.

An essay containing the seeds of what would become this book, "The Fibrous Text," was published in the *Journal of Artists' Books* 38 (2015), thanks to Brad Freeman and the ever-supportive, ever-inspiring April Sheridan.

The artist's book *The Fibrous Text* was developed at the Marriott Library Book Arts Studio, University of Utah, where Marnie Powers-Torrey, Emily Tipps, and David Wolske provided expertise, patience, and encouragement. I also owe a debt of gratitude to Chris Dunsmore and John Thorp for their help and advice on all things books and otherwise.

I was honored to receive a Literary Encyclopedia Research Award that enabled research at the Bibliothèque Nationale in Paris, France, during 2016. Thanks to Anne-Laure Tissut and Françoise Sammarcelli, I also had the chance to speak at the Sorbonne. Merci à vous!

A Steffensen-Cannon scholarship at the University of Utah allowed me to devote an entire year to this work. Another fellowship from the Tanner Humanities Center, Salt Lake City, Utah, was indispensable to finishing this project, and I am grateful to my readers there, and especially to Bob Goldberg.

x **Acknowledgments**

I am grateful to the Department of English at the University of Utah and the faculty who helped this project from its beginnings, especially my doctoral committee, including Howard Horwitz, Lance Olsen, and Erin O'Connell. And special gratitude goes to Scott Black and Craig Dworkin, generous of both time and spirit, whose insights have shaped this book and shaped me.

Unending thanks to so many whose conversations and friendship sustained me as they helped me think through this work, especially Bevin Blaber, Dale Enggass, Emily Rose Lyver, Brandiann Molby, and Adam Weinstein.

More unending thanks to my supportive family, especially my parents, Margaret and Bill, my sister, Christina, and my brothers, Ryan and Dan.

Finally, this book is for Robert, my signal, my anchor, my lighthouse. I am the luckiest.

Introduction: Between Theory and Art(ist's Book)

In 2015, the New York bookstore Printed Matter moved from its Chelsea stronghold to a capacious storefront on Eleventh Avenue. Here, the myriad periodicals, zines, journals, photography works, and other books generally gathered under the term "artists' books" enjoyed considerably more space than their prior cramped headquarters allowed. Printed Matter, the brainchild of Sol LeWitt and Lucy Lippard, had moved more than once since its Tribeca beginnings in 1976, but this current move was motivated, as the website explained in 2017, by the recent "explosion of independently published projects": a "tremendous renaissance" in the publishing of artists' books as the field continues to grow at a rapid pace.

One contemporary periodical available at Printed Matter, *Convolution*, edited by Paul Stephens, comprises four print issues (as of this writing) since its beginnings in fall 2011, extending, too, to a reprint of Robert Grenier's 1979 experimental poster poem *Cambridge M'Ass*. First billed as a "Journal for Experimental Criticism," *Convolution* has since identified itself as a "Journal of Conceptual Criticism." "Experimental" or "conceptual" criticism indicates here "the idea of publishing criticism that was more exploratory and more open to unforeseen outcomes." In practice, this means that every issue is precisely composed from disparate elements and themes spanning form and content. Articles range from the researched and scholarly to the suggestive and collagistic. What constitutes writing spans text and image, photographs, inserts, and other ancillary materials. Often printed in full-color offset on substantial paper stock, *Convolution*'s typography tends toward minimalist or sans serif. No advertisements interrupt the page sequencing, further enabling a materially immersive reading experience.

Outside these basic production values, the design and format change with every issue, refusing any obvious semblance of visual continuity. Volume 2

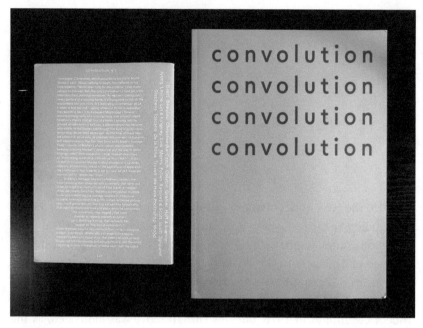

Figure 0.1
Back cover of *Convolution* 2, a.k.a. page 130, and front cover of *Convolution* 4. Convolution/We Have Photoshop (design).

(2013), for example, is 22 by 16 cm and 129 pages, with monotone orange covers, accompanied by an additional gold volume, an annotated index to Diana Kingsley's photography. Before she even opens the issue, the reader is arrested by front and back covers that, displaying pages 130–131, indicate a discrepancy between beginning as form and beginning as content—for page 1 actually occurs in the middle of the volume. The following issue (2014) is noticeably larger at 23 by 30 cm, 162 pages, with white covers and primarily black and white printing, with spot color, throughout. A cursory glance inside this volume reveals a breadth of subject matter: first, full-color reproductions of Aram Saroyan's concrete poem "TOP," followed by Nick Thurston's elaborations on his conceptual work *Of the Subcontract*, and other essays on topics ranging from poetry to photography that attempt to follow Gregory Bateson's dictum, reproduced on page 15: "A metalogue is a conversation about some problematic subject. The conversation should be such that … the structure of the conversation as a whole is also relevant to that same subject." While the edition size of each issue is unknown, one

can assume it isn't large; the overlap between authors in these issues—and the devotion to a certain strain of avant-garde—suggests a kind of coterie readership, which is further cemented by the fact that *Convolution* does not accept unsolicited submissions.

In *Convolution* we find a model that incorporates critical viewpoints into an artists' publication, in which, along the lines of Bateson's metalogue, material form and content mutually inform each other. Each issue signifies through its design as well as its printed text, assigning material form an important and dynamic role in reading. This is not an entirely new model, either: *Convolution* is the contemporary expression of two traditions. It recalls periodicals where art intersects with criticism, denoted by publications like the surrealist *Minotaure* (1933–1939) or the more recent *Cabinet* (2000–present), which spans a variety of genres. As artists' magazine, it pays homage to works such as Vito Acconci and Bernadette Mayer's *0 to 9* (1967–1969) or, even more fitting, multimedia magazines in a box like *Aspen* (1965–1971), whose every issue took a radically different format such that a given issue could include an LP or a film along with print media. *Aspen*'s issue no. 4, designed by Quentin Fiore, is especially relevant, as it centered on Marshall McLuhan's work (Fiore was also, of course, responsible for recasting the artistic interpretation of McLuhan's *The Medium Is the Massage*). Included materials in periodicals like *Aspen* also suggest an interest in the media of the moment (as that LP demonstrates), their possibilities and expectations ready to be exploited or subverted.

Convolution emblematizes our starting point, a blend of art and criticism that considers its material form at every step. Discussions of interpreting material form often focus on work that falls easily under literary genres, from letterpressed poetry broadsides to digital interactive fiction, yet *Convolution* points toward a vibrant, often neglected genre of discussion that borrows from these other genres to reshape its own. Of course, an overwhelming number of philosophical or theoretical texts tacitly or even explicitly agree with McLuhan's by now familiar dictum that "the medium is the message" while continuing to produce work that ignores, or takes for granted, its materiality. In standout cases, however, theorists create works that present arguments through their materiality as well as their semantic content: the *Encyclopedia Da Costa* of Georges Bataille and others, Jacques Derrida's *Glas*, Avital Ronell's *The Telephone Book*, and Mark C. Taylor's *Hiding* and its accompanying digital literature piece *The Réal: Las Vegas, NV*.

In this book, I examine these unconventional theoretical works through a media-specific lens, investigating how their considerations of material and argument changes the definitions of both terms. Expanding these terms of the argument even allows us to draw examples from further afield, considering Johanna Drucker's *Stochastic Poetics* and Susan Howe's *Tom Tit Tot*.

One immediate conclusion from reading in this materially oriented way is that the shape of argument can be more complex than we tend to assume, and what falls under the guise of argument is often broader than we realize. In the following pages, I will develop the tenets of what I think of as artistic arguments, a term that indicates theory that pushes back against the expectations of the theory or criticism genre, specifically by employing signification that exceeds the semantics of printed text. Artistic arguments are irreducible to a series of linear logical propositions, instead making their arguments as complex assemblages. Irreducibility and assemblage, of course, immediately call to mind a range of other theoretical models: the inheritance of Gilles Deleuze and Félix Guattari's rhizome in media studies work by, for example, Jerome McGann, Gregory Ulmer, Marcel O'Gorman, and Johanna Drucker; or N. Katherine Hayles's reimagining of Roland Barthes's "irreducible plural" that characterizes media-specific analysis. Further from the realm of media studies, however, other models also give shape to the artistic argument: Georges Bataille's *l'informe*, formlessness; Michel Serres's parasitic systematics; Jean-Jacques Lecercle's linguistic concept of the "remainder"; and—as any discussion that touches on artists' books must acknowledge—Stéphane Mallarmé's idea of the material Book. Finally, as hinted by the Grenier poem that accompanies *Convolution*'s regular publication, poetics, especially Language poetry, contributes to our understanding of the artistic argument.

There are other, wider implications for artistic arguments suggested by their unconventional significations, too. Robustly foregrounding their materiality, artistic arguments also reflect back on the media that creates them. Through typography, color, image, format, even paper stock, these works startle their readers into an awareness of the permutations and possibilities of the page. Besides these more local considerations, too, each artistic argument anticipates some aspect of digital thinking. Their (mostly) print forms speak directly to contemporary concerns: hypertext, communication theory, networks, digital distribution.

While distinct, each artistic argument's contribution springs from a common source: the role of noise. As we seek to define media and how it works,

as technology shifts and rewrites itself, artistic arguments remind us of the provisionality of these definitions. Media, they suggest, are shot through with noise that can never be eradicated. Moreover, rather than seeking to exclude the noise that obscures the signal, artistic arguments take forms in which noise is a deliberate presence—and a necessary one for reading.

Situating a Book Studies Project: Artists' Books Studies

Artistic arguments are fundamentally hybrid. Considering them requires a hybrid approach that seeks synchronicities across spaces that may, at first, appear disparate. A sense of the material, though, is always important to these approaches. In a 2001 speech to the Society for the History of Authorship, Reading, and Publishing, Jonathan Rose argues for "book studies," which he neatly summarizes: "Once upon a time, professors studied literary *works*. Then, for the past twenty-five years or so, they studied *texts*. Now, we should redirect our attention to *books*. The problem with focusing on texts is that no one can read a text—not until it is incarnated in the material form of a book."[1] In Rose's formulation, book studies is a field in its infancy, with ambitions for a diverse combination of bibliography, literary studies, information and media studies, printing and design knowledge— anything that sheds light on "how books (not texts) have been created and reproduced, how books have been disseminated and read, how books have been preserved and destroyed."[2] He envisions future university programs in which the concerns of the written word, whether technological, literary, sociological, or historical, are filtered through material lenses. Rose's audience for this lecture suggests that bibliography, as well as literary studies, needs a more multifaceted concept of the field, a concern that unites many of the scholars gathered here (in media studies, for example, N. Katherine Hayles and Jerome McGann argue along similar lines).

In the context of artistic arguments, a bibliographic approach encourages us to closely attend to individual, even idiosyncratic, aspects of the production and dissemination of these works. (Despite Rose's enthusiasm for "books," I will also use "texts" and "works," as not all of my subjects are codices.) The edges around concepts like production or dissemination blur, too, as each text partakes of media onto which it also reflects, a recursive process specific to its historical moment. To understand the role of technology in *The Telephone Book*, for example, we must extend our scope of inquiry to design and layout as stipulated by typographer Richard

Eckersley and compositor Michael Jensen, while the different formations and editions of *Glas* suggest subtly different interpretations of its material, revealing thought in mutation. The "texts of skin" that *Hiding* describes take shape in print, digital, and organic media (as in the physical bodies of Shelley Jackson's *Skin*) through a kind of family resemblance rather than being identical to one another. Family resemblance is critical, in fact, to considering media. As Adrian Johns argues in his influential *The Nature of the Book* (1998), what appears fixed is actually highly susceptible to change and editing, both from a historiographical perspective and in the sense of what constitutes a medium. Or, as Craig Dworkin writes: "Media ... consist of analyses of networked objects in specific social settings" that are "as much acts of interpretation as material things."[3] Considering these works entails considering their specific social and bibliographic situations, whether through an inquiry into process or even, as in the case of the *Encyclopedia Da Costa*, tracing the history of change over time in response to a reading audience.

Focusing on a book's bibliographic situation takes on further nuance when the book is an artist's book. Many scholars of artists' books are also artists in their own right, suggesting cross-pollination between theory and praxis. The key figure here is Johanna Drucker, whose trajectory through bibliography to media studies to digital humanities is echoed in an oeuvre of artists' books that are among the most recognized in the field. Drucker is an early delineator of this field, as well; in works like her now-classic *The Century of Artists' Books*, she attempts to define "bookness" as a "zone of activity ... at the intersection of a number of different disciplines, fields and ideas."[4] Under this rubric, an artist's book might take myriad shapes, while possessing the critical quality of self-reflexivity, "interrogat[ing] the conceptual or material form of the book as part of its intention, thematic interests, or production activities."[5] "Some reason to be and to be a book": Drucker's rule of thumb is capacious enough to accommodate many works, built as it is around a conceptual investment in "bookness" that goes beyond material, media, or process. A book that's letterpressed, for example, is not an artist's book simply by virtue of its printing, nor is an unreadable book of blank pages *not* engaging with the idea of bookness, because it still relies on the idea of a readable book. Self-reflexive about their form, artistic arguments are not just arguments in books, but arguments *about* books, about ways of reading and how they work.

Devoting substantial time to genre definition and historical overview, *The Century of Artists' Books* is representative of the majority of writing on artists' books. Drucker locates the ur-scene of U.S. artists' book history in Ed Ruscha's 1963 *Twentysix Gasoline Stations*, an influential "democratic multiple" of a small (17 x 9 cm) black-and-white book, produced on the artist's own press, with its iconic photographs of twenty-six gasoline stations and minimal text. If Ruscha provides one touchstone for the genre, Dick Higgins provides another. In his 1969 artist's book *Foew&ombwhnw*, Higgins brings poetry, performance, and essay together on a rowdy page, material that is nonetheless constrained in two Bible-like columns. *Foew&ombwhnw*'s materiality exemplifies Higgins's concept of "intermedia," which Drucker references, and which contrasts with the "concept of the pure medium" such as painting, being fundamentally "populist" and multiple. Bookending the 1960s, these two artists' books follow the thread established in Lucy Lippard's 1977 essay for *Art in America*, which designates the artist's book as a product of the 1960s. Clive Phillpot explains:

> The book art which sprung out of the sixties differed radically from the products of previous associations between artists and books. Earlier in the century futurist artists, dada artists, and constructivist artists had all been print-oriented.... It was the social and artistic revolutions of the fifties and sixties that made possible the conception of the book as an integrated reproducible artwork.[6]

Collected in Joan Lyons's *Artists' Books: A Critical Anthology and Sourcebook*, these essays establish an early genealogy for artists' books studies that emphasizes reproducibility or multiplicity as well as access, locating their inception in a particular historical moment that just anticipates the lineage of artistic arguments.

Moving away from the fine-artist-turned-book-artist model, our historical conception of the artist's book continues to undergo change and refinement. More recent scholarship shifts the focus from artists' books to book art. As Betty Bright notes in her *No Longer Innocent: Book Art in America 1960–1980*,

> General terms such as "artist's book" or "book art" actually convey radically different meanings to various groups in the field.... [S]ome critics adopted the terms "artist's book" in the early 1970s to identify only the multiple bookwork. For these writers there was simply no other valid kind of artist's book, and in steadfastly arguing their point of view, they succeeded to a great extent in dismissing art world identities for fine press, deluxe, and sculptural bookworks.... In contrast, the term "book art" has escaped such partisanship.[7]

Bright goes on to note that just as "artist's book" still contains a trace of the multiple bookwork (such as Ruscha's), "book art" (such as William Morris's work, with which she begins) echoes a skill- or craft-based conception and its attendant denigration, a split between art and skill that Bright sees in need of remedy.

Arguing for book art as valid artistic expression, Bright expands both the definition and canon of artists' books. She identifies three main subgenres of artist's book or book art: the fine press book, the deluxe book, and the bookwork (which includes multiples and sculptural books). These subgenres also give rise to texts like Garrett Stewart's *Bookwork: Medium to Object to Concept to Art*, which explores sculptural bookwork in its conceptual, appropriated, and unreadable forms. Stewart focuses on what he terms "bibliobjects," like Marcel Broodthaers's *Pense-Bête* (1964), in which the artist rendered his unsold poetry volumes unreadable by coating them in plaster, or the contemporary work of Brian Dettmer, who sculpts codices into fantastical shapes. Bright's work paves the way for something closer to Rose's "book studies," embracing a more fluid conception of genre which is historically, socially, and aesthetically interdependent.

Gathering book art into the fold leads us to those who lean more toward the maker end of the scholar-maker continuum. Here definitions assume a decidedly more practical timbre. On what constitutes an artist's book, book artist Keith Smith echoes a Duchampian school of thought, pronouncing: "If that person declares it a book, it *is* a book!"[8] Smith's books, including *Structure of the Visual Book* (1984) and *Text in the Book Format* (1989), bridge the gap between traditional bookbinding textbooks and artists' books, of which his own form an ongoing series. Accordingly, Smith's tone oscillates between conceptual—esoteric, even—and instructional. For Smith, anticipating work by new media theorists, the book is located in the play between its tangible elements (binding, text and images, cadence and sequence of pages) and the perceptual and interpretive experience of its reader. Reading is an embodied and multisensory activity, an emphasis we see in artistic arguments as well, especially in the "texts of skin" which I discuss in chapter 4. More generally, Smith reminds us that reading is not an extraction process, in which we distill a text into information, but a highly specific and immersive experience that is materially determined.

The interdependent relationship between material form and semantic content, sketched out by Smith and others, is a more contentious subject

for growing artists' books studies than one might think. In 2015, the College Book Art Association—itself not even ten years old at the time—began its *Book Art Theory* blog, intending to "call attention to criticism and theory about the book as a medium and/or subject in works of art and, more generally, about book art" by those working and teaching in the field.[9] In the blog's first entry, artist and scholar Susan Viguers muses: "Does text-to-be-read belong in the artist's book?" Arguing that semantic text has a place in artists' books, Viguers attempts to address the often "problematic relation of text 'packaged for its semantic content' (to use a phrase from Thomas Vogler's 'When a Book Is Not a Book') and the book as art."[10] As the inaugural entry, and the CBAA's youthfulness, suggest, artists' books studies as a cohesive field is still in its infancy, subject to inherited ideas from fine art that prioritize the visual over the textual. For many book artists and their "readers," even when a book is not glued shut à la Broodthaers's *Pense-Bête*, its text may still operate as an afterthought.

Book studies, artists' books studies, or book art studies: the evolving field provides an opportunity for new perspectives on works that traditionally fall outside of preestablished models. Perhaps the field is better served through defining a way of thinking rather than a corpus. The CBAA blog, a few months on from Viguers's original question, featured Levi Sherman conceptualizing what he terms "book thinking," which asks: "What can we gain from artists' books as discourse, from considering formal qualities like structure and sequence within social contexts like literacy and book culture?"[11] Sherman advocates for expanding book thinking to wider contexts, including the political, social, and philosophical or theoretical. Applying book thinking to overtly theoretical works, we find a productive relationship among art, material, and semantics, where material form and different kinds of content are necessary for interpretation.

The Book as Technology, or, Books and Screens

In *No Longer Innocent*, Bright asks: "Is it a book if its pagination occurs in the eye and mind, but not through touch?"[12] Of course, electronic literature or digital literature (which I will use interchangeably) *does* occur through touch—but it is a touch created through its technological affordances. Indeed, six years prior to Bright's question, the Electronic Literature Organization, dedicated to "works with important literary aspects that

take advantage of the capabilities and contexts provided by the stand-alone or networked computer," was established by Jeff Ballowe, Scott Rettberg, and experimental author Robert Coover.[13] This is not to say that the ELO marked the beginning of digital work, especially poetry; the Canadian concrete and sound poet bpNichol, for example, was utilizing the computer as early as in his 1984 poem *First Screening*. Much like Drucker's definition of artists' books, ELO's statement positions digital literature as self-reflexive, foregrounding its medial or material form for the reader/user. Here, too, the kinds of multiple or fluid definitions we saw in Rose's "book studies" proliferate: "Electronic literature does not reside in any single medium or institution," declares the ELO website. Other digital scholars, not necessarily of electronic literature, undertake similar calls for hybridity: the first page of Marcel O'Gorman's 2006 *E-Crit: Digital Media, Critical Theory, and the Humanities* calls for developing "electronic critique," an "interdisciplinary program that combines English, Communications, Computer Information Systems, and Fine Art."[14] Hybrid definitions and self-reflexivity are important to reading artistic arguments, which implies that book technology and computer technology benefit from articulating their points of connection. Both, after all, are technologies. And both are subject to current reconsiderations of what that might mean for reading.

Regardless of its digital or analog subject, or its interpretive, cognitive, or media-archaeological approach, scholarly work that argues for the importance of materiality is indebted to N. Katherine Hayles, who sets out the principles of "media-specific analysis" in her landmark 2004 essay "Print Is Flat, Code Is Deep." Media-specific analysis seeks "a more precise vocabulary of screen and page, digital program and analogue interface, code and ink, mutable image and durably inscribed mark, texton and scripton, computer and book," in contrast to the flattening potential of the term "text."[15] Hayles provides a definition of materiality as "the interplay between a text's physical characteristics and its signifying strategies," arguing that "This definition opens the possibility of considering texts as embodied entities while still maintaining a central focus on interpretation."[16] Less bibliographic than interpretive, even "literary," media-specific analysis combines an attention to media with a focus on interpretation that resonates within literary studies, and book studies, more generally. It has obvious relevance for artistic arguments, which foreground the importance of media both in their production and in their semantic arguments.

The principles Hayles references also reflect and factor into other media studies work that sees interpretive concerns as entangled with material ones. Drucker herself, whose artist's book *Stochastic Poetics* is discussed in this book's conclusion, takes up some of these concerns in her scholarship on digital media. Writing about electronic and "traditional" media, Drucker argues that, in place of an analog/digital binary, "emphasis should be put on the service of the conceptual insights that each, by its limitations and possibilities, provides to the other."[17] These intersections appear in work like SpecLab, a "speculative computing" project Drucker undertook with Jerome McGann at the University of Virginia from 2001 to 2003 that sought to "challenge the conceptual foundations of digital humanities through aesthetic provocations."[18] As detailed in a book of the same name, SpecLab attempts to negotiate between digital and traditional humanities. This reading across the perceived analog/digital divide, or across old and new media, or even across the material and the literary or semantic, also characterizes the kind of reading required by artistic arguments.

Focusing specifically on artists' books in conjunction with digital literature, Manuel Portela's *Scripting Reading Motions: The Codex and the Computer as Self-Reflexive Machines* provides a final example of reading material specificity. Portela considers the digital (like codework by Jim Andrews), artists' books (by Drucker) and contemporary literature (such as Mark Z. Danielewski's *Only Revolutions*), and cognitive science to argue that we experience texts in a totally embodied way. Materiality isn't important only from a bibliographic, social, or literary perspective; for Portela, materiality operates particularly intimately. He develops a cognitive or perceptual approach to meaning, which is "thematized and simulated through material interventions that call for an embodied awareness of the performance" of reading.[19] (This language, like Smith's, also echoes artistic arguments' emphasis on embodiment as a source of interpretation.) Like Portela, Lori Emerson also combines analog and digital subjects in her recent *Reading Writing Interfaces: From the Digital to the Bookbound* (perhaps the only work to bring together Jason Nelson's digital art and the fascicles of Emily Dickinson). Emerson's focus is the interface rather than the cognitive, the point of relation between reader or user and work that simultaneously masks and makes available how it works. Portela's and Emerson's books are emblematic of contemporary media-specific readings which remind us that the so-called analog/digital divide is fluid—not a

binary but a shorthand for a spectrum of activity across which points of connection chart.

Writers like these demonstrate that the concerns of media studies and artists' books studies overlap and mingle, in approach and even subject matter. Artistic arguments, too, have a place in this discussion. Each work demonstrates self-awareness about its particular technology and production: the letterpress-printed, broadside-influenced *Encyclopedia Da Costa*; *Glas*'s layout in two columns, originally conceived on a typewriter and translated with care into a print book; *Hiding*'s themes metamorphosed into the interactive CD-ROM of *The Réal* and the unconventional surface of Jackson's *Skin*. Sometimes the relationship is even more directly involved with process. Of working with designer Eckersley on *The Telephone Book*, Ronell relates: "Thanks to Richard, *The Telephone Book* breaks up the sovereignty of the Book and becomes a child of *techné*, beholden to its technical matrix."[20] She is referring to its typography, which explicitly references its digital origins through, for example, printers' marks deliberately left on the page; she is also referring, however, to the fact that "to [her] knowledge ... it was the first work that owed its graphic existence and stance entirely to the computer."[21]

The Telephone Book develops a meaningful conversation between its medium and its semantics, computer technology further enhancing its thematics of another communication technology, the telephone. Even when an artistic argument is not explicitly about a technology like the telephone, though, it embraces the specific technologies that enable its precise inscription, subtly redrawing the boundaries of media at the same time. *Stochastic Poetics*, to take another example, incorporates language from Drucker's scholarship on digital media in the work itself; it too spans media, available as a letterpress-printed artist's book as well as a PDF freely distributed online. *Tom Tit Tot*'s different medial forms span distinct print editions as well as a sonic interpretation, through Howe's work with the composer David Grubbs. All these works are actively curious about how process and media can craft meaning.

From our viewpoint, artistic arguments also shed light on distinct topics in new media, speaking directly to issues relating to contemporary digital theory and technology. *Glas*'s form anticipates and comments on hypertextual reading practices, while *The Telephone Book* typographically explores communication theory and poses an argument about how we use terms in

digital theory. *The Réal* is an early and overlooked digital work that expands the definition of electronic literature, while *Hiding* attempts to define and clarify the concept of a network. Finally, *Stochastic Poetics* and *Tom Tit Tot* reflect on the process of making a book, and what bookness means, in the digital age. Even a work like the *Da Costa*, published prior to any idea (much less ubiquity) of the digital network, helps set the stage by critiquing distribution practices and describing the networked shape of the artistic arguments to come.

A Shape for Artistic Argument

Media theory and artists' books criticism argue for the mutuality of material form and content, yet these texts tend to skirt their own precepts, presenting arguments that are formally estranged from their subjects. Nor are theoretical texts often considered as rewarding subjects for media-specific analyses, in contrast to the litany of literary works that invite material consideration. In 1981, writing in the *New York Times*, Geoffrey Hartman echoes McGann's gesture toward media-specific criticism, pleading the case for expanding the scope of argumentative texts to include a "literature of criticism." Theory or criticism, Hartman argues, has as much a claim to creative—even poetic—interpretation as literature does: "[I]f there is no reason to deny the critical essay a dignity and even a creative touch of its own, then criticism, too, will have to be read closely. It should not be fobbed off as a secondary activity, as a handmaiden to more 'creative' modes of thinking like poems or novels."[22] Unsurprisingly, Hartman makes this argument specifically in the context of defending Derrida's *Glas*, a work which demands precisely this kind of close reading. Like other artistic arguments, *Glas* insists on a reading that exceeds the way we normally approach criticism.

But what does "creative" mean here? So far, we have treated the creative as material, emphasizing the need to read theory as an artist's book. Discussing Kevin Osborn's nearly illegible artist's book *Tropos*, Renée Riese Hubert and Judd D. Hubert declare it a work of poststructuralist theory as well as an artifact: "It attains by technique, and not at all by discourse, undecidability."[23] This distinction marks (or, recalling Susan Viguers, perhaps reinscribes) a difference between discourse and technique that doesn't apply to artistic arguments. Rather, discourse and technique, semantic argument

and material, work in tandem with one another. The theory that surrounds and supports artistic arguments is as creative and innovative, even poetic, as the material that comprises them.

Artistic arguments share not only a dedication to self-conscious materiality but also, from a discursive perspective, a similar genealogy. The avant-garde heterogeneity of Bataille clearly anticipates Derrida's poststructuralism, which Ronell adapts with a sociocultural sensibility, and Taylor further compounds with art historical and theological perspectives. This genealogy is also present in a locally historical way: Derrida was a close mentor to Ronell and an acknowledged friend and influence to Taylor, suggesting a transmittal and transformation of ideas that take different shapes both conceptually and materially. Tying together this work is the idea, most simply put, that conventional and dominant modes of argumentation can be insufficient. Bataille's emphasis on nonknowledge as antiorganizational and antilogical foreshadows *Glas*'s and *Hiding*'s critique of Hegelian dialectic, while *The Telephone Book* considers Heidegger with a critical eye. Through critiquing philosophers who have historically shaped thought, artistic arguments critique the shape of thought produced by these thinkers as reductive, simplified, inadequate to the complex networks required to describe increasingly diverse subjects.

For our purposes in this book, Bataille lays the foundation for a thoroughgoing heterogeneity, coordination without subordination of elements, that characterizes artistic arguments. Heterogeneity irresistibly calls to mind Gilles Deleuze and Félix Guattari's famous rhizome, the shape of a logic that is multiple, surface-oriented, "acentered."[24] It's worth remembering, too, that the rhizome—so often borrowed and overcoded since the original release of *A Thousand Plateaus*—is not an abstract concept in its original context. Returning to the first pages of *A Thousand Plateaus*, we find that the rhizome originally is introduced by way of the book, both as a concept and as the item in the reader's hands. "There is no difference between what a book talks about and how it is made," the authors assert. "As an assemblage, a book has only itself, in connection with other assemblages."[25] Against the "root-book" that grows upward, maintaining hierarchy and order, Deleuze and Guattari picture an alternative book created by grafting. This grafted or rhizomatic logic structures artistic arguments in conceptual and material ways: as assemblages, they bring together disparate subjects and material parts while maintaining the integrity of their differences.

Heterogeneity and assemblage denote not only diversity of materials and subjects, but their multiplicity. Multiplicity or plurality also has a literary history: Barthes, in his definitive "From Work to Text," insists that a text "accomplishes the very plural of meaning: an *irreducible* ... plural."[26] This "irreducible plural" implies a potential expansion from Barthes's more abstract "activity of production" to the actual haptic production of a book.[27] In fact, Hayles addresses Barthes at the beginning of "Print Is Flat" on this very point. Acknowledging "From Work to Text" as "prescient" given its emphasis on a "network" that is actualized, to some extent, in digital media, Hayles nonetheless points out that Barthes's focus on the text "elid[es] differences in media," a situation remedied by media-specific analysis.[28] "From Work to Text" thus becomes a kind of connector from the world of literary theory to the world of media theory, the former positing a framework which the latter concretizes, revises, and gives body to.

The idea of a new shape for argument, one that takes materiality into account, echoes the cultural and literary shift from print to digital media. After all, if "it is a definitive characteristic of traditional scholars to reject any mode of discourse that diverges from the path of the conventional hierarchical format," that "conventional hierarchical format" is linked specifically to a certain conception of print, as O'Gorman argues.[29] New media offers at minimum an opportunity to reevaluate how theory can function, but some critics go much further; for example, Gregory Ulmer claims that "several influential commentators have observed that hypermedia 'literalizes' or represents the material embodiment of poststructuralist (mostly French) theories of text."[30] O'Gorman, too, takes it for granted that "the major tenets of deconstruction ... were displaced into technology, that is, hypertext."[31] Following this line of thinking, artistic arguments, with their poststructuralist genealogy, also share a natural affinity with hypertext.

Scholars like Ulmer and O'Gorman, who view the textual network as the natural inheritance of the digital network, tend toward a proliferation of terminology: new technologies (and ways of reading) would seem to require new methodologies. So O'Gorman introduces "hypericonomy," which he defines as "discourse organized according to the pictorial pun," while Ulmer's term "heuretics" emphasizes invention and "generative productivity" in the realm of theory.[32] O'Gorman's interest in the visual also speaks to Mark C. Taylor's concept of "imagology," focused on images as signifying systems (which the fourth chapter of this book addresses more

directly). Of some interest to the shape of artistic argument is Ulmer's concept of "chorography," the key principle of which states: "do not choose between the different meanings of key terms, but compose by using all the meanings," a heterogeneous proposition that recalls Bataille.[33] Both O'Gorman and Ulmer, like Rose and Bright in their respective fields, also set out programs of hybridity that should be familiar to us by now: Ulmer's stated desire, for example, is to "appl[y] to academic discourse the lessons arising out of a matrix crossing French poststructuralist theory, avant-garde art experiences, and electronic media."[34] When materiality is recognized as important to argument, changing media drives the need to reconsider theory.

Searching for new shapes of argument, these theorists often turn to visual or pictorial terminology. But the idea of assemblage goes beyond image to include other aspects of a book that we tend to think of as nonsignifying, as merely ancillary to the semantic text. Deleuze and Guattari sketch possibilities for "the unproductive, the sterile, the unengendered, the unconsumable," possibilities which again echo Bataille.[35] The "unproductive" or nonproductive specifically resonates with Bataille's idea of excess, the "unproductive expenditure" that tries to jam or block the system, whether it be political, philosophical, or epistemological. Applied to theory, productivity becomes a feature of the organized, linear, summarizable argument, whereas aspects such as color or typography are dismissed as mere ornament. In the context of artistic arguments, however, the nonproductive becomes aligned with the material, that which doesn't conventionally signify—what we commonly perceive as noise, a term that captures visual (static across a screen) and audio resonances.

The critical point here is that what is usually seen as nonproductive can nonetheless produce meaning, if we only pay attention to it. So the unconventional shape of artistic arguments includes what is prima facie meaningless or incidental to make an argument about its potential for meaning in a very different way. Meaning, artistic arguments indicate, can indeed be found in noise. Following linguist Jean-Jacques Lecercle, we take noise to be "no dissolution of language. Beneath the apparent chaos, another, irregular and partial, attempt at order emerges."[36] Lecercle is defining here what he calls the "remainder" (a term that especially connects to Derrida's *Glas*, as we will see). The remainder exceeds the "grammatical map" that simplifies and makes language accessible.[37] It is the exception to the rules, treated not

as something to be anesthetized, but as something that proves a delightful focus of attention, a source of pleasure. Nor is the remainder completely nonsensical. Demonstrating that "irregular and partial attempt at order," it "stresses the fact that, when a rule of syntax is broken, the result is still linguistically coherent, i.e. intelligible," providing openings for poetic or expressive language.[38]

The remainder points to two attributes of noise: its status as "excess" (Lecercle's term) and its inevitability—even necessity—in language.[39] Being drawn to noise as a source of interest is "a reflection of the normal workings of language, of the existence of a remainder, of its unavoidable return within grammar itself."[40] Lecercle takes pains to show that the remainder isn't specific to any one genre. Any language use produces a remainder, including theoretical language.

For artistic arguments, the remainder is not only linguistic, but material; it is the distracting typography or the jarring audio clip, for example, that the reader is tempted to attend to but feels compelled to ignore in favor of the more serious stated argument. But to more fully understand artistic arguments, it is crucial to give in to this temptation, to seek meaning in material. Toward this end, McGann sketches a kind of material equivalent to Lecercle's remainder. Even prior to his work on digital media, McGann's *The Textual Condition* (1991) lays out an expansive view of what can produce meaning: "We must attend to textual material which are not regularly studied by those interested in 'poetry': to typefaces, bindings, book prices, page format, and all those textual phenomena usually regarded as (at best) peripheral" to the text.[41] McGann's specific list of "textual material" is definitively paratextual; for us, however, it suggests a possible link to Lecercle's remainder, pointing toward what the next chapter develops more robustly as "nonsemantics," elements that contribute to and create noise in artistic arguments.

McGann's and Lecercle's observations, while not limited to poetry, take it as their starting point. Avant-garde poetics and new media have historically reciprocated ideas, about which more below, but here Language writer and poet Charles Bernstein's concept of "extralexical" offers some insight as another potential framework. Discussing the relationship of performed poetry to poetry on the page, Bernstein notes, "Focusing attention on a poem's content or form typically involves putting the audiotext as well as the typography—the sound and look—of the poem into the disattend

track."[42] "Form" is meant narrowly here, not including textual elements that are released from significance. Bernstein argues that such elements ("the sound and look") nonetheless signify: "Such elements as the visual appearance of the text or the sound of the work in performance may be extralexical but they are not extrasemantic. When textual elements that are conventionally framed out as nonsemantic are acknowledged as significant, the result is a proliferation of possible frames of interpretation."[43] Bernstein aligns "extrasemantic" and "significant"; his use of "extralexical" is a closer analog to the "nonsemantic" of artistic arguments. Still, the conclusion lands in a familiar place. What falls outside written (or spoken) language proper still contains multiple possibilities of signification.

Bernstein gathers ideas like "audiotext" and "typography" under the same umbrella, suggesting that sound and image can function along similar lines. As the chapter on Ronell indicates, noise is aural and visual, troubling the line from book or text to reader. McGann also mentions noise: "Were we interested here in communication theory, rather than in textuality, such redundancies would be studied as 'noise,' and their value for the theory would be a negative one."[44] Noise, when experienced in a literary context for McGann, leads to an awareness of "self-embodiment" on the part of the reader. In the context of artistic arguments, noise also suggests that definitions or categories are unreliable, while revealing itself to be less a "negative value" than a surprisingly necessary condition for meaning.

McGann sets up the conditions for extratextual or extrasemantic meaning, conditions that he applies across experimental, concrete, and typographically innovative work. As for Lecercle, this work is not limited to literary genres. As McGann points out in *The Textual Condition*, all texts signify through their materiality, "only some operate more clearly than others."[45] His "Composition as Explanation," a later essay that takes the form of an imagined dialogue, gestures toward a potential theory that would operate in this way. McGann remarks that "not every part of an argument— even a scholarly argument—is or ought to be coherent and expository. The question is whether critical writing can find formal equivalences for its subject matter and still preserve its communicative function."[46] Artistic arguments demonstrate exactly such "formal equivalency" between subject and presentation, an equivalency determined by each work's material particularities.

Taken together, Lecercle, McGann, and Bernstein offer perspectives on how nonsemantics create noise in artistic arguments, each emphasizing, at some point, that noise has a role to play in language and communication. According to Michel Serres, noise, the "parasite" in his titular book, has a critical role: "In the beginning was the noise," Serres writes.[47] Noise supersedes the word, or the logos, to become the precursor for communication. Contrary to the way we conceive of it, the word needs noise. At the same time, would-be communicators must seek to abolish an excess of noise, to minimize its presence. Like *The Telephone Book*'s fuzzy type, the white space of the page that separates the two columns of *Glas*, or the overprinting in *Stochastic Poetics*, noise simultaneously threatens and enables communication, bringing our attention to the material qualities that make reading possible.

Shifting our definition of communication to prioritize noise, Serres derives systems not through their structures but through their breakages. He asks: "Is the system a set of constraints on our attempts at optimization, or do these latter, quite simply, produce the system itself?"[48] A machine is subject to entropy and breakdowns, yet these are things our imaginations constantly fail to incorporate into our idea of the machine. At these points of breakage or subversion, the system is recreated, and a new structure branches sideways—not building off the original, but using it as a graft to begin again. In reading artistic arguments as irreducible plurals, attending to material implies attending to these moments of connection and reconnection, what Derrida constantly refers to in *Glas* as *couper*, or "cutting," not as verb but as noun: a vegetal valence that points toward replanting. Such a reading traces the paths of multiplicity, the tangled wires inside *The Telephone Book* or the ways in which authorship is masked and parodied in the *Da Costa*, without reassimilating them into a frictionless system.

The shape of artistic argument draws from ideas in media studies, poetics, communication theory, and linguistics. While these fields appear disparate, perhaps even "entirely different intellectual universes," their strands affiliate to help clarify how semantics and nonsemantics weave together in these unconventional arguments.[49] Nonsemantics produce noise in specific ways: Jacques Derrida's "remains" in *Glas*, Avital Ronell's typographical illegibilities in *The Telephone Book*, Mark C. Taylor's loss in *Hiding* and *The Réal*, and Johanna Drucker's and Susan Howe's poetics in *Stochastic*

Poetics and *Tom Tit Tot*. These artistic arguments, with their complex mate-
rial forms, remind us that noise is always present in communication, and
that it rewards attention. As Lecercle writes: "There is always something
grammatical about delirium, there is always something delirious about lan-
guage," if we only know how to read.[50]

The Book, Material Instrument

The nineteenth-century French symbolist poet Stéphane Mallarmé is a
totem figure for this project, a Hermes whose work easily traverses poetry,
the artist's book, and more conceptual concerns. These conceptual or theo-
retical concerns are always centered on bookness: one typically evocative
essay ventures that "everything in the world exists in order to end up as a
book."[51] Bookness is at once material and spiritual, as this essay title—"The
Book, Spiritual Instrument"—confirms. The book's spirituality emerges
from its "array of flourishes," physical and philological.[52] Mallarmé's inter-
est in the spiritual, mystical, or potential book speaks to *Glas*, with its two
columns following the shape of the Torah, and also to philosophers such
as Edmond Jabès and Maurice Blanchot, all clear influences on Derrida's
thought in *Glas* and elsewhere.[53] But its material grounding gestures toward
artistic arguments in general, too. Mallarmé sees the book as a uniquely
powerful entity, and his conception of the Book, an idealized object that
would encompass "all existing relations between everything," was a proj-
ect that would obsess him for over thirty years. The Book is manifestly
impossible to realize; tellingly, what Mallarmé realized most fully were
his notes on its structure and form, its production and distribution.[54] Its
spiritual concerns are always premised on its materiality. In "The Book to
Come," Blanchot directly addresses Mallarmé's Book as "architectural and
deliberate, not as a collection of chance though marvelous impressions."[55]
Instead, it is a "purposeful computation."[56] It expresses multiple facets in its
material form, "les subdivisions prismatiques de l'Idée" (prismatic subdivi-
sions of the Idea), or what Richard Sieburth calls "that scene of the mind
in play, in action on the *support* of the page."[57] Sieburth also characterizes
Paul Valéry's *Cahiers*, Hölderlin's late manuscripts, and Emily Dickinson's
envelope poems as harmonizing with some version of these "prismatic sub-
divisions" that insist on their material status at the same time they reach
for transcendence.

While never executed either in print or performance during his lifetime, the material form of Mallarmé's *Livre* is still envisioned concretely. In his extensive notes, "the references to numbering, intersections, and arabesque patterns suggest a powerful and compelling material dimension to poetic language and perception," Anna Sigríður Arnar argues.[58] As Derrida will in *Glas*, Mallarmé connects his project to the spiderweb, himself a "sacred spider" spinning what Arnar terms "webs or networks ... to establish symmetries of difference and similarity."[59] The Book undoubtedly implies "some tangible structure," even if said structure could fully exist only in a future time for its author.[60]

Mallarmé's body of work, from the Book to his essays to the typographically innovative *Un coup de dés*, indicates a wider world for thought that appears in manifold, and for concepts deliberately arising from material forms. These works follow the "prismatic subdivision" of multiplicity or nonlinearity, often resisting totality and easy organization. Like Mallarmé's Book, their unfinished states suggest a yearning for more apt material and medial forms than a standard printed and bound codex. Ludwig Wittgenstein's *Zettel*, for example, comprises a collection of cut fragments that the philosopher had collected in a box over a period of several years. Some of these fragments are clipped together while others are loose, and some correlate to fragments published elsewhere, primarily the *Philosophical Investigations*. Translators G. E. M. Anscombe and G. H. von Wright admit that "at first [they were] rather puzzled" about the box's contents, which could have been an "accidental collection of left-overs" or a "receptacle for random deposits of casual scraps of writing"—a description that recalls Lecercle's remainder or Bataille's waste.[61] Close inspection reveals that Wittgenstein "worked on [the fragments], altered and polished them in their cut-up condition" in a kind of pre-compositional state.[62] Peter Krapp, surveying notecard or collection works that historically prefigure hypertext, notes that *Zettel*'s "cut-and-paste was integral to [Wittgenstein's] writing method to an extent that puts the avant-garde claims of hyperfiction to shame."[63] While Krapp assumes the end goal as a linear argument, it may be worth noting that Wittgenstein's later style in general does not always proceed linearly; the *Philosophical Investigations*, to take an obvious example, feels indebted not to a linear argument structure but to the concept of family resemblance it introduces. Most likely Wittgenstein did not intend a philosophical *Aspen*, a book-in-a-box. But *Zettel* nonetheless demonstrates a kind of unwillingness to totality,

a fundamentally material way of composing thought that appears to express the "purposeful computation" Blanchot notes of Mallarmé.

The sprawling expanse of Walter Benjamin's *Arcades Project* expresses this unwillingness to totality even more thoroughly. Unlike *Zettel*, whose fragments are composed by the author, Benjamin's multilingual opus is a citational gallery of signs, another early example of a textual network. Collected from countless sources over thirteen years, there is a telling fragment early on: "Method of this project: literary montage."[64] Sieburth argues that "the amount of source material [Benjamin] copied so exceeds anything he might conceivably need to adduce as documentary evidence in an eventual book that one can only conclude that this ritual of transcription is less a rehearsal for his *livre à venir* than its most central *rite du passage*."[65] The process of writing becomes, with or without authorial intention, the product. Marjorie Perloff adds that the book essentially creates its own textual "arcade," which, like most artistic arguments, has been considered as a philosophical text but whose literary merit has been neglected.[66] Focusing on the critical-creative citationality of the *Arcades Project*, Perloff sees Benjamin's work as fundamental to twentieth-century conceptual and postconceptual poetics, as the title of her book, *Unoriginal Genius*, clearly indicates.

Apart from these sprawling, ideologically driven, incomplete forms, much contemporary creative criticism—like *Convolution*—is measured and localized, finding expression in zine or micropress publications heavily influenced by the avant-garde. Creative-critical endeavors are especially indebted to avant-garde poetics (recall the Robert Grenier poster that *Convolution* produces), suggesting an ongoing relationship that links the avant-garde to a certain theoretical lineage as well as an investment in exploring the capacities of media. Ulmer and O'Gorman are among those who have commented on poststructuralism's indebtedness to the avant-garde, while *Convolution* editor Paul Stephens claims in his 2015 book that "many of the central aesthetic and political questions with regard to information overload are addressed or anticipated within twentieth-century avant-garde writing."[67] "Information overload" may be symptomatic of current digital thinking, but Stephens argues that its roots, critical and creative, stretch back to the avant-garde, naming another Language poet in the process:

> To adapt a question posed by Lyn Hejinian—"Isn't the avant-garde always pedagogical?"—I would ask, "Isn't the avant-garde always technological?" Much of the work of the twentieth-century avant-garde was extremely self-conscious

of the rapid changes in technologies of communication and data storage. From Dada photomontage to hypertext poetry, avant-garde methodology has been deeply concerned with remediation and transcoding—the movement from one technological medium or format to another.[68]

Stephens convincingly argues that material and media specificity is a facet of avant-garde experimentation, which explores and recalibrates technological affordances, much as artistic arguments do. Artistic arguments, then, are indebted to the avant-garde, which models their desire for "self-conscious" formal shapes to accommodate or fully express their unconventional uses of language. Such a desire is also premised, as it is for the avant-garde and Language poetry, on treating language as always materially embodied.

Following in the footsteps of the mimeo revolution of the 1960s and 70s, contemporary critical-creative work attempts to subvert traditional methods of publication as well as traditional conceptions of genre. "Get online; cut and paste; search and destroy; share and share alike.... *Do it yourself,*" exhorts the end of *Do or DIY*, a small-scale 2012 pamphlet published by Information as Material (iam).[69] Under Craig Dworkin, Simon Morris, and Nick Thurston, iam publishes print and other media on subjects ranging from conceptual work to an essay (a "user's manual," after Georges Perec) on nothing. In a similar vein, Michael Cross, Thom Donovan, and Kyle Schlesinger's press ON Contemporary Practice utilizes the skills of its founders, two of whom head other micropresses, to produce critical work in thoughtful material form that includes poetic essay as well as more scholarly work. The press's periodical form is devoted solely to criticism. ON Contemporary Practice, unlike iam, publishes only print. Their social circumstances, though, closely align: both presses rely on and emphasize collaboration and community outside dominant publishing and creative paradigms. iam calmly declares its desire to "disrupt the existing order of things," while ON's website states that "the most valuable critical writing is that motivated by desire, friendship, sociopolitical commitment, and discourse among one's communities and peers."[70]

These communities, much like the *Da Costa* and Acéphale groups that are the next chapter's focus, have a tendency to overlap in membership and interests—Schlesinger, along with Jed Birmingham, also releases the periodical *Mimeo Mimeo* (on "the mimeo revolution as an attitude") and heads Cuneiform Press, which publishes creative and critical work that incorporates letterpress as well as offset printing. A recent Cuneiform collection,

Blurred Library, by Visual Studies Workshop director and book artist Tate Shaw, serves as a typical example, with diverse essayistic forms like a "round-table" composed of citations by writers living and dead (Brian Massumi, Paul Ricoeur, Hayles, and others). Other micropresses that produce materially aware critical-creative work include Aaron Cohick's NewLights Press, which combines experimental letterpress practices and digital technologies, producing mostly poetry with occasional forays into essay. In his work, Cohick consistently articulates how different material inscriptions give rise to different interpretation. The "second iteration" of the ongoing *New Manifesto of the NewLights Press* discusses the perceived death of the book and its replacement by computer: "*They are right:* a handheld device that can access any text from any place does a better job of delivering information. *They are wrong:* books and the writing-designing-printing-binding-distributing-reading of them have never been solely about delivering &or [sic] receiving information."[71] Like Keith Smith and others, Cohick emphasizes that reading is an engrossing, multisensory experience, rather than a simple transmission of ideas. The *Manifesto* itself is a highly self-conscious piece, a combination of experimental letterpress printing and traditional offset in a pamphlet-stitch-bound codex. Cohick even uses a collagraph which progressively degrades, suggesting the ever-changing nature of the book. But this is not an artist's book in the sense that Drucker or even Bright might argue: a digital version of the *Manifesto* can also be found online for free. Like other micropresses, the NewLights Press is a small affair—Cohick the sole engineer—interested in a technological avant-garde that appeals to its coterie readership.

Born-digital critical work that takes similar advantage of its medium, on the other hand, is still in its infancy, our period one marked by digital incunabula. Experimental digital magazines like *Triple Canopy* or *Entropy* almost always publish creative work, while more scholarly and hybrid work appears in *Textshop Experiments* (which directly acknowledges Ulmer's influence), *Inflexions*, and *Trace*; the latter are even peer-reviewed, new venues striving toward academic legitimization. Larger projects, such as Amanda Visconti's "participatory" Joyce rendering, *Infinite Ulysses*, and Jason Helms's multimedia *Rhizcomics: Rhetoric, Technology, and New Media Composition* indicate possibilities for long-form digital works, including direct user input. Participatory poetics returns us, finally, to the genre-redefining Mallarmé. In early 2018, a group of artists affiliated with the Mimosa House in London attempted an ambitious three-part hours-long performance of *Le*

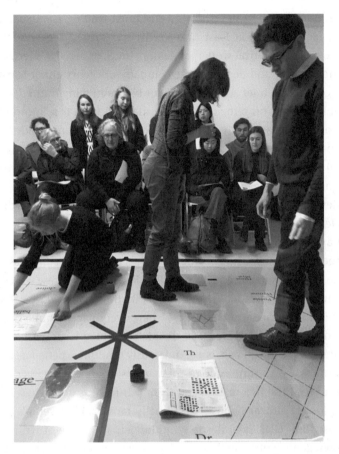

Figure 0.2
Mimosa House performance of Mallarmé's *The Book*, March 3, 2018. Photo credit:
Linda Rocco.

livre, using Mallarmé's notes and other texts. Besides print and digital, this
event suggests, there may be yet other media or material apt for unconven-
tional patterns of thought.

Material Forms, Material Formlessness

Of course, what I am considering here under the rubric of artistic argu-
ments are texts that have been the subject of critical consideration before.
This consideration rarely incorporates a materially interested perspective,

however, and certainly never gives a sustained reading from such a position. In fact scholars, at least historically, have taken a deeply skeptical stance toward theoretical work that demonstrates material awareness. Striking material form and design in the company of theory either is met with silence or merits a brief acknowledgment before moving on to discussions inevitably focused on semantics. When material form is acknowledged, it tends to be seen as garish embellishment, needless complication, somewhere between gimmicky and unduly challenging. From this perspective, material isn't capable of making an argument, only distracting from one, threatening the sense of serious so-called underlying philosophy.

Reviewing *Glas* for the *New York Times* in 1987, John Sturrock's disgust is palpable: "Irresponsible views such as Mr. Derrida's are better left to poets, who may positively welcome such voluptuous surrender to the surfaces of language."[72] Sturrock, who elsewhere defends the author, expresses outrage over the "voluptuous surrender" that *Glas* demands—a phrase which might call to mind, with quite a different timbre, Barthes's *jouissance*—a surrender located in the "surfaces of language," where every page reminds the reader it is being read as a page. Derrida's double-columned format is beyond the pale: "Reading 'Glas,' in fact, is a scandalously random experience, for, quite apart from when to turn aside to these insets, there is the larger question of how to read the two main columns of print," Sturrock writes, bemoaning the loss of "linear habits."[73] He finally falls back on genre's apparent solidities: "But 'Glas' is philosophy no longer; as a piece of writing it has no known genre"; ultimately, it "asks too much of one's patience and intelligence," in contrast to Derrida's other writings of "inordinate brilliance ... difficult books to say the least, but conventionally philosophical."[74] Not to be conventionally philosophical is not to be philosophical at all.

Robert Coover comes to a similar, if more tempered, conclusion in his review of Ronell's *Telephone Book*. Coover notes that the book's design is promising and alluring at first, "abstractly interesting (much more so, I think, in a book like William Gass's integrally designed *Willie Masters' Lonesome Wife*, published over two decades ago), often entertaining and pertinent to the telephone's own show biz origins."[75] The comparison with Gass is illuminating, and not only because Coover himself is an experimental author, even before his involvement with the Electronic Literature Organization. Coover notes that Gass's work is more effective because it is "integrally designed"—treating form and content together—while the difference

in genre (fiction instead of philosophy) isn't acknowledged as a factor. Like Sturrock's assessment, though, finally "[the design] greatly distract[s] and tire[s] the eye, it occludes whatever sustained statement the text might contain behind all the visual pyrotechnics, suggesting a circus smaller than its posters."[76] Eckersley's painstaking collaborations with Ronell (they corresponded, according to the designer, on every individual page) are diminished as "design stunts" that mask the truth of the argument, which in the end, "to the extent one can follow such a homeless thing, seems to be that of a fairly conventional academic paper."[77] Where *Glas* is deemed insufficiently philosophical, *The Telephone Book* is insufficiently artistic; artistry and design obscure its more critical (and by default more banal) argument.

A decade makes less difference than one might think. In an interview with *JAC*, Taylor notes, "The general maxim is that the more creative the work the more hostile the reception."[78] Discussing his body of work, Taylor differentiates "writing" from "not writing," based on a somewhat idiosyncratic distinction between "thinking" and "scholarship." *Hiding* and *The Réal* are both deemed "writing," products of creative thought. Taylor elaborates:

> Works that I have labeled not-writing are regularly reviewed positively in scholarly journals. They conform to accepted protocols and can be engaged in traditional terms. Many of the writerly texts—ranging from those that are primarily graphic to those that are graphic as well as visual—tend to be more problematic for readers.... In many ways, *Hiding* is the most inventive book I have written, and, yet, it is the least understood book. Though it looks more like *Wired* than a university press book, if you were to read the reviews, you would not know it looked any different from standard university press books. It's as if the images do not exist.[79]

Taylor's "accepted protocols" and "traditional terms" resonate with Sturrock and Coover's "conventional" philosophy, denoting an easy categorization. Radical material form and design—"graphic as well as visual"—destabilizes genre, and in so doing, troubles traditional notions of reading argument and even threatens to delegitimize its subject. When presented with artistic arguments, the historical tendency has been to minimize their shapes. As Taylor puts it ruefully, "It's as if the images do not exist."

The suspicion is that material form cloaks the true argument, which lies "behind all the visual pyrotechnics," in Coover's words, and which inevitably must take semantic form. Visual pyrotechnics are noise, in contrast

to the signal of message. As Taylor demonstrates through and throughout *Hiding*, however, surface and style *are* substance for artistic arguments. Attending to the noise their surfaces produce reveals noise itself as not only ineradicable but necessary, in a local sense as well as for any communication in general.

No surprise, then, that an unconventional shape of argument is required: an assemblage or network of semantics and nonsemantics with a particular investment in how material expresses meaning. We find a proto-network in the first chapter's discussion of Bataille's concept of formlessness, *l'informe*, characterized in the "Critical Dictionary" as "something like a spider or spit."[80] In the context of language, it gives "not the meaning of words, but their tasks." By this, Yve-Alain Bois argues, Bataille indicates that "[i]t is not so much a stable motif to which we can refer, a symbolizable theme, a given quality, as it is a term allowing one to operate a declassification.... [T]he formless has only an operational existence."[81] The formless, or formlessness, becomes an engine or agent for the dismantling of generic and medial boundaries. *L'informe* resonates with modern-day communication networks, allowing for excess and noise.

In the first chapter, the network that is formlessness leads to a sustained exploration of the *Encyclopedia Da Costa*. Published in three fascicles from 1947 to 1949 by a group of authors and artists including Isabelle and Patrick Waldberg, Georges Bataille, André Breton, and Marcel Duchamp (who was also responsible for design and layout), its first fascicle was anonymous. Due in part to the mystery surrounding its contributors, critical literature on the *Da Costa* is noticeably scarce, especially work that explores how its media specificity and bibliographic history shape interpretation.[82] From the beginning, the *Da Costa* subverts reading conventions. This first fascicle was released as if following a prior one that did not, in fact, exist, with pagination beginning at 207, while the text begins in the middle of a word to punctuate the uncomfortable *in medias res*. Moreover, the supposed objectivity of the form it parodies—the encyclopedia, with its French Enlightenment pretenses—has gone egregiously awry. Entries include the first-person voice and describe anecdotes or vulgar jokes, are satiric and deliberately provocative, and vary wildly from page to page, interspersed with images. These details point to the *l'informe* as the material and conceptual heterogeneity which drives the *Da Costa*.

In the *Da Costa*, formlessness and heterogeneity also set the stage for a discussion of nonsemantic elements. Chapter 1 further establishes how nonsemantics are informed by what Bataille terms "nonknowledge," an idea that seeks what is excessive to language but still contains meaning. For our materially oriented project, nonsemantics encompass material and structural components, typography and design, as well as arrangement and medium. Additionally, nonsemantics in the *Da Costa* operate through juxtaposition of text, image, and layout, which creates a diversity of tones and styles, as well as the work's social circumstances of production: anonymity, multiple authors, and idiosyncratic distribution. Nonsemantics begin to provide a glimpse of how noise unfolds on the page.

The second chapter revisits Derrida's *Glas*, published originally in 1974 and in English translation in 1986, arguing for its use of layout and white space as a kind of noise that enables its proto-hypertextual design. *Glas* takes the shape of a ten-by-ten-inch square tome, in which the lines of argumentation are enacted through the book's two-columned layout. The columns are devoted to Jean Genet and Hegel, with Genet's column (on the right) enacting a subtle critique of Hegel through its larger typeface. This choice of size also stages an intervention into Western type hierarchies, which stipulate reading larger to smaller and left to right; going further, Hegel's concept of synthesis is visually suspended by the two textual columns that resist reconciliation. And rather than maintaining stability, these two columns, rendered in the classic serif Garamond, are riddled with interruptions and eruptions—what Derrida calls "judases"—in the modern sansserif Gill Sans. Judases offer questions, comments, and quotations from the Littré dictionary, which unevenly stop and start as the book progresses to create intertextuality directly on the page. Anticipating the halting motions and multiple threads of hypertext, *Glas* is designed to subvert conventional reading, its shape enacting the oscillations of its argument while continually confronting the reader with the material fact of reading.

As the layout creates instability that never resolves (in fact, the last line of the book refers back to the first in a Joycean movement), the white space of the page between the columns serves as the excess or "remains" of the printed text. "Remains," which directly recalls the remainder, underwrite *Glas* both semantically and materially. As Derrida says in another essay, "Between Brackets I," "This incalculable remainder would be the 'subject'

of *Glas* if there were one.... The ungraspable—remains ... is the relation without relation of the two columns or colossi or bands."[83] The "relation without relation" echoes the typographical form of the book. Like noise, which enables and threatens communication, the white space of the page both enables and threatens language, producing a material remains that elude semantics. Following Peter Krapp's argument, *Glas*'s material remains also demand to be considered alongside any discussion of the book as proto-hypertext. They remain as noise, cautioning against any idea of an all-encompassing archive or index.

Noise at its most Serresian appears in this book's third chapter, on Ronell's *The Telephone Book*. As Ronell cautions in her introduction, "You are expected to stay open to the static and interference that will occupy these lines."[84] The "lines" between text and reader are prone to static, manifesting directly on the page as illegibility: typographical rules are pointedly broken, leaving rivers in the body text or printer's marks on the page, while other pages are completely illegible through overprinting or other effects. This illegibility is further coded as a technological feminine. The figure of the woman—as Heideggerean "young thing," Jung's schizophrenic Miss St., Ma Bell, and even Edison's colleague Watson—is always linked with technological developments, hovering in an uncanny space between person and object.

Produced as noise by typographical illegibility, the technological feminine participates in discussions of gender and media while finally resisting recuperation into any discourse. In the context of new media theory and Bruno Latour's actor-network theory, as well as cyborg feminism, the technological feminine gestures at the limits of these fields' attempts to trace the outlines of the black box we call media.

The digital as inscription comes to the forefront in the fourth chapter, which triangulates Taylor's *Hiding*, his digital literature work *The Réal*, and Shelley Jackson's *Skin* as what I term texts of skin. Recalling Bataille, these works are heterogeneous in material form as well as content. In *Hiding*, Taylor ranges across diverse subjects, from Hegel to Paul Auster, on brightly colored pages of different layouts, weights, and finishes. The surface of the text becomes the skin, text and skin mutually defining a space for interpretation: "When the sign becomes embodied, the body becomes a sign," Taylor writes.[85] Texts of skin foreground the body as the site of reading, which appeals to the senses as much as to the semantic mind, especially in the

audiovisual and tactile appeals of the digital *Réal* and the radically tactile tattoos of *Skin*. In *Hiding*, Taylor develops "rules of nontotalizing structures that function as a whole," which characterize the networked shape of texts of skin.[86]

Texts of skin present noise as loss in material and thematic registers: the loss in any information transfer, the loss of semantics at the horizon of the senses, and the loss, as entropy, that is a function of time. In *Hiding*, for example, Taylor places side by side the personal loss of his father and the extreme bodily experiments, approaching loss of consciousness, of performance artists like Stelarc; these moments are made material for the reader through black mourning pages and thin, translucent paper on which images bleed into text. *The Réal* demonstrates entropy through its story, set in a postapocalyptic Las Vegas of the future, as well as through its material situation—written for an older platform, it is barely accessible to the modern user. In Jackson's piece, which is distributed word by word among over two thousand participants, the story literally ages with its bearers. Texts of skin make apparent the entropic direction of all inscription, the increasing noise that troubles transmission.

In "Diagrammatic and Stochastic Writing and Poetics," Johanna Drucker poses a question: "How does poetic language register against the larger field of language practices?"[87] Against noise, she asks, how can poetry be heard or understood? This is the central question of Drucker's artist's book *Stochastic Poetics*, which, along with Susan Howe's *Tom Tit Tot*, is the subject of our conclusion. Both pieces create fields of collaged and overprinted text, in different typefaces and with edits included, directly on the page. *Stochastic Poetics*, which considers digital technology using old media, enacts a quantum poetics that constantly moves and shifts. *Tom Tit Tot*, which weaves together text as mourning and magic, locates noise of a different kind in the archives from which Howe gathers material. Drucker and Howe are both known for creative and critical work that blurs boundaries between genres, and the shape of artistic argument expands to include these two works. Highly citational and heteroglossic, posing challenges to reading through illegibility, their composition and printing nonsemantically figure noise.

There is no stable reading at the level of the page, but Drucker's and Howe's works also self-destabilize at the level of production and reception. Both books express a hyperawareness of their primary status, letterpressed small-edition artists' books, through their material forms. Howe's work,

with its binding and gold-embossed title reminiscent of a library book, includes a plate at the beginning titled "The Temple of Time," in which time is made of titles, books that line the walls of a building stretching beyond vision. Her letterpressed language suggests the antique technology of moveable type even as it broadcasts its impossibility: letterforms are broken and irrevocably cut and damaged; and some letterforms show signs of use that stand in opposition to their actual printing method, from plates created expressly for the text. *Stochastic Poetics* likewise significantly flaunts the rules of printing. Forgoing a locked-up form, which would enable consistent replication across an edition, Drucker instead releases the type to move, creating an edition in which no two copies are the same. Both artists' books are also available in other forms: *Stochastic Poetics* can be downloaded as a PDF from Drucker's website, while *Tom Tit Tot* exists in several print forms, including as part of a trade collection, *Debths*, by New Directions in 2017. Additionally, both authors have given live readings (performances might be a more apt term) from these works, further complicating the idea of a single or stable reading. Instead, these works are robustly n-dimensional, a final concept that clarifies the shape of artistic arguments.

In her essay "Noise That Stays Noise," poet Cole Swensen refers to a "self-organization" arising from noise in literary works: "In literature, noise is not necessarily something to be suppressed, as it constitutes the potential for increasing the complexity of the system of which it is a part."[88] Following semiotician Yuri Lotman, she mentions "nonsemantic linguistic effects" that create noise.[89] Drawn together through how they function rather than any single genre, artistic arguments translate Swensen's perspective on noise outside of literature to new genres. For argument, criticism, or theory, too, the ineradicable presence of noise turns out to increase complexity and enrich reading, rather than simply hinder it. As concluding with Drucker and Howe indicates, thinking through the nonsemantics of material form has implications beyond the interpretations afforded to just the critical genre, and insists that noise is relevant to any communication.

Artistic arguments encourage us to think about how meaning is made, relying on the intricacies and affordances of page and screen. Changing our perspectives about the media they utilize, offering subtle histories of technology and interpretation, they also contribute to our thinking around digital media today. Nonsemantic elements produce noise that interrupts semantic reading, inviting us to listen with our full attention.

1 In Pursuit of Nonknowledge in the *Encyclopedia Da Costa*

How do you classify a writer like Georges Bataille? Novelist, poet, essayist, economist, philosopher, mystic? The answer is so difficult that the literary manuals generally prefer to forget about Bataille who, in fact, wrote texts, perhaps continuously one single text.

—Roland Barthes, "From Work to Text"

But these [my books] don't make up a seamless list or category, occupying a homogeneous or flat space; on the contrary, they suggest a tormented, hilly landscape—chaotic, fractal, more faithful to reality.

—Michel Serres, *Conversations on Science, Culture, and Time*

In 1919, Marcel Duchamp appends "LHOOQ" to the *Mona Lisa*, creating one of his famous assisted ready-mades. Meaningless as written language, the letters must be pronounced to reveal their meaning: "Elle a chaud au cul," she is hot in the ass, sexually restless. Duchamp adopts a similar technique for his pseudonym, in which "Eros, c'est la vie" (Eros, that's life) becomes Rrose Sélavy. While this is most likely the best-known instance of the *Mona Lisa* being reproduced, it is not the first instance. In 1887, one Eugène Bataille created a "Mona Lisa smoking a pipe," which was published in the long-running humorous journal *Le Rire*. Like Duchamp, Bataille also had a pseudonym: Arthur Sapeck. The name, the laugh, the pseudonym, the proximity to Duchamp irresistibly suggest another name, one more closely associated with the latter artist: that of Lord Auch, or Georges Bataille.

What appears to be an isolated incident—Duchamp's 1919 piece—quickly reveals a tangled story. One signature opens, and out tumble four: the Duchamp *Mona Lisa* and the Bataille *Mona Lisa*; Duchamp and Rrose

Sélavy; Eugène Bataille and Arthur Sapeck; Eugène Bataille and Georges Bataille. Names are not stable references to unique identities but are unwieldy, suggesting resonances across time and across media. They play on the different nuances of spoken and written language, humorizing and sexualizing it. The resonances of these multiple signatures expand, too, into the image, a nonsemantic example. Signification is linguistic, visual, and aural.

Eugène Bataille was part of Les Incohérents, a short-lived but well-known art movement originating, alongside the Hydropathes literary club and works like Alfred Jarry's *Ubu Roi*, in the fin-de-siècle Montmartre art scene. The Incohérents anticipate the overlapping circles quickly forming and reforming during the first half of the twentieth century, two moments in time marked by similarities of political unrest, humor and irony, and the power of communities and the dissemination of the printed word. These circles expanded from the surrealists and Dadaists to productions such as the journals *Contre-Attaque* (1935–1936) and *Documents* (1936–1939), the Collège de 'Pataphysique society (1948–onward), and the Acéphale group and its eponymous publication (1936–1939). Amid the artistic and social turmoil of the times, Bataille and Duchamp, along with an ever-changing cast of characters centered around champions of the avant-garde Isabelle and Patrick Waldberg, were involved in the work under consideration here: an anonymous thirty-one-page fascicle under the title *Le Da Costa Encyclopédique* (1947), followed by two signed fascicles under the title *Mémento universel Da Costa I and II*.[1]

The *Da Costa* (by which I indicate the three fascicles as a group) was undertaken as a radical political and social endeavor—beginning with the controversial anonymity of the first fascicle—as well as an artistic one, using the encyclopedic form in an effort to undermine the bourgeois Enlightenment principles of order and knowledge. It was designed by Duchamp and letterpress-printed in the hasty manner of a broadside, with advertisements that paraded under the pretenses of an actual encyclopedia while being completely fabricated. Punching up, often at thinly veiled targets, its tone was venomous. Its contributors railed against French culture and norms while, ironically, relying on a French tradition—*fumisme*. Coined by Georges Fragerolle, *fumisme* refers to deliberate sharp wit in the service of criticism: "To be considered a wit, it is sometimes enough to be an ass in a lion's skin; to be a good *fumiste*, it is often required to be a lion in an

ass's skin."[2] Fragerolle implemented this precept in the Hydropathes, a fin-de-siècle club, but the *Da Costa* group, around fifty years later, would take it to extremes, cloaking serious intentions in absurd jokes, bawdy images, and playful publication details. Everything old is new again, or always al-readymade.

The *Da Costa* explores some of the themes originally found in the magazine *Acéphale* and, especially, the part of *Documents* known as the "Critical Dictionary." Authored by Bataille and others, the "Critical Dictionary" was a supplement to the main magazine, undertaking a critical exploration and subversion of the reference work that could irritate the primary publication's editors. After fifteen issues, *Documents* folded, taking the "Critical Dictionary" with it, but interest in the aphoristic reference work (and some of the "Dictionary's" associated authors) continued with the *Da Costa*. Unlike the "Critical Dictionary," the *Da Costa*'s three fascicles were published as standalone works; unlike the journal *Acéphale*, which was upfront about its genre, these works subverted genre at a meta-level by purporting to be encyclopedic. The *Da Costa* deliberately juxtaposes the ephemerality of the magazine with the presumed solidity of the reference work, a juxtaposition apparent in its material form as well as its stated content. Reading the *Da Costa*, then, entails reading its material qualities, its social circumstances, and even its distribution as mutually informative with its explicitly semantic content.

Such a material reading underwrites our twofold argument, or—to translate the term "acéphale"—a bivalvular argument, two parts that operate in tandem without a central unifying principle, like the two shells of a headless mollusk. The first part focuses on the *Da Costa* from a more external perspective, developing its status as an artists' magazine, and the second part considers the text from a closer perspective, connecting its various thematics. Two images, as well, serve as metonyms for this bivalvular argument. The first, drawn by André Masson, is the famous Acéphale figure that graces the cover of the five issues of *Acéphale*. In this figure the head has been cut off; a skull confronts the viewer from the figure's phallic area as his two hands grasp a heart and dagger.

Alasdair Brotchie notes the neat inversion from da Vinci's Vitruvian Man (a Renaissance man, here rewritten) to Masson's "as below, so above," in which the proper hierarchy or order of things is rendered headless and power is relocated to the erotic.[3] Reading the *Da Costa* firmly in the tradition of the *Acéphale* affiliates' continued exploration of eroticism, sex,

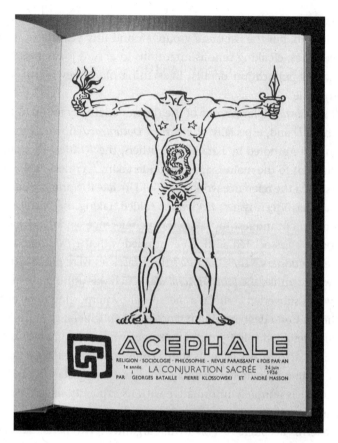

Figure 1.1
The Acéphale.

and violence, we can see Masson's image as a model for the dissemination of knowledge and power, a kind of mastheadlessness. The Acéphale figure signals the *Da Costa*'s status as a communal document comprising different authors, styles, and subjects, subverting top-down distribution and rejecting claims of authorship and authenticity. As a completely anonymous publication, the first fascicle has the most uncompromising attitude toward authorship, but the second and third fascicles continue to play with these questions through pseudonyms and misdirecting errata. Nor was the mystery of its authors immediately cleared up: in tracing its history, Pierre-Henri Kleiber doesn't link Duchamp's name to the project until 1959, and

Bataille's name doesn't appear in conjunction with the project until 1995 (which accounts for the lack of awareness and scholarship, even by Bataille scholars, around the work).

Instead of the purported objectivity and factuality of a reference work, the *Da Costa* embraces biases and authorial presences; the first fascicle declares this orientation at its beginning through our second bivalvular image, the anonymat. Much like Duchamp's play between written and spoken language, the anonymat expresses not just the relationship of the makers to the ones in power, but the relationship between different kinds of signifiers that are linguistic and imagistic. The image on the cover of

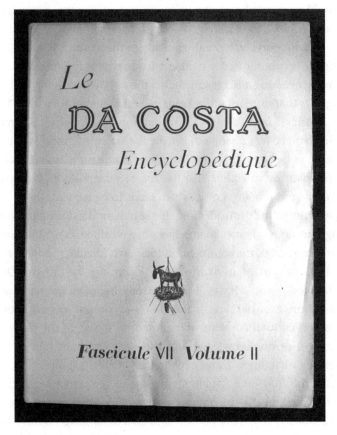

Figure 1.2
The anonymat on the first fascicle's cover.

the *Da Costa* is a rebus, an "ane au nid-mat" or donkey in a crow's nest—a homonym that replaces the author.[4]

At first glance, the anonymat reminds the reader of nothing so much as a printer's mark, a material reminder of form or format's importance to this work in which author, with its connotations of uniqueness and originality, has been replaced by printer. Aside from possibly ridiculing religion by suggesting Christ coming in on an ass, the image in this context is nonsensical. The anonymat signifies as a rebus, an image that points to a word that points to an absence. And this absence, construed in the singular, is technically true: the author is no *one*, but is many. The *Da Costa* punctures the encyclopedia's supposed disinterest; its explicitly subjective entries make what would normally be conventional—a lack of signatures in a reference work—into a motivated statement. The reader accepts the genre as self-evident, information corresponding neatly to the world, and when this correspondence is complicated, a demand arises: who is responsible?

Deferring meaning and responsibility, the anonymat, in place of a signature, suggests that nonsemantics are as critical as semantics to the *Da Costa*. "Nonsemantics," framed in the introduction by McGann, Lecercle, and Bernstein, here covers a range of nonsigns that still signify. What is nonsemantic may be semisemantic, like a portmanteau; material, like paper, image, or color; or structural, like the use of juxtaposition. Nonsemantics jar the reader and produce noise, which tends to be ignored: the unconventional page distracting the reader from her search for the (inevitably semantic) meaning. But nonsemantics themselves offer possibilities for interpretation, enacting some part of the argument on their own (media) specific terms.

Bataille's concept of nonknowledge (*nonsavoir*), key to the *Da Costa* and other works, also adds to our understanding of nonsemantics. If the Acéphale is the external face of the *Da Costa*, turned toward publication concerns and cultural contexts, the anonymat speaks to the nonsemantic manifestation of nonknowledge, the "nonsense without remedy" that is the method of Bataille's "inner experience."[5] Published almost simultaneously with the *Da Costa*, Bataille's eponymous text attempts to delineate an "inner experience"—the phrase is Nietzsche's—that rejects knowledge, which Bataille assigns as the purpose and goal of language, in favor of nonknowledge, which presents a limit experience or horizon of thought or consciousness. Nonknowledge is "receded by insights, putting into play forces of all kinds, not linked to anything, starting again, not building stone by

stone."[6] Resonant of Gertrude Stein's "Beginning again and again," non-knowledge foregoes progression, progress, or stability. Instead, it puts "forces of all kinds" into play. Like the headless Acéphale, nonknowledge is a rejection of hierarchy and order.

Such a rejection begins with language—Bataille cites a necessary "poetic perversion of words," which aligns with the nonsemantic and recalls the poetic, playful remainder.[7] Of course, the "project" of language is not so easily perverted or shaken off, and the semantic hovers around the nonsemantic, even as Bataille tries to imagine an alternative. Nonknowledge can only really function as a vector or a horizon, not a hard or fast category but a field of inquiry. Expressed through material form and content, nonknowledge manifests in the *Da Costa* in wildly varying guises: the thematics of heterogeneity, formlessness, and crazy flight patterns as shapes for understanding; anonymity; immediacy, which reckons with the moment as both historical and ephemeral; appropriation, broken genealogies, and bastardization; and *l'huamour*, the nexus of laughter (*humour*) and eros (*amour*). These disparate elements form a fuzzy set that nonetheless never devolves into complete chaos. Nonknowledge has real stakes, attempting to model a radical epistemology of language and thought that prioritizes antisystemic thinking and affective response. These stakes also influence the larger spirit of work in this book. Like nonsemantics, nonknowledge suggests an alternative to semantic language that claims interest and enrichment on its own terms. Exploring the possibilities of signification, we seek unusual and compelling relationships among material, structural, and formal elements that rely on the embodied reader.

Bivalve: Acéphale

The figure of the Acéphale exemplifies the *Da Costa*'s historical, artistic, and political circumstances, which are inextricable from its material and meaning as an artists' magazine. Intended for quick consumption and potential disposal, the enterprise of the little magazine or artists' magazine is fraught with urgency, as Gwen Allen writes: "To publish a magazine is to enter into a heightened relationship with the present moment."[8] This sense of immediacy figures around and in the *Da Costa*, which directly engages with the social and political climate of the time, taking an ironic attitude toward French nationalism, the military, religion, education and philosophy, and

what Brotchie calls "the niceties of bourgeois existence."[9] The tone of the *Da Costa* is unmistakably sarcastic, ranging from "false erudition to stupidity," as Kleiber writes.[10] Besides its larger polemics, the *Da Costa* also comments sardonically on artists and intellectuals of the time, coded or pointed references that were not lost on its audience. A review in *Paru* no. 39 (1948) remarks on the "total disrespect" the *Da Costa* exhibits.[11] Even contemporary readers unaware of local social complexities can glean the defiant tone in entries such as "Expression" and "Isou," which parody the pretenses (or pretensions) of Isidore Isou and imagism, or "Con-men," which ruthlessly mocks then-current attempts at interpreting Kafka.[12]

Yet the *Da Costa*'s vehemence and ire, especially when taking on larger sociopolitical issues, are motivated. Kleiber argues, "The experience of the *Da Costa* is inseparable from the war, the upheavals that it introduced into individual existence, the demoralization that it brought about, the unexpected contacts it promoted, the demands it posed to those who had for a while questioned the future of civilization."[13] Sparked by the rise of fascism, both Bataille and his onetime colleague André Breton were interested in "myths capable of rivaling those of fascism."[14] Their answers, significantly different, were a source of contention for their relationship but also reflected larger trends; Breton's surrealism came under attack by Bataille and others, and Bataille's own mystical Acéphale activities also prompted a good deal of animosity for their radicalism, violence, and perceived "aggression."[15] These activities included secret meetings and discussion of human sacrifice, but they also (more prosaically) included an attempt at a new calendar, as the group expressed a desire to reconfigure or reconceptualize time. This focus on temporality is captured in the *Da Costa*'s form, its "heightened relationship with the present moment" expressed as artists' magazine.

The *Da Costa*'s dedication to *fumisme* extends from its semantic content to its material production and distribution. With deliberately misleading pagination that begins at page 207, the first fascicle was subtitled "Fascicule VII Volume II," landing its reader in the middle of a nonexistent series. The second and third fascicles, in contrast, are labeled I and II. Signifying urgency and sowing confusion in the reader, the first fascicle even begins in the middle of a word. "Like the relationships and communities they embody, artists' magazines are volatile and mutable," Allen writes,[16] and the community around the *Da Costa* was considerably unstable, with collaborators bickering among themselves (especially about Breton's contribution), and

many contributors appearing only in the first fascicle. Of the original insti-
gators of the *Da Costa*—mainly Patrick and Isabelle Waldberg, Robert Lebel,
Charles Duits, and Jean Ferry—only the Waldbergs, Lebel, and designer-
contributor Duchamp remained, with almost all other contributors, includ-
ing Bataille, dropping out of the project, while other contributors came
aboard.[17] The magazine's material form changes as well: from thirty-one
pages, the last two fascicles reduce to sixteen pages each, with a smaller
overall format. The title changes, the work's overt encyclopedic ambitions
(*Le Da Costa Encyclopédique*) recast as derivative (*Mémento universel Da Costa*,
recalling the *Mémento Larousse encyclopédique et illustré*) while retaining the
form of the reference work. Moreover, the alphabetical constraint of the
first, in which every entry begins with *E*, is abandoned in the second two
fascicles in favor of conventional alphabetical order. Perhaps most signifi-
cant, most of the articles are signed, although some authors (most often
Robert Lebel) use a pseudonym.[18] The *Da Costa*'s authorial recombinations
and issue-to-issue changes unmistakably recall Allen's characterization of
the artists' magazine.

One constant material feature is the encyclopedic form that structures
the three fascicles. In line with its critique of French political and social
mores, the *Da Costa* takes aim at the encyclopedia as a grand concept of the
French Enlightenment. A brief glance at Denis Diderot and Jean le Rond
d'Alembert's "Preliminary Discourse" to their monumental work beginning
in 1751 reveals their aim: "to set forth the order and connection of the
parts of human knowledge," as well as "to contain the general principles
that form the basis of each science and each art."[19] This sweeping ambition,
suggesting a comprehensive ordering of a knowable world, is never fully
realized; from the beginning, the Enlightenment encyclopedia was subject
to rifts, setbacks, and revisions in authorship, publication, and distribu-
tion. The *Da Costa* emphasizes this incompleteness and changeability while
appropriating the formal shape of the encyclopedia.

Just as the *Da Costa* emerges from a culture of artists' magazines at the
time, its fascination with the encyclopedic tradition speaks to a richly mined
vein of (particularly French) writing that subverts genres. In his *Eau sur eau*,
Christophe Lamiot considers the *Da Costa* alongside Stéphane Mallarmé's
English-language treatise *Les mots anglaises* (1877), Gustave Flaubert's satiric
Dictionnaire des idées reçues (1880), Henri Michaux's philosophical travel
narrative *Voyage en Grande Garabagne* (1936), Michel Leiris's experimental

poem *Glossaire j'y serre mes gloses* (1939), and Francis Ponge's prose poems *Le parti pris des choses* (1942). Of these, Leiris's work resonates most strongly with the *Da Costa* project. Involved with *Documents* but not with the *Da Costa*, Leiris, in *Glossaire*, utilizes a "principle of eroticism" that recalls the sexualized imagery and language of the *Da Costa* through puns and language play.[20] The material forms of the two works unfold at opposite ends of the spectrum, however: Leiris's work appears much like a traditional fine art publication, its text and images (also drawn by André Masson) carefully printed on thick Arches paper stock with a deckle edge in a numbered edition, in contrast to the *Da Costa*'s slapdash production (which I discuss in more detail below).

Describing these "lexicographical poets," Lamiot sees a common thread uniting aims that are sociopolitical as well as poetic: "Every writer considers ideology through the dictionary form."[21] Lexicographical poets are not interested in reconstructing meaning, but instead attempt to "manifest the possibility and the demand of an order until then ignored or passed over in silence."[22] For Lamiot, the *Da Costa* and the earlier "Critical Dictionary" "present and propagate a model of agreement between individuals, a social order that follows a linguistic one."[23] This mode of agreement is apparent in practice; it also manifests through co-signatures, present in the *Da Costa*'s second and third fascicles and in the earlier "Critical Dictionary." Such cosigning of articles "radically isolate[s] the authors through comparison with this dictionary tradition."[24] The "Critical Dictionary" and *Da Costa*, by acknowledging the subjectivity involved in their entries, subtly undermine the primacy of the reference work while instead positing a nonhierarchical order based on community and the potentialities of language.

Other literary works besides lexicographical ones speak to the *Da Costa* project. Perhaps most notably, Jorge Luis Borges's "Tlön, Uqbar, Orbis Tertius" (1940) comes to mind. Indeed, this story of an impossible encyclopedia entry, which ultimately creates what it describes, may have been in the *Da Costa* creators' minds—it certainly was a touchstone for the associated Collège de 'Pataphysique.[25] The *Abridged Surrealist Dictionary* (1938), organized mostly by Breton but to which others, including Leiris, contributed, also bears a superficial resemblance in form and authorship to the *Da Costa*, if not a deep connection.[26] At the same time, the *Da Costa* and other lexicographical works foreshadow Derrida's *Glas*, with its extensive usage of the Dictionnaire Littré and two-columned format. Even the *E* constraint in the first fascicle seems to anticipate Georges Perec's 1969 novel *La disparition*, a

lipogram from which the letter *E* has been excised. Constraint as an avant-garde practice travels through the *Da Costa*; to the Oulipo, whose founder Raymond Queneau was a colleague of Bataille, Leiris, and other authors; and to Perec, probably the most famous Oulippean novelist. The *Da Costa*'s influences, and the works it anticipates, help situate the project in well-known avant-garde and artistic traditions inspired by the dictionary and encyclopedia.[27]

In conjunction with the material form of the reference work, the *Da Costa* also explores another powerful model of information dissemination: the newspaper. The collaborators followed convention for the release of reference works, publishing announcements and press releases. For the first fascicle's publication, an announcement was printed in the journal *Fontaine* (1946), while the *London Gallery News* proclaimed (in English), "DA COSTA TO PUBLISH HIS ENCYCLOPAEDIA IN PARIS."[28] While maintaining the façade of an encyclopedia, these announcements use language that nonetheless hints at the encyclopedia's nonobjective status: it is "his," Da Costa's, encyclopedia, but despite the grandiose tone, no one knew who this Da Costa could be. The creators even went so far as to create their own fictional newspaper, *The Herald*, which included a blurb by "The Editors" at the foot of the first page acknowledging that "This edition of the Herald has been gotten together with the aid of a pair of scissors and a paste pot."[29] For the second fascicle, an announcement was published as an insert in the journal *Combat* (1948), proclaiming "Une Encyclopedie Anticonformiste" (An Anticonformist Encyclopedia) and "Au Service de L'inintelligence" (In the Service of Unintelligence).[30] Parodying Breton's 1930–1933 periodical *Surrealism in the Service of the Revolution*, this second phrase emphasizes "inintelligence" as devotion to the trivial and banal. It also suggests a more lighthearted analog of nonknowledge, linked conceptually as well as through the semisemantic space of a nonstandard word. "Au Service de L'inintelligence" appears, too, on promotional paper bookmarks released in green, pink, and orange, the reverse of which mysteriously asks: "What will be the next incarnation of evil?"[31] "Pastiche, mystification, collage, juxtaposition of articles, a bawdy spirit, [are] all things that situate this journalistic hapax in the context of the encyclopedia announcement," writes Kleiber; and the *Da Costa*'s "journalistic hapax" is both semantic and material, partaking in *fumisme* while also suggesting the importance of nonknowledge or inintelligence and the authorial (sleight of) hand.[32]

In addition to the announcements and ephemera, the *Da Costa* investigates other aspects of the synchronicities between newspaper and encyclopedia forms. In their side-by-side columns, the two genres share a similar goal of disseminating legitimate and objective information. As the *Da Costa* comes out of the "Critical Dictionary" and other lexicographical works, it also inherits the styles and concerns of the two surrealist *Cadavre* broadsides of 1924 and 1930. These broadsides are a clear parody of the newspaper form—short, tabloid-style pamphlets with large wood type spelling out "UN CADAVRE" at the head of each cover. Written by multiple contributors, both multicolumnar broadsides also utilize multiple typefaces in another material expression of heterogeneity. The first *Cadavre*, for which Breton was the primary instigator, attacks French writer Anatole France, playing on the notion of body or corpse as the body of work, or corpus, while France's name inevitably implies a more national cultural impoverishment. As with the confluence of the signatures that begins this chapter, the name—of the corpus or corpse, and of France—is made material, multiplied, and complicated. The first broadside ends on an almost sinister note that anticipates the *Da Costa*'s "next incarnation of evil," declaring: "On the next occasion there will be a new cadaver."[33]

As promised, there was another, a 1930 *Cadavre* that turned the attack on Breton himself. This *Cadavre* announces its increased importance through its design: the paper is larger in size, with four columns rather than three, and the title utilizes even bolder, heavier wood type. An image of Breton, in the guise of a (presumably self-anointed) Catholic saint, splashes across the front page. Accusing Breton of fraternizing with the police, Communist sympathies, and retaining his bourgeois privilege, these articles include Bataille's scathing "The Castrated Lion," which ends on a vulgar note: "Mais on ne reverse rien avec une grosse gidouille molle, avec un paquet-bibliothèque de rêves" (But you can't overturn anything with a big soft club, with a library-packet of dreams). The *Cadavres* anticipate the *Da Costa*'s stylistic heterogeneity, dedication to collaboration, relationship to power and information, and interest in parody at semantic and nonsemantic—specifically, structural and material—levels.

As the *Da Costa* extends the *Cadavres*' parodic and sarcastic tone to cover a broader range of subjects, it echoes the broadsides' material form. The broadside, even more ephemeral and quickly consumable than an artists' magazine, distances itself further from the stolidity of the encyclopedia.

In addition to sharing a columnar format, the *Da Costa*'s first fascicle has covers that are remarkably similar in paper stock and color to some of the 1930 *Cadavre*s. All three *Da Costa* fascicles are printed on thin, cheap paper and are staple-bound. The printing was done in haste (although with more care than the *Cadavre*s, perhaps suggesting a greater time investment), with unstable baselines and imperfect back-to-front registration. The text is riddled with editorial and spelling errors, while the last fascicle has an "Erratum" stamp correcting an attribution. These material details place *Da Costa* in the realm of the periodical as well as the encyclopedia. Ultimately, it performs as a hybrid that combines the newspaper, broadside, and encyclopedia, highlighting the tension between journalistic forms, with their quick production and consumption, and the encyclopedia, with its posited reliable knowledge.

Bivalve: Anonymat

The strange shape of the *Da Costa* refuses assimilation into neat genres, instead utilizing and subverting these genres—journalistic, encyclopedic, or theoretical—to create formless heterogeneity, not chaotic but in the sense of *l'informe*. Here, heterogeneity creates noise, exemplifying nonknowledge's "forces of all kinds" that shape the *Da Costa* as winds shape dunes. In "The Psychological Structure of Fascism," Bataille defines the heterogeneous as that which "concerns elements which are impossible to assimilate"; it speaks to no less than "the sacred," and "includes everything resulting from *unproductive* expenditure."[34] Leaving the sacred aside for the moment, we can easily conceive of the *Da Costa* in terms of heterogeneity's resistance to recuperation into a system. Heterogeneity "must positively envisage the waste products" of any system: political, social, epistemological.[35] What is unproductive, wasteful—in this context, noise—is still important.

One consequence of heterogeneity is its irreducibility: in its form, its content, and even its changeable social situation, the *Da Costa* (like all artistic arguments) cannot be distilled to a single argument or meaning. At a semantic level, the *Da Costa* exhibits heterogeneity through its uneven texture, created by its detailed anecdotes, animated opinions, and jokes—often vulgar—rather than the "general principles" that reflect the Enlightenment encyclopedic project. As Brotchie also notes, "the heterogeneous eschews completion," an eschewal which is apparent materially in the *Da Costa*'s

deliberately misnumbered fascicles, pagination, and references to potential future publications.[36]

The *Da Costa*'s heterogeneity combines semantics with nonsemantics, utilizing images and design/typographical details alongside its jokes, parodies, and stories to exacerbate the overall noise. Throughout, language is deployed to express ideas, but it also is treated as material, as the first incomplete word makes clear. This first word, "-festations," is nonsensical at first glance. Kleiber proposes the word as "manifestations," where "mani-" as "hand" recalls two full-page images elsewhere in the fascicle: "This hand can be found multiplied and made obscene in the sign language alphabet of 'Eroticism,'" as well as in "Fingerprints."[37] "Manifestations" might also be a dismissive reference to the manifestos proliferating at the time, including *Dada Manifesto*s by Hugo Ball and Tristan Tzara and Breton's *Surrealist Manifesto*, examples of the kind of earnestness the *Da Costa* is keen to avoid. In a printer's context, too, the absent prefix "mani-" inevitably recalls the manicule, the engraving of a finger that, like the leading hyphen, points to the first entry and reminds the reader that words on the page have a material presence. Citationality also suggests linguistic materiality, in which language is treated much like the "cut and paste" job that created the fictional newspaper *The Herald*. In the *Da Costa*, original content is mixed with citations, which either are not attributed or are entirely fictionalized: "Eclipse" and "Eternity," for example, are taken from Alfred Jarry's *Faustroll* (1911), while "Excess" performs its definition by including an excess of quotations, alternating every other sentence.[38]

Materiality does not imply stability, however. Unwieldy language, pointing in many directions at once, abounds in the *Da Costa*, presenting examples of what Bataille calls "slipping words." In *Inner Experience*, he defines the "slipping word" through the word "silence," which is "itself proof of its own death."[39] (Premonitions of Derrida's *glissement du signifiant*, the slipping signifier that points to more signifiers indefinitely, are inevitable, although Derrida advocates a more thorough "freeplay" that isn't necessarily found here.) A "slipping word" enacts some quality of its meaning, slipping between what it means and what it does. In the *Da Costa*'s absurdist story "Spectre of the Anvil," Anvil turns from the name of a royal architect to an object—an anvil—through mishearing.[40] The phrase then enters the common lexicon, a signature drifting ever further from its bearer. In the second fascicle, this process is reversed: what begins as an adjective,

"infame" (loathsome), becomes the name on the grave of the one it origi-
nally described.[41] The tenuousness of the signifier, especially of the signa-
ture or the name, is apparent through these entries.

Some slipping words appear caught between two words, semisemantic
signifiers that suggest a nonmimetic philosophy of language. An entry like
"Estorganisation" gestures toward "east" and "organization" but is ulti-
mately untranslatable in either direction: one of many places where the *Da
Costa* demonstrates how the meanings of slipping words can be "impossible
to assimilate."[42] Slipping words are also bestowed with some critical impor-
tance to the project as a whole. "Nonknowledge" and "inintelligence"
both operate in a semisemantic space, as does *l'huamour*, which combines
"humor" and "amour." Slipping words describe concepts that exceed the
boundaries of conventional language while still partly employing conven-
tional signification.

The heterogeneous texture of the *Da Costa* also involves the nonseman-
tic in the form of images. The *Da Costa*'s engravings, originating from the
Deberny foundry, are known as clichés, highlighting the banality of the
images presented: courtly women and men, children playing, soldiers and
helmets. (Kleiber also connects their generic nature to Duchamp's ready-
mades.)[43] Here their deployment sometimes fulfills expectation (an anvil
appears next to the "Spectre of the Anvil," for example) and sometimes sub-
verts it in a self-conscious movement. The first fascicle includes an image
of a blank sign—a sign of a sign of blankness or potentiality—next to the
entry "Encyclopedia," as if refusing to help define the text that bears defi-
nitions.[44] Another sign, this one a half-page, ends the second fascicle by
declaring "ARRET POUR ENTRETIEN" (Stop for Maintenance), emphasizing
the publication as ongoing work in progress that resists the organization
of a *telos*. Typography, too, functions as image: on the last page of the last
fascicle, for example, every line is broken in the absurdist entry "-TOIR."
Surrounded by hyphens, "-TOIR" echoes the first fascicle's "-festations,"
as well as reaching back to the "abattoir" entry in *Acéphale*, a place where
bones, like lines, are broken. It also recalls the escritoire (or "escritoir"), a
portable writing kit in the eighteenth century, a representation of the pro-
cess of writing as deliberately material.[45]

The *Da Costa* grafts semantic and nonsemantic elements together to
form an irreducible work: what Barthes refers to as Bataille's "single text"
actually is meant to indicate this sense of irreducibility, undermining the

notion of any text as single. Grafting recalls a garden, perhaps the "garden" of reading mentioned in Mallarmé's "The Book, Spiritual Instrument."[46] In this garden Mallarmé locates a "white butterfly," its wings like the wind-fluttered pages of an open codex, whose movements suggest a complex notion of reading.[47] Mallarmé describes the butterfly as *"everywhere at once, nowhere"* (emphasis in original).[48] Its multidirectional flight returns us to the idea of formlessness, a concept that first appears in the "Critical Dictionary." "Formlessness" begins by reflecting on the form of the reference work, provocatively stating: "A dictionary begins when it no longer gives the meanings of words, but their tasks."[49] Here the dictionary is a metonym for the structure of language and of knowledge, undermining the apparent stability of these structures. Formlessness "serves to bring things down in the world," or, in another translation, to "declassify," further blurring or undoing the fixed edges of definition.[50] Such declassification allows for heterogeneity, and heterogeneous language implies no less than a heterogeneous universe: "Affirming that the universe resembles nothing and is only *formless* amounts to saying that the universe is something like a spider or spit," the entry ends.[51] Resisting the dichotomy that asks us to choose chaos or fixedness, formlessness instead offers its own alternative, a subversion of categorization that enables the *Da Costa's* possibilities of nonsemantic signification—and those of other artistic arguments—to come into play.

Besides its own heterogeneous shape, the *Da Costa* depicts models of formlessness throughout its pages. Extending the call of the "Critical Dictionary" to declassify language, the *Da Costa's* entry "Encyclopedia" proposes: "An encyclopedia worthy of the name cannot trouble itself with realistic consideration," but must instead create space for the future.[52] This space again is premised on the delimitation of language: "From a realm where, as yet, grammarians have not yet established their police, there flies up a whole swarm of vaporous expressions, butterflies of language, which sometimes, in a chance sally, we can catch in flight. By chance also they may strike against your forehead and mark you with a sign, seemingly indecipherable."[53] Like Mallarmé's butterfly, these "butterflies of language" are light and airy; they cannot be pinned down with meaning or made to bear weight. They appear "vaporous" or even, in the context of some of the *Da Costa's* banal or petty anecdotes, vapid. It is precisely this fleetness, though, that enables them to avoid the "grammarians" who "police" language, censoring and limiting its meanings.

Seemingly too small to be of significance, the butterflies' flight path traces formlessness, much as elsewhere in Bataille's writing the "fly fallen in ink" poses a question about the nature of the universe.[54] Nor is ink, the "sign" struck against one's forehead (the center of philosophical thought), an incidental inclusion: it conceptualizes language as the discernible trace of this flight. The formless as flight pattern is, as Michel Serres attests, "an extremely complex design, incomprehensible and appearing chaotic or random," in which the butterfly or fly *"implicates* something that his movements then *explicate"* (emphasis in original).[55] The flight and its sign only appear "indecipherable"; looking to their movements explicates meaning. Serres even specifically links this movement to the encyclopedia: "We always believe that the expanse of the encyclopedia or of knowledge is seamless and orderly—but who said so?"[56]

Traces of flight span the expanse of the *Da Costa* in semantic and nonsemantic capacities. Alongside its narrative based on slipping words, "Spectre of the Anvil" also contains an anecdote about royal swans which, reflecting the brilliance of the sun, are eventually cooked (perhaps recalling the bejeweled dead tortoise, life sacrificed for artifice, in Joris-Karl Huysmans's 1884 *À rebours*).[57] An image of a feather, without context, appears next to "Examination," and feathers are casually mentioned in "Ennui."[58] A highly mediated sense of flight even appears in "Eskimo's" reference to Duchamp's "griffe volante," a mistitle that Brotchie supposes refers to "Coeur volant," but also might suggest the artist's *Hat Rack*, a piece in which a hat rack suspended from the ceiling takes the shape of a *griffe*, or "claw."[59] The quickness with which the *Da Costa* moves among heterogeneous material describes a crazy pattern of flight, in which subjects, emptied of weighty expectations, float as light as feathers.

Flight also serves as a metonym for sex, a critical component that the *Da Costa* explores explicitly, through suggestive entries, and implicitly, through structure and image. Consider the entry "Elegy," which relates the story of "Boirot," a boorish man who seduces a bride-to-be, and ends in a dirty joke.[60] "Elegy" deliberately refuses to impart a moral lesson or even a simple description, opting instead to use language in the service of banality and vulgarity. More pointedly, "Erotin" references a mysterious "author of pornographic works" (undoubtedly a nod to Bataille himself) on whose writing "like a sign, the butterfly of spasm settles."[61] This spasmodic butterfly is propelled by heterogeneousness: "Of literary forms, l'Erotin neglects

none," but "exhausts [them] in a single work." Sexual exhaustion is equated with various kinds of writing in which the heterogeneous is a source of eros.

The full-page image titled "Erotism," meanwhile, depicts the American Sign Language alphabet but rewrites its letters with sexually suggestive terms: "Accost, Burgle, Cunnilinguate ..." that maintain the alphabet as constraint.[62] The "lingua" of "cunnilinguate" slips from the speaking tongue to the sexualized tongue to the speaking hand to the sexualized hand. In each case, sex is superimposed onto language, or even displaces it. Perverting conventional signification, written language becomes the hand motions of sign language, which are further mediated as a visual representation on the page: signing becomes the sign. Signing also extends to the ink on the page that marks a signature, which here is supplanted by the ephemeral motions of hands that trace a path through the air like a butterfly.

Even at a structural level, sexualization imposes itself as juxtaposition. Especially in the first fascicle, the *Da Costa* engages in a cycle where an elevated or inflated (as in high-minded) statement or tone is immediately followed by a deflating or undercutting one, a zigzag motion that recalls the fly's flight pattern with postcoital overtones. In a self-reflexive gesture, the entry "Elevation" enacts exactly this process, using an explicitly "elevated" tone to discuss the labor of a weaver.[63] The entry immediately following, "Elias," describes its titular character as "The Miracle Child," who was supposed to "have been transfigured into the Holy Spirit" but instead devotes his life to the "linen trade," recalling the subject immediately prior.[64] An even clearer sexualized juxtaposition appears in "Soaring Flight's" lofty language, describing the grandeur of Parisian landmarks before ending with an admiring ejaculation about the "pricks of Sacré Coeur and the Tour Eiffel."[65]

Deferral (possibly without end) is built into the structure of the dictionary or encyclopedia, much like Vladimir Nabokov's "word golf" in the index of his novel *Pale Fire*, in which entries point to other entries in repeating loops. In the *Da Costa*, one set of entries unexpectedly creates a narrative thread within the heterogeneous texture. Seven entries beginning with "Eulogy (of the periwig)," later attributed to author Charles Duits, open into a linked story.[66] Taking nationalism as their target, these entries relate the story of one Anatole de Fondpierre (almost surely another reference to Anatole France, already attacked in the first *Cadavre*). The entries describe Fondpierre as a "veritable Prince of the state" who "defends our language

against neologisms" and "those wretches who dare to take those liberties with it."[67] Nonsense, the apparition of nonknowledge, offends Fondpierre's "gallic decency."[68] Like Samson, the poet's power lies in his hair, which he loses at the start of the story; hence the satiric defense of the periwig, which might have saved Anatole from becoming an "elderly nonentity who turned out bad verses."[69] The lack of hair also suggests a lack of head, again recalling the Acéphale. The story, told as if quoted from a literary source, leads the reader through encyclopedia entries where each entry references the one prior and the one following in the story. The final entry, "Exempt," refers both to its preceding entry and the original "Eulogy," creating a closed loop. Banal and sarcastic, the story refuses to properly conclude in a linear fashion, instead continuing a structural deferral that connotes sexual and aesthetic frustration.

Here and elsewhere in Bataille, sex and waste are analogical, both terms suggesting a perversion of order. Waste, like noise, is excessive to a system, and attending to it threatens stability: the entry "Sewers" attempts to recast the idea of the sewer as a source of "sacrifices and magic ... we no longer know."[70] Both sex and waste can also be comical, as apparent in entries like "Moramuko," which refers to fictional texts "Fecality and Fiscality" and a "General Treatise of Scatopolitics."[71] And both sex and waste have a tinge of disease about them, suggesting the formless spread of infection. The language of infection infiltrates the *Da Costa* in entries like "Emerald," a citation from Raymond Roussel's 1914 novel *Locus Solus*, which describes a "parasite."[72] In "Scrofula," which plays on a homonym between "cruel ones" and "disease," eros and waste are explicitly linked.[73] In *The Sorcerer's Apprentice*, Bataille writes: "We can only fight as an infection, as a matter of fact we must engage in combat on the terrain where the monster can be found ready," suggesting an additional political or social component to infection.[74] Besides acting as chaotic flight and sexualized juxtaposition, the slippage of language operates like infection, contaminating meaning.

Eros also directly calls back to the thematics of the anonymat that begins with the rebus on the *Da Costa*'s cover. Like Rrose Sélavy, L'Erotin, as the entry "Erotin" explains, is a pseudonym that recalls a homonym, "air hautain" or "proud bearing."[75] This play with false signatures is meant to be admired: "What a challenge, thrown down at the slovenly rabble of writers who sign their names," exclaims the entry.[76] (A kind of complementary sentiment appears in "Erratum," which mocks a poet concerned with a

misspelling of his name.)[77] The slippage between the writer L'Erotin and his heterogeneous work, and the writer *of* "L'Erotin" along with the other writers of the heterogeneous entries in *Da Costa*, invites the reader to reflect again on the signature as playfully unsteady. "Erotin" is accompanied by an image of a mask, a kind of manifestation of anonymity that declares personhood while hiding identity—or declares identity itself a question of style.

If L'Erotin suggests another kind of signature for the anonymat, other nonsemantic signatures present themselves, too. The rose covers of the first fascicle recall the Larousse dictionary's *pages roses*, a pink section in the dictionary containing Latin sayings, quotations, and maxims. (The *pages roses* were of particular interest at this historical moment, with poet Jacques Prévert paying homage to them in his 1951 *Spectacle*.) The rose pages also suggest a slipping signification from Larousse to La Rose and, never far, Duchamp's Rrose. The pink cover of the first fascicle is replaced with a blue cover on the two *Mémentos*, and Deberny, responsible for the engravings, is also the source of the decorative typeface that spells out the name *Da Costa* on each fascicle. This typeface, known as Clair De Lune, was designed by George Auriol in the same calligraphic style that characterizes all his art nouveau typefaces—which were popular with many fin-de-siècle audiences, including, amusingly, Anatole France.[78] Here, it makes an appearance solely for the name *Da Costa*, mischievously calling attention to its status as stand-in for an author's signature: a typeface, synonymous with reproducibility, meant to mediate calligraphic handwriting, which suggests an author named Da Costa who is not a person at all.

Indeed, who is this Da Costa? The name probably refers to the surrealist painter Antonio Pedro Da Costa, who knew the Waldbergs and other contributors; there is a somewhat hazy anecdote based on how common the name "Da Costa" is in Portugal.[79] The name might also refer to Belle da Costa Greene, the director of the Morgan Library, who figured in Duchamp's creation of Rrose Sélavy.[80] (In a historical moment of shifting signatures and signifiers, Belle da Costa herself adopted the name to pass as Portuguese instead of African American.) More intriguingly, Kleiber notes a naturalist by the name of Emmanuel Mendes Da Costa who gives his name to a bivalve mollusk, an acéphale.[81] Kleiber is cautious about advancing this hypothesis, but there is evidence: the full name of this particular Da Costa (and the date, 1776, when his *Elements of Conchology* was published) appears in the entry titled "Fingerprints."[82] In his preface to *Elements of*

Figure 1.3
"Empreintes Digitales" [Fingerprints]

Conchology, Da Costa is somewhat obsessed with opposing what he terms the "Linnaean obscenity" in naming bivalves: "Science should be chaste and delicate. Ribaldry at times has been passed for wit, but Linnaeaus alone passes it for terms of science."[83] There is a hint of comic appropriation, then, in bringing the name Da Costa back into what is definitely a ribald context.

"Fingerprints" contains a clue to the fictitious author while also visually extending the thematics of the anonymat. "Fingerprints," a full-page image, claims to display the fingerprints of various Da Costas, but its sixteen squares give the impression of tree bark rather than skin. If the written signature refers to a unique identity, the fingerprint is a haptic manifestation (where "mani-" again points to the hand) of authorship and originality. It is the irreproducible mark of selfhood, reproduced on the page. Casting "Fingerprints" as tree bark also revises the cite of identity (given its reproducibility) to the site of identity, a physical location. For the reader familiar with the Acéphale group, tree bark recalls the Marly forest outside Paris, site of secret meetings and phenomenal investigations for its members. This forest also brings us from "mani-" back to "-festations": the first full sentence of the *Da Costa*, which occurs in this entry, reads, "The individuals

of this group are then the victims of a strange activity."[84] In "Fingerprints," the "strange activity" relates the bivalve to the tree to human skin, suggesting nothing less than a vast and mysterious heterogeneity of being: the universe, shaped like a spider.

These moments that question, double, and explore the signature and identity are playful, but they are also premised on the rejection of authority, which is critical to nonknowledge. Knowledge, Bataille writes, implies authority, which is always implicit in language: "God: final word meaning that every word, later on[,] will fail."[85] Rejecting God as the author of the self parallels rejecting a declaration of authorship. In Bataille's "Notes" to *Inner Experience*, years before Barthes's "Death of the Author," we read: "What alone liberates me is the idea that a book is really let go, no longer belongs to its author."[86] The *Da Costa*'s insistence on anonymity is synonymous with Bataille's rejection of authority more generally, replacing it with the search for nonknowledge instead.

Moreover, Bataille argues, communication itself—the central theme of his 1957 collection of essays responding to Sartre, *Literature and Evil*—requires a rejection of authority. Under this rubric, the anonymity of the *Da Costa* does not hinder but facilitates its attempt at communication—even one that is marked from the very beginning, in the first full entry, as at once a game of chess (*échecs*) and a "failure."[87] The double meaning of *échecs* is further stressed through its accompanying image of a chessboard: the only image in the entire *Da Costa* (barring the anonymat on its cover) that is hand-drawn (by Duchamp) rather than an engraving or cliché. Above the image is the problem "Black to play and win," a kind of correspondence with Duchamp's famous impossible endgame problem titled "White to play and win."[88] Because we have no choice but to use language, even in articulating resistance, we play a game we can't expect to win.

Resisting authority and hierarchy, the *Da Costa* also resists a conventional genealogy that standardizes temporality. In keeping with its ephemeral genre, it proposes a sense of immediacy as the base for considering time. Besides their work with Acéphale, which sought to reconceptualize temporality through a new calendar, Bataille and his compatriots' ongoing defense of Nietzsche indicates their preoccupation with genealogy, a concept with roots in the German philosopher's *Genealogy of Morals*. Seeking alternative structures for history and time is at the forefront of all these works. While "Encyclopedia" emphasizes meaning as a future endeavor,

other entries such as "Splendor" and "Economy" argue that "poetry is *in the moment*."[89] This commitment to the current moment appears even more strongly in "Eglise," where the "past and future, both grossly over-valued, reduce the present to a simple transition."[90] By contrast, the *Da Costa* suggests, the present is the subject most worthy of attention.

Still, many times exist next to one another on the encyclopedic page, and the *Da Costa* articulates its restructured genealogies through its appropriated material form. Much like Derrida's father-son thematic, or linguistics of the *argot*, which will appear in *Glas*, the encyclopedic form of the *Da Costa* is bastardized. Literally reframing its source material, the *Da Costa* directly copies its layout from Charles-Joseph Panckoucke's 1782–1832 *L'encyclopédie méthodique ou par ordre de matières, par une Société de gens de lettres* (Methodical Encyclopedia by Order of Subject Matter), as Kleiber demonstrates using mockups from the Waldbergs' library.[91] Moreover, the Panckoucke itself draws on a bastard lineage. The Panckoucke editors "cut up" the original *Encyclopédie* rather than writing or rewriting entries, rearranging D'Alembert and Diderot's work to reflect order by discipline rather than alphabetical order. The *Da Costa* pays homage to this DIY citationality, maintaining the Panckoucke's material form while changing the content entirely. Further casting the *Encyclopédie méthodique* as a kind of bastard son to the prototypical encyclopedic enterprise, Panckoucke himself had trouble securing permission from Diderot for the project. Mirroring the logic behind the Deberny clichés, Kleiber offers the whole *Da Costa* as another kind of Duchampian "ready-made" where Panckoucke provides the template.[92] The *Da Costa*'s last fascicle also manifests this bastard genealogy nonsemantically through its images solely of shoes and feet, a potential nod to the false etymology of encyclopedia from *pied* or "foot."[93] The "Critical Dictionary" entry titled "Big Toe" also leaps to mind, in which "man's secret horror of his foot" as site of dirt and abnormalities is complicated by a "sexual uneasiness" associated with "the most excessive point of deviance."[94] Like the Acéphale, "Big Toe" inverts the hierarchy that places foot at the bottom and head at the top, further situating the antihierarchical move in the context of illegitimate genealogy.

As the emphasis shifts from head to foot, inverted genealogy also shifts the focus from adults to children. An avant-garde fascination with children is apparent from Breton's *First Manifesto* to Duchamp, whose work emphasizes play as a concept.[95] In the *Da Costa*, "Enfantin" sets out the familial

relationship as a problem: "The child, the father: we are beginning to see that there is no duality more important to resolve."[96] In the *Da Costa*, maintaining a direct, linear, and orderly transfer of knowledge and power from parents to children is analogous to maintaining authority and thus oppression (a dynamic that also replicates itself at a sociopolitical level). The entries "Edifying" and "Education" critique this transfer of power, with "Education" commenting on the immediately prior "Edifying." "Edifying" indulges in a sentimental and moral lesson, describing the last words of a dying man ("I love you ... Kindness ... Justice") (ellipses in the original).[97] "Education" immediately overturns this tone, proposing instead of bourgeois morality an intention "to combat and to divide authority wherever it sets itself up."[98] The entry undermines the idea of "Education" in general as that which enacts "degradation" on the originally combative parent-child relationship. While both "parent and child [are] subject to 'edifying' discourses on their long and intimate experience of the same filthy mire," the child's resistance is a source of admiration and strength. It cannot, however, be maintained: "the son ... thanks the father who previously severely corrected him: 'It was,' he modestly admits, 'the means by which you made a man of me.'"[99] Becoming a "man" is degrading to the sense of freedom the *Da Costa* associates with children. In *Inner Experience*, Bataille writes: "Grown-ups *obviously* reduce the being that comes into the world ... to trinkets" (emphasis in original).[100] "Childhood" is not only metonymic with "freedom," but speaks to the need for an irreducible view of the world.

Bastard genealogy links the *Da Costa*'s discussion of children to its consideration of visual art, too. Given its resolute embrace of waste and dirt, it is no surprise that the *Da Costa* is not interested in beauty: if "The Beautiful [is] the father of the family," as the second fascicle's "Bonjour Monsieur Giocometti" scornfully notes, the *Da Costa* aligns its interests with the bastard children who are not subordinate to this father.[101] Against beauty, the entry "Comic" sets the graphic comics that are the domain of American children. Moreover, "Comic" argues, the world of adults is the primary source of comedy for children, who see them in their proper habitude as "clowns."[102]

The *Da Costa*'s investment in the comedic, expressed through image and tone as well as directly in entries like "Comic," recalls another semisemantic word that operates alongside nonknowledge or inintelligence: "l'huamour." Breton, an inspiration and antagonist throughout the *Da Costa*, again may

be shadowing the entry with his concept of "black humor" (*humour noir*), the first use of the now-standard term, which was the focus of his banned 1940 anthology, rereleased at the same time as the first *Da Costa* fascicle. Twisting humor to combine with *amour* rather than *noir*, l'huamour is developed at length in the last fascicle. Against love's associations with "elevated sentiments," l'huamour proposes both comedy and (perhaps surprisingly) poetry.[103] Erotic love is set against "courtly" love in a move that cites Sade, who is credited with restoring the relationship between sex and violence through a language that, like bastard genealogy or slipping words, can be expressed only through slang or *argot*. (Such a moment foreshadows for us *Glas*'s obsession with *argot* and its sexualization through the figure of Jean Genet.) Existing in a semisemantic space, *argot* has the potential to enact a coded sexual "paroxysm" that conventional language cannot allow. Confronted with a slang-filled list of Sade's sexual exploits and demands, "if the reader isn't already acquainted with all that is being proposed ... at least courtly love is being killed with a vast burst of laughter."[104] L'huamour is a source of power, a moment in which a "burst of laughter" kills the pretenses of courtly love, of traditional order based only on myth.

This "burst of laughter" also links back to *Da Costa*'s preoccupation with immediacy. L'huamour must be undertaken in urgency: "all is won or lost each instant it is risked."[105] Urgency critiques love's supposed or expected longevity: along with the sacred, the entry argues, duration must be detached from love. Indeed, l'huamour posits, it is precisely this sense of arising from the moment that empowers love, its uncontrollable spasm of laughter "only glimpsed in moments of extreme consciousness that follow erotic excess."[106] Through l'huamour we reach the desired "extreme consciousness," which suggests nonknowledge's yearning toward what is, as its limit case, inexpressible. The immediacy l'huamour implicates also brings us full circle, back to the magazine's production: the endeavor as a whole, in this light, is a material attempt at a "burst of laughter," its "erotic excess," swooping flight, absurd images, and wordplay all a gamble to startle the reader into a moment of clarity or ecstasy.

In *Inner Experience*, Bataille writes, using all caps to communicate urgency, a sentence-long paragraph: "NONKNOWLEDGE COMMUNICATES ECSTASY."[107] L'huamour is an ecstatic concept, lasting the duration of an orgasm or a laugh. The last line of "L'huamour" urges the reader to "Renounce, if you will, coming to best understand," with the pun on

"coming."[108] L'huamour resists desire's subordination to the pursuit of knowledge as superior: we do not come to understand, but to resist understanding, to experience the moment for itself as it brings us out of ourselves. "Erotic excess" is excessive to knowledge or information, excessive even to language. In another all-caps sentence, Bataille insists: "NONKNOWLEDGE LAYS BARE"; l'huamour, likewise, expresses "the will to lay bare" that drives inner experience.[109] The sense of immediacy or urgency, the burst of laughter, the orgiastic spasm, combine in service of this laying bare, a brief moment in which language falls away.

L'huamour also recalls the anonymat and its thematics of identity and understanding. It "feeds on details," but these details relate to specificity rather than uniqueness—much like the *Da Costa*'s entries that focus almost myopically on the local and personal.[110] As with the image of reproduced "Fingerprints" that undermine the idea of the unique self, l'huamour insists on interchangeability as a virtue, attempting to demolish authorship and authority in the process. The concept reflects the *Da Costa* contributors' conviction that "humor, systematically exploited, could provide the cohesion for renewed group action," as Brotchie notes.[111] Evidenced through humor but also by the heterogeneity suggested by the anonymat, "renewed group action" drives the project. What is heterogeneous still must cohere, and the anonymat assumes importance as the symbol for a community which borrows one of its central concepts from Nietzsche: "To understand one another, it is not enough that one use the same words; one also has to use the same words for the same species of inner experiences; in the end one has to have one's experiences in *common*" (emphasis in original).[112] In place of authority, inner experience assumes importance, providing the possibility of communicating to a community of the like-minded. "There can be no knowledge without a community of researchers, nor any inner experience without a community of those who live it," Bataille insists.[113] What may appear at first to be a drive toward solitude or isolation in pursuit of nonknowledge is, according to this reasoning, actually the opposite. Inner experience and community are direct correlates of one another, and communication becomes the critical link between them. Similar to his claims in *Literature and Evil*, Bataille states: "communication is a fact that is in no way added to human existence, but constitutes it."[114]

Community here indicates a replacement for more traditional sources of authority: most immediately, authorship, as well as the *Da Costa*'s social,

political, and artistic targets. Bataille refers to "the community of those who have no community."[115] This community, bound together by their contempt for conventional binds such as nationalism, bourgeois ethics, and hierarchical power structures is "atheological"—antireligious, but also antiauthoritative. If God is the final word, then atheology also resists the project of language, driven by desire for knowledge and even mastery. Instead, it is a study of what Stuart Kendall terms the "effects" of nonknowledge: "Delirium; ecstasy; poetic, sexual, sacred effusions; the absence of consciousness; the debauchery of thought; the death of thought," which manifest as the many heterogeneous and material threads of the *Da Costa*.[116] These threads suggest possibilities for the nonsemantic beyond the scope of the *Da Costa*: the nonsemantic, they suggest, holds the possibility of a fundamentally different kind of communication that attempts to sidestep the problems (of authority, of *telos*, of social and political aims) embedded within language.

Of course, no one can be assured of having the same experiences in common, and communication is always tenuous. Like the "failure" set out as a chess problem at the beginning of the *Da Costa*, communication must fail at some level, signal succumbing to noise. As the butterfly leaves a trace of its flight in ink, writing is the trace of this attempt. Of Bataille's writing in general, Kendall notes: "In place of a coherent theoretical position, this writing marks the outline of a failed recognition; it presents the movement of a thought as that thought is lost to itself."[117] Failure is not meaninglessness, but an acknowledgment of the limits of thought, language, and coherency. Acknowledging the presence of static in any communication undermines the efficacy of any "coherent theoretical position" in the *Da Costa*. More broadly, this tempered view indicates that any theoretical position that relies on semantics to communicate can only go so far before it fails. Aspirations of coherency are destined to suffer the same fate as the unfinished encyclopedia of Diderot. And what appears as a "seamless expanse" is shot through with noise.

In place of authority, the *Da Costa* suggests community; in place of coherency, it insists on heterogeneity, drawing semantic and nonsemantic threads together. Its texture comprises, among other threads, the thematics of the anonymat; immediacy and urgency; appropriation and bastardization; and l'huamour. These threads interface with one another as well, creating a "spiderweb" of the formless. Through the nonsemantic, the *Da Costa* suggests that any text utilizing nonsemantics to convey aspects of

its argument tacitly acknowledges the limits of language, the places where communication necessarily fails. Likewise, the *Da Costa* points to the vanity within a desire for completion or unity (or homogeneity): the totality exemplified by the encyclopedic form is, in Nietzsche's words, an "illusion." Embracing heterogeneity implies embracing the impossibility of totality. As Brotchie writes, "the heterogeneous eschews completion," even through its material form.[118] The translation of the *Da Costa*'s title as, alternatively, *The Da Costa Encyclopedia* or *The Complete Da Costa* resounds as especially ironic in light of the work's disdain for the idea of a complete system.

In the *Da Costa*, the relationship between semantics and nonsemantics suggests how an argument of deliberate formlessness might communicate an awareness of its own attempts at communication. This deliberate formlessness also suggests a kind of proto-network for the digital age: a shape like Bataille's "spit," where top-down design is impossible. The formless as network links disparate elements together while differentiating them, creating the heterogeneous texture across which communication happens. The *Da Costa*'s desire for instantaneity, too, reads as surprisingly contemporary, a foreshadower of our obsession with synchronous communication, as well as with being of-the-moment, up-to-date, in regard to technology. Instantaneous access to information and to others through digital networks enables rapid communication between many different kinds of communities. Formlessness characterizes the shape that accommodates all kinds of messages.

Formlessness provides the beginning shape for the works discussed in the next chapters. In both material and thought, artistic arguments rely on the premise that "propositions can be shattered, denied, reordered; and ... those propositions that would follow could be shattered, denied, and reordered in their turn."[119] They are works that lean heavily on the impossibility of totality, emphasizing themselves as unfinished, ongoing, and open to revision as addition, to new branches of the network that have been grafted from elsewhere. The terminology connected with artistic arguments shifts and metamorphizes in accordance with its specific material form and theoretical concerns. Their networked structures, though, will always be susceptible to blips like the ecstatic moments when "nonknowledge lays bare." Along with semantics, nonsemantics manifest as bursts of noise in the system that draw our attention to their potential.

2 Networks and Remains on the Page in Jacques Derrida's *Glas*

Published in 1974 by Editions Galilée, Jacques Derrida's *Glas* has a design that stands apart from the philosopher's other work. Divided into columns like a holy text, it remained untranslated until 1986, when the University of Nebraska Press published an English translation by John P. Leavey, Jr., and Richard Rand. This English translation was accompanied by Leavey's *Glassary*, which elaborated Derrida's allusions through annotations and analysis, and echoed both its square form and its deliberately shaped body text. The two books were some of the first projects for the Press designed by Richard Eckersley, who would go on to become one of the foremost book designers in the United States (responsible for, among other work, the subject of the next chapter, Ronell's *The Telephone Book*).[1] Media studies has noted *Glas*'s potential as a kind of double-columned anticipation of hypertext reading, but criticism in general tends to move quickly over its material form per se. This material form, however, has significance at more than one level. The book creates citational and thematic networks, which span versions of *Glas* beyond the Galilée and UNL print editions to include periodicals and even visual art. Like all artistic arguments, the networked *Glas* emphasizes static and noise through combining semantic and nonsemantic content. In doing so, it not only models proto-hypertext reading practices, but, more critically, cautions against overly ambitious aims in the digital realm.

Glas's argumentative density is emblematic of Derrida's writing at the time, and is further complicated by its unconventional structure. Its two columns, subject to intrusions and interruptions, run down each page. Upon publication, its design warranted some notice, but of the kind that immediately sought discourse on Derrida's own terms. "Is *Glas* a book? a text? What is its form? Can it be read?" Leavey asks in *Glassary*.[2] In fact, this question—"How to read *Glas*?"—recurs in criticism around the work

following its English publication. Philosopher Gayatri Chakravorty Spivak, attempting to provide answers as well as questions in her "*Glas*-Piece," states the many ways in which "I can read *Glas*," not only as typography but also as autobiography and mythology, among others.[3] But even Spivak's is a reading that metamorphizes the material fact of the book, rather than a sustained engagement with the shape of the work as enacting something over and above its stated argument. In all the ways you read *Glas*, you must also read its material situation: nonsemantics such as its typographical shape, including the interruptions or "judases," and—like the *Da Costa's* slipping words—its fascination with *argot*, slang.

Glas's columns are not identical but unequal in size, and this inequality is critical, suggesting an architecture permanently in construction. To adequately read the text, then, requires reading this architecture. "I can read *Glas*," Spivak iterates, "not merely as a story or an argument but as a significant typographical design."[4] *Glas*'s "significant typographical design" works nonsemantically, allowing noise to infiltrate between its columns and within its textblocks. Peter Krapp writes that *Glas* "makes the boundaries between philosophy and literature tremble."[5] Its destabilization of conventional layout enacts a destabilization of genre as well.

Destabilization transfers from the layout to the reader, who must engage in a double reading, losing and picking up threads from each section, oscillating between the columns and reading content and form simultaneously. Elsewhere, in "Between Brackets I," Derrida stresses the significance of the two columns' relationship: "This incalculable remainder would be the 'subject' of *Glas* if there were one.... The ungraspable—remain(s) ... is the relation without relation of the two columns or colossi or bands."[6] To read the "subject" (with the provisionality Derrida's quotation marks attribute to it) entails considering *how* we read *as* we read, attending to the implications of the material form. The "relation without relation" is also a spatial relation, in which the white space expresses the "remains" that mutely resist integration or interpretation.

The "relation without relation" describes the relationship between the columns in terms of tension, indeterminacy, and oscillation. We read in fits and starts, constantly in motion. We are subject in *Glas* to what Derrida describes as "the undecided suspense of what remains on the march or on the margin within the true, but nevertheless not being false in no longer being reduced to the true."[7] The marginal space around the two colossi of

text allows and makes possible this indeterminacy. In Hegel, who is a key figure for the text, thesis and antithesis resolve into synthesis. As counterpoint, *Glas* resists such resolution through its indeterminate form, as well as its explicitly stated content.

But what about the white space between the columns? While we read the typographical design that enables meaning in *Glas*, we must also attempt to read the white space of the page. As the background to writing, white space is always palimpsestic, recognized only when overwritten by the black text that obscures it. It exists for the reader only to be inscribed, its blankness negated in some way. Properly speaking, white space cannot be read in itself, yet it is required to enable reading. What lies beneath the columns also forms an abyss between them, which allows the oscillating movement of our reading. Through these "ungraspable remains," *Glas* poses a question of identity that takes the shape of the signature. To bookmakers, a "signature" is a section of papers folded into pages. This material definition is compounded by the Derridean signature, asking the reader to consider *Glas* as a series of signatures—both formal and thematic—which fold and overlap one another to compose a book. Intertextuality works semantically, while the material signature works nonsemantically: as in Mallarmé's *Un coup de dés*, "the 'blanks' ... assume importance."[8]

In the larger context of media studies, these blanks are also important. O'Gorman, in *E-Crit*, notes the tendency in digital humanities toward Derrida's "archive fever," a "desire for the archive" as a stabilizing origin or repository of repose.[9] Such a desire often leads to what O'Gorman views as antiquated methodologies: "Remediating the canon requires a concerted focus on the materiality of writing, and not on the writers themselves."[10] But an archive is always riddled with gaps, as Derrida argues. Against the idea of a complete and instantaneously accessible archive, O'Gorman brings into the discussion Lecercle's "remainder"—a term that resonates in *Glas*'s "remains."

Remains stand as a caveat to the promise of endless connection for new media, as they remind us of *Glas*'s resistance to stable genre or stable reading practices. In a philosophical context, Geoffrey Hartman emphasizes the "remains" against systematics that seek to purge "remainders (mere sounds, waste-products, excrement, death)."[11] From a material standpoint, *Glas*'s remains are the white space that, like noise, draw our attention to the unusual text shapes that negate it and require it, all at the same time.

A Spiderweb of Signs

In a radio interview quoted by Benoît Peeters in his biography of the philosopher, Derrida describes the early composition of *Glas*:

> The two main bands lived together in my memory as I was writing them, and it was then, belatedly, that I calculated where to insert the Judas holes, on the bodies of the two columns. But, concretely, it was done in a very artisanal fashion, which must have required several rewritings, goings over, cutting and pasting on the manuscript, on the page, of an ultimately artisanal kind. But the artisanal was to some extent mimicking the ideal machine that I would like to have built so as to write the thing all in one go.[12]

Elsewhere, Derrida clarifies that he had "placed text-shards on cardboard with the help of scissors, by hand."[13] In this account he rejects the promise of the "ideal machine," instead claiming that "if it had been possible at that time to calculate the effects of *Glas* by computer and write a bicolumnar text, he would not have done it."[14] Regardless, Derrida composed *Glas* on a typewriter, eventually abandoning his original plan of publishing it with Fata Morgana and turning to Galilée instead. At Galilée, he worked with Michel Delorme and Dominique de Fleurian to compose what Peeters calls "an extraordinary technical feat."[15] Challenging genre conventions at every turn, the book offered no blurb, no footnotes, and no bibliography, despite its many citations.

Glas's origin story is tangled, and multiple versions of the text further complicate its narrative. While an early version of *Glas* appeared in a special issue of *L'Arc* devoted to Derrida in 1973, and Denoël/Gonthier (Paris) published a two-volume *Glas* in 1981, the UNL version (to which I will refer) mimics the Galilée almost exactly, and offers a fully developed statement of its ideas, some of which originated in a Hegel seminar.[16] Of these print versions, neither the Denoël/Gonthier nor the *L'Arc* article is in two columns. As noted above, Leavey's *Glassary* also extends the *Glas* network. The same size and square format as *Glas*, *Glassary*'s columnar structure denotes different textual threads: essays by Leavey and Gregory Ulmer are in three columns, while textual annotations are in two. As in *Glas* itself, these genres still remain somewhat unstable.[17] Leavey's essay, for example, integrates quotations and other texts, and takes the ostensible shape of a journal. Meanwhile, large blank spaces dominate the upper left and lower right of the spread. Sometimes more space reaches across the spread from the verso,

other times from the recto, but this vertical shape defined by negative space is always in play. For French- and English-language readers who read top left to lower right on the page, these typographical caesura reiterate the start-and-stop motion of reading, delaying the beginning and postponing the ending. They echo the semantics of *Glas*, where the text's end returns to its beginning à la *Finnegans Wake*, and also darkly hint at a columnar, coffin-like shape on its side, anticipating the tomb motif in *Glas*.

Like the network of production, the project is also structured by myriad countersignatures. *Glassary* exists under Leavey and Ulmer's signatures, and Leavey, as translator, also leaves his mark on *Glas*. Translation is a kind of citation, as Leavey's interview title suggests: both citation and translation face the impossible task of standing in for their original context. "The placement of the translation is always, if you want, in movement or oscillation" between these two, he explains.[18] This word comes up again in *Glassary*. Leavey writes, "The 'I''s of *Glas* are never easily settled; they are multiple and mime the very text they are reading. I will oscillate between them, at times writing Derrida, at times I."[19] The oscillating movement between *Glas*'s columns mimics the movement of the translated book, too, breaking down the distinction between author and other, internal and external.

In a material register, *Glas* spells out its investment in countersignature on its very cover. Set in Glaser Stencil, a Futura-based typeface created by Milton Glaser, the first four letters of Glaser's name are cleverly situated as the title. In Eckersley's design, Glaser's "glas" stencils over Derrida's book, a graffitied tag. The title, which should designate the unique work of a single person, has been co-opted, reminding the reader of the productive network that spans writer and translator, book designer, and even typeface designer.

Countersignatures, which challenge and augment Derrida's authorship, continue to proliferate upon opening the book. Inside *Glas*, the two columns—the right devoted to Genet, the left to Hegel—have an appearance of stability that is quickly undermined by flaunting typographical convention.[20] *Glas*'s right column is set in a larger typeface than the left, which poses a problem for reading that travels left to right and larger to smaller. Or, as the first page states: "Two unequal columns, they say distyle [*disent-ils*], each of which—envelop(e)(s) or sheath(es), incalculably reverses, turns inside out, replaces, remarks, overlaps [*recoupe*] the other."[21] The pun on "distyle," a porch with two columns, introduces the need to read this text as architecture, even if it is, in a sense, unable to be entered.

(We will remain on the porch.) These "unequal" columns are always on the way to doing or undoing one another, subject to a clamor of voices ("they say ..." [*ils disent*]).

In this din, other voices also intrude, inset texts whose sans-serif Gill Sans contrasts with the Garamond serif book face. As mentioned earlier, Derrida calls the inset texts "judases," a name in which Leavey finds, among other meanings, a "betraying" of the texts.[22] These judases complicate the page, creating visual noise. To borrow terminology from Johanna Drucker, rather than being "embedded," like a typical quotation, they appear "enframed" or even "entangled."[23] Enframement suggests escape is possible for text instead of submission or submersion to a greater text, but in a "fully entangled field" such as *Glas*, discussion and commentary are intertwined to such an extent that they lose any essential definition. As their design signals, the judases cause fragmentation and confusion for the reader's eye. Faced with forces from the margin, Drucker describes how "text begins to fragment, pulled outward from the coherent center."[24] Or, in the case of *Glas*, the fragments begin to create the text.

As judases bastardize the text, *Glas* asks: "Is there a place for the bastard in ontotheology or in the Hegelian family? that [sic] is a question to be left to one side, to be held on the margin."[25] Sometimes judases are "held on the margin" and other times are centered in a column, posing as an unsanctioned result of two columns that never marry and become one in the eyes of an institution. Their bastard language punctures or punctuates the system of the text with "a stitched pocket, a cyst, or a blister in yet big with the column-text."[26] They are also column-specific. Judases in the Hegel column appear between complete lines, while in the Genet column they break in during sentences, lines, even words.[27] This detail maintains or rehearses some of the subjects' individual contexts (Hegel as unified, Genet as erratic), but adds additional difficulty for the reader, who has to carry multiple threads at once. The judases interrupt the columns, thwarting our desire to stabilize the "family" of Hegel and Genet into a good Hegelian family.

Bringing those other voices into the text through direct quotation, judases create a network of citations. Hegel's *Phenomenology of Spirit* and other works, including a long section of letters to and about his sister (more family ties), constantly intrude, citations often given in the original German that introduce polyglossia into *Glas*'s multiplicity. Genet's body of

work is directly quoted as well: *Miracle of the Rose, Our Lady of the Flowers, The Thief's Journal, Funeral Rites, The Maids* ... But there are also sections that quote, delve into, or reference Freud, Saussure, Sartre and *Saint Genet*, Nietzsche, and Poe.[28] Mallarmé appears in the shadows, as Derrida discusses Mallarmé's "Aumône" and "Cloches" in conjunction with Poe's "The Bells."[29] Hélène Cixous, too, contributes an aural significance through the "laughter" of the woman as Derrida pokes at Hegel's phallocentrism.[30] And Derrida's most constant companion is another two-columned document, the Littré dictionary, a reference of references.

Bataille, named only once in conjunction with his poem "The glas," also hovers around the text, hiding behind Genet as Derrida constantly returns to excrement and desire.[31] Derrida's "This *glas* can be read as the interminable analysis of vomit" recalls Bataille's formlessness, the "universe ... something like a spider, or spit."[32] Elsewhere, Derrida, in an Acéphalic vein, calls for "a writing of decapitation."[33] The connection between Bataille and Genet is itself fraught, too—Derrida quotes *Literature and Evil*, in which Bataille accuses Genet of "failing."[34] Set apart on the page, the all-caps text "GENET'S FAILURE [*ECHEC*]" recalls the *Da Costa*'s Duchampian game of chess, itself based, like a book, on the interplay of black and white.[35]

These citations are stitched together to form a nonunified textual network in which *argot*, slang, is crucial. Another bastard, "argot" denotes unsanctioned sideways communication that operates (much like the *Da Costa*'s slipping words) in a semisemantic space. The Littré doesn't even contain the word. "Argot" finds one origin in Genet, who describes it as a specialized vocabulary belonging to sailors and inmates—those on the margins of societal institutions and official language. From *argot* Derrida travels to *Argonauts*, the "golden fleece" woven together: "the text is the golden fleece.... The galley would go by the name here of Argo."[36] *Glas* defines its gold as "galleys," or drafts, rather than finished and complete works: they are on the move, like ships.

Like the "golden fleece" of the text, the chorus of voices is cast in material terms. Fleece becomes fabric, which also comprises clothes made of "lace and silk" spun from a spider.[37] The spider's work is sewing or weaving through excretion or secretion—*glas*'s sticky glue falls somewhere between a mother's milk or a father's semen.[38] From this excretion, the "plurality of continuous jerks" that is the movement of reading side to side, text and textile are created.[39] But the textile is always tenuous, hanging by a

thread. The book is embroidery, citation, graft, argot; a web and network, it's always incomplete. Its seam, running down and branching out over the page, "overlaps itself here more than once."[40]

The movement of "continuous jerks" leads from weaving to grafting to "banding erect," which first appears on page three and accumulates significations, lewd and otherwise, throughout the text. For Genet vis-à-vis Derrida, banding erect moves between stamen and semen, flower and erection. For Derrida himself, these meanings all bear on the material signature taking place. "Banding" and "binding" are never far from one another in the form of the *ligature* or "inner binding."[41] Derrida sees this as a book that, like the galleys, must be "rebound," requiring "basting between the two columns."[42] ("Banding erect" also has other material connotations, such as in *Signéponge*, where Derrida links bands to the band around a French novel.)[43] Here the Littré also provides a definition specifically related to printing, where bands are "pieces of iron attached to the two tongues in the middle of the press's cradle, on which the train rolls."[44] If these two columns are two tongues, the train (presumably the cylinder) rolls through the nothing that separates them, the white space that "bands erect" as nothingness ("the mere nothing bands erect," Derrida insists) at the moment it's printed over.[45]

Fleece, *tissue*, fabric that creates clothing or a collar: as if unravelling Bataille's despised "frock coat," which attempts to cover over the shape of things, these textiles describe the networked text, its formless shape irreducible to a single proposition or argument.[46] The "content ... of this representative abyss" of significations is a kind of "CHIMERA," a term Derrida applies to Genet's text but which at the same time points to his own.[47] What appears to be descriptive or representative describes or represents only itself. For Derrida, all text is citational. Citation and text, judas and colossus, are only differentiated in *Glas* nonsemantically, by their formal qualities—their placement on the page.

Columns and Between Columns

Upon receiving their copy of *Glas*, the University of Florida sent a note to their French bookseller stating that their copy was "defective," missing a table of contents and beginning pages. "We often have this kind of request from our customers concerning this title," the bookseller wrote

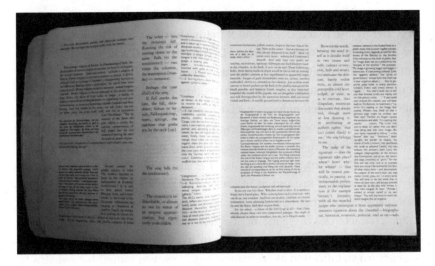

Figure 2.1
Opening spread of *Glas*. Reproduced from *Glas* by Jacques Derrida, translated by John P. Leavey, Jr., and Richard Rand, by permission of the University of Nebraska Press.

back, explaining that "This is the manner of Derrida." As well as scorning front matter, *Glas* begins *in medias res* with two fragments: "what, after all, of the remain(s), today, for us, here, now, of a Hegel?" paired with *"what remained of a Rembrandt torn into small, very regular squares and rammed down the shithole."*[48]

These questions of remains direct the text nonsemantically, but they are also present semantically. In a move that echoes both Lecercle's remainder and Mallarmé's throw of the die, Derrida writes, "the incalculable of *what remained* calculates itself, elaborates all the *coups* [strokes, blows, etc.], twists or scaffolds them in silence."[49] The incalculable is that which cannot be calculated, reconciled (as a sum), or brought together in unity. After the "all" that Hegel's name means, this first question asks, what is left over? In Hegel's dialectic, thesis and antithesis only realize themselves in and through synthesis. Hegel's systematics are based on unity, a unifying principle that coheres and brings concepts into hierarchy. *Glas* charts a bastard course, discussing the sign without accepting or rejecting the signification, opting instead to keep it continually in question.

"Glas" becomes another nickname for this question of *"what remained,"* the word reverberating with meanings. Glas, the death-bell tolling or its

insubstantial echo, marks the approach of glory through death, according to Genet. It also marks one point of many shifting significations, similar to the Argonaut-*argot* chain, that lead Derrida to pursue, say, Genet's name to a mountain flower (*gênet*) to gladiolus, glans, glas.[50] These shifting significations are "the march of an unknown: its *glas*, which is in action here."[51] Significations link together loosely. Like the space between stitches, the chain exacerbates the space that separates signifier from signified(s): "what emits a tolling of the knell, *un coup de glas*, is the fact that the flower, for example, inasmuch as it signs, no longer signifies anything."[52] Signifieds continually escape, always just out of reach. So the glas becomes rigorously indeterminable, signifying in multiples that never arrive at their destination. Krapp characterizes these moments: "The infinitely open chain of returns, stone-tomb-erection-death and so on in its disseminative effect threatens to overturn signification at every moment; however, something remains."[53] Determined by this movement more than any specific content, the text becomes a *"glas* machine," producing noise.[54]

While the links of significations exert pressure on the Hegelian dialectic, the columnar form owes much to Genet. On the right side, *Glas* quotes: "'*what remained of a Rembrandt torn into small, very regular squares and rammed down the shithole*' is divided in two." Genet's original title is actually "Ce qui est resté d'un Rembrandt déchiré en petits carrés bien réguliers, et foutu aux chiottes," or as commonly translated, "What Remains of a Rembrandt Torn into Four Equal Pieces and Flushed Down the Toilet." In Derrida's text, "remains" becomes "remained," positing tension between the citation and its citation. The form itself, too, cites Genet. As published in *Tel Quel* (spring 1967), Genet's "Ce qui est resté" was printed in two columns.[55] In *Glas*, Genet's form incorporates—and typographically displaces—Hegel's language and system, subsuming it to its own two-columned logic.

Glas's fascination with the bicolumnar form emphasizes that writing is always graphical. In "Ce qui est resté," Derrida writes, the columns form an "X, an almost perfect chiasm(us), more than perfect, of two texts, each one set facing the other: a gallery and a graphy that guard one another."[56] "Gallery" reminds us of a picture, in keeping with the Rembrandt, but it also ghosts "galley" again. In philology, "graphy" (*graphie*) is a graphic symbol representing a phoneme—again pointing to the distance between signifier and signified, as well as the signifier's shape on the page. Drawing, writing, and grafting, of course, all come from the Greek *graphe*, γραφη, another

etymology that fragments into association. The relation between the two X-texts is characterized as "almost" or "more than" but is never exactly perfect; there will always be excess, whether as semantic remainder—the writing that χ (the chi in "chiasmus") stands in for—or as nonsemantic "chasm" that separates the two columns. In the chasm we enact the glas's oscillating movement, reading "the undecided suspense between two opposite though continuous significations."[57] We read one and the other column in fits and starts, unable to read the whole page at once.

Glas's ongoing investigation of the signature begins with Hegel and Genet but is also present in the nonsemantics of page design. Continuing a thematic Derrida begins in "Plato's Pharmacy," the signature is a paradox that functions like noise, accomplishing its status at the same time it becomes null. It is both inside the text, "which it is presumed to sign," and outside of it.[58] As soon as it signs the text, the signature "emancipates as well the product that dispenses with the signature, with the name of the father or of the mother the product no longer needs to function."[59] The signature is part of the text but also enables it. It "emancipates" the text: standing *for* it, it stands apart *from* it. Filiation is "lost" or broken through its very establishment. The page mirrors this hinging movement: it becomes recognizable as a page—and readable—at the moment it's over-inscribed, made invisible. Whether the Lacanian "name of the father" or Genet's gender-switching "mother" named Harcamone, in *The Miracle of the Rose*, it is the name that bears significance.[60] Genet provides a perfect example of the signature, a case study who appears inside his works as character and outside them as author. In *Glas*, his written signature materializes on the page, another cosigner of the text.[61] The bookmaker's signature of pages was known in its early days as a "quire"; here, the signature resounds with a "choir" of voices.

Derrida's own signature is also at stake in a graphical way. In "*Glas*-Piece," Spivak argues that *Glas* is a coded autobiographical text, reading Derrida's signature in the fold that separates the spread as well as between the "two hollow phalloi" that disseminate meanings into the "fold of the hymen."[62] The father and mother return here, but Spivak casts Derrida as a bastard son, who can only produce an encrypted signature. In the fold, proper grammar becomes *argot*, sidestepping outright articulation and so avoiding assimilation back into regular signification. Noise obscures its signal. Derrida's name also appears in another *argot* moment, as the JD of an inverted *déjà*,

"already," which appears in conjunction with *Glas*'s discussion on writing as "already dead."[63] *Déjà*, appropriately enough, repeats: "This strange *already* (déjà) has to be deciphered," teases the text.[64] Throughout, in fact, *Glas* urges a model of reading as deciphering: "Those still in a hurry to recognize are patient for a moment: provided that it be anagrams, anamorphoses, somewhat more complicated, deferred and diverted semantic insinuations capitalized in the depths of a crypt."[65] Recognition is "deferred and diverted," while the logic of *argot* determines encryption. Is the column, long and thin as a Giacometti sculpture, a crypt?[66] The idea of a signature that ceases to exist as it comes into existence might suggest as much, especially given the "body" texts that form the columns.

The text's body is always connected to remains, though, including its more grotesque and sexual significances. Like all shifting signifiers, these sexual significances never completely come together. Instead, they are nonproductive models, like Bataille's waste. As well as resembling tombs, the columns band erect on the page, recalling ancient Greek *herms*, pillars adorned with phalloi. Derrida mulls over Hegel's *Aesthetics*, which describes a "phallic column of India."[67] Across the page from the Hegel-phallus, suggestively described as "larger at the base than at the top," a scene from Genet's *The Balcony* (another architectural protuberance) mentions a "gigantic phallus."[68] Another judas (anticipating, for us, texts of skin) sees "in the stone of each column ... tattoos in the folded flesh of a phallic body that is never legible except in banding erect."[69] "Stone" reads as a judas in the column's "body," a *herm* that speaks to hermeneutics: how to make something legible when "banding erect" and "falling to the tomb" happen at the same moment? "He [Genet] bands erect in his *seing*, but also occupies it like a sarcophagus," Derrida writes.[70] The *seing*, an archaic word for "signature," points semantically toward *sema* (sign), *sang* (blood), and semen. (It also shares an etymology with "tocsin.") *Petit mort* and *gros mort* both leave their remains. Between crypt and hermetic column, the emission of whiteness from the phallus runs down the page, asking to be deciphered.

This whiteness—the white space of the page—undergoes, like other nonsemantic elements in *Glas*, shifting significations. It is also the silence that surrounds the glas, a silence which functions as white noise. "The incalculable of *what remained* calculates itself, elaborates all the *coups* [strokes, blows, etc.], twists or scaffolds them in silence," writes Derrida. The oscillating movement of reading between columns relies on white space, from

which the text emerges. The graphic form of the "chiasm(us)" relies on that enciphered "chasm" that defines the page through the inscription of negative space.

White space has a ghostly body, framed in *Glas* in terms of materiality, tissue or fiber, a gap of "mere nothing which bands erect." We read "nothing" in the Shakespearean sense, perhaps (in the oscillating text, female genitalia may band erect like a phallus), but also as no text, no character. In a block of body text set apart on the page, Derrida writes: "Let us space. The art of this text is the air it causes to circulate between its screens."[71] Air is essential to the text, allowing it to breathe, even if all air contains microbes (spores, seeds, the possibility of insemination or dissemination). While resounding as the digital screen for the contemporary reader, these "screens" are also figured in a traditional way as the space between threads in a weave: "All the examples stand out, are cut out [*se découpent*] in this way. Regard the holes if you can," reads another textblock set off from the text.[72] *Glas* asks us to read negative space, "holes," "air," with the same critical importance as we would semantic argument.

The significance of space is apparent even in the front matter of *Glas*.[73] The first title, "Glas," on the book's first (unpaginated) page, moves at an angle downward. By subtly manipulating the thin paper stock, we can see a second "Glas" behind it, the "Glas" on the next page. This "Glas" begins at the same place on the page but moves at the reverse angle, traveling upward.

Together, these two titles enact an oscillation, a near-meeting, that foreshadows the chains of significations in the body text. The actual point of their intersection isn't on either page, but instead is located in the moment when the reader turns the page, introducing the critical sense of sequence that the columns perform in the rest of the book. To make this point, and nonpoint, requires the particular opacity of the book's paper, enabling us to see white space and at once to see through it. As these first two pages purposefully remind us, space is a force.

Reading space and text, we read the page as a screen, neither fully white nor fully black but a mesh between. It is also a "veil," a term accompanying "spit," milk, and semen in Derrida's discussion of Genet's *Our Lady of the Flowers*.[74] Partially opaque and fluid, these *gl-* gluey substances catch particles from the air, susceptible to infiltration or parasitism. As a veil, they partly obscure objects (and sometimes make them obscene). The text as veil remains "suspended," resisting development into "the sole object of a

Figure 2.2
Two title pages of *Glas* pressed closely together. Reproduced from *Glas* by Jacques Derrida, translated by John P. Leavey, Jr., and Richard Rand, by permission of the University of Nebraska Press.

univocal description ... that veers immediately into the ... contrary of what it claims to be. The suspension of the veil or of the spit, the elaboration time of the excrement is then *also* the indecision between reference's two directions. Its narrow opening, its hiatus."[75] Multivocality formally reflects in the page's multicolumnar format, a veil suspended in air. As well as the two directions of the page, we must read the "narrow opening" of uninscribed space.

Enabling the oscillation of the text, white space signifies materially and conceptually, reveling in multiplicities. Edmond Jabès, responding to *Glas*, asks: "What is the book? ... An answer that I would divert from its original mystical sense and submit to your literal reflection: that the Book is 'what the black of fire carves into the white of fire.'"[76] Jabès's question leads us into another double reading, one that overlays material and "mystical" concerns: the "mystical" fire of the word and its "literal" black against the page's whiteness. *L'espace blanc* is a concern that, like the signature, enables the printed letterform while standing apart from it. Jabès writes: "Do we not need the blank space, the fraction of silence between words to read or hear them?—words have no tie to one another except this absence."[77] Signal's dependence on noise—"words have no tie to one another except this absence"—is general, and germane, to writing.

For Jabès the question of writing, the question of the book, are always conjoined with the question of Judaism. In this context, we can see a notable resemblance between *Glas* and the Talmudic page. "From the Talmud Derrida has borrowed the pagination, the confrontation of texts" in "homage," Jean-Bernard Moraly writes.[78] But *Glas* also investigates nothingness as integral to the Jewish tabernacle. Derrida describes the tabernacle, a "texture of 'bands'" (again, the echo of "banding erect"), that forms the heart of the Jewish identity, the "Jewish hearth."[79] The tabernacle holds a secret: under its veil is nothingness, "no center, no heart, an empty space, nothing."[80] This nothingness defines, constrains, and pervades the Jewish identity, according to Hegel, who seeks to incorporate it into the dialectic—to nullify the null. Yet, Derrida concludes, Jewish identity continues to pose a "risk" to Hegel's Christian system.[81] In the tabernacle's nothingness lies the possibility of resisting the dialectical impulse. Materially, then, *Glas*'s Talmudic layout references and sustains this resistance, with its "heart" of white space.

Absence's remains speak to a cleavage that pervades Jewish identity. The conversation again turns to doubling as Derrida notes of Jabès's own

thought: "The Jew is split, and split first of all between the two dimensions of the letter: allegory and literality," two dimensions that recall Jabès's "mystical and literal" interpretation(s).[82] The "double reading" that *Glas* demands, then, might also be characterized as Jewish reading—reading a text that, cleft, cleaves to itself across an abyss.[83] Double reading, oscillating reading, threatens the idea of a unified discourse, and for the Jew, according to Derrida, reading is always cleft. The letter is already broken: Jabès refers to "broken Tables," which in turn recall Blanchot's broken tablets in "The Absence of the Book."[84] Blanchot picks up the thread of original brokenness, to which he ascribes Talmudic legibility: "The writing on the first tablets does not become readable until after they are broken and because they are broken—after and because of the resumption of the oral decision," Blanchot declares.[85] Illegibility precedes legibility, and the tablets are written rather than transcribed from the spoken. The spoken has been lost, and the written is a commentary on absence. As Serres writes, "In the beginning was the noise."

With its emphasis on white space and incompleteness, *Glas*'s form can also be read as these broken tables or tablets, the latter a word that conveys another material significance—the history of language, of understanding, is also the history of the book. Derrida's note on the rabbi and the poet also applies to the tension between the columns: "Forever unable to reunite with each other, yet so close to each other, how could they ever regain the *realm*?"[86] The realm or the reading, unified or untroubled, is approached only through these material forms: broken shapes, tombs, judases. Writing "obeys the principle of discontinuity," which in turn requires absence, silence, space of whiteness: "the caesura makes meaning emerge. It does not do so alone, of course; but without interruption—between letters, words, sentences, books—no signification could be awakened."[87] In *Glas*, whiteness, palimpsestic, is a space of waiting, suspension. Unlike the cryptic columns, whiteness doesn't signify death but, rather, sleep—its waking likewise prompting the reader to a tenuous awareness.

A Networked *Glas*

Glas's branching significations authorize a similarly expansive universe of print, from its beginnings in *L'Arc* to the editions under consideration here. Our material reading of the text reads across versions and editions to locate points of rupture and connection. With their precision and use of white

space, Eckersley's *Glas* and *Glassary* most fully express Derrida's text in a material form. But the UNL printing is not far from the original publication by Galilée, which, although it lacks the *Glassary*, mirrors the UNL edition in fundamental ways. Galilée printed *Glas* first in 1974 and reprinted it in 1995 and 2004. Similar to the UNL edition it precedes, the Galilée edition is a slightly smaller square (9.5 by 9.5 inches). The front matter is set conventionally, with centered serif text, in contrast to the UNL's title treatment and spacing. The body text, too, is set in a Garamond serif, but the sansserif text appears lighter than the UNL's Gill Sans.

Galilée was not the only French house to publish *Glas*. A two-volume edition was published by Denoël/Gonthier (Paris) in 1981. This odd cousin takes the size and shape of a novel, around seven by four inches, as part of the Bibliothèque Médiations series. In its reduced state, the page has been modified, transformed into a spread. To read two columns, we must read across the gutter. White space functions only nominally, then, in this edition. Hegel's page is still set in a smaller typeface than Genet's, while the judases, not Gill Sans in this edition either, are lighter in weight. The hierarchy obtains in a subdued way.

The Denoël/Gonthier also bears a novel cover. The title is set in burgundy for volume I, gray for volume II. A subtitle, "Que reste-t-il du savoir absolu?," appears flush right on Volume I and flush left on Volume II. The cover image, too, is mirrored on both volumes. This image, a color photo of "Colosses de Memnon" at Thebes, is placed flush left and flush right in volume I and II, respectively.[88] Said to sing at dawn, resounding with a kind of glas, these colossi guarded the pharaoh Amenhotep's tomb. Placing the volumes as a spread, with volume I at right, the colossi regard themselves ("each one set facing the other …").[89] Two tiny figures are set close to the fore edge and toward the binding, completing the sense of mirroring. They are dwarfed by the colossi, a clear stand-in for the columns (also called "colossi") that are absent in this edition. Placed side by side, the volumes offer instead a spread cut in two, to be navigated by the reader. And indeed the book is cut in two, volume II picking up where volume I ends, at a mention of the "guillotine."[90]

As mentioned above, the earliest printed iteration of *Glas* appears in an issue of *L'Arc*, a French journal published from 1958 to 1986. Issue 54 (1973), devoted to Derrida, is subtitled "Le sauvage," after the title of Catherine Clément's introduction.[91] This "savageness" "respects neither time nor

the rules of reasonable interpretation"—a reference to Derrida's usual subject or unusual typographical form.[92] The introduction to "Glas" concludes with a note on said form. "GLAS forms the title of an opening that appears. On each page, two columns and two bands: opposed, in appearance one regarding the other," writes Clément.[93] The form that appears in *L'Arc*, however, is not the double colossi but a single column only. While the introduction mentions the Hegel column, only the Genet column is printed here. The judases, meanwhile—beginning with the "catachresis" aside, on page 2 of the UNL edition—are printed in two columns. Their interrupting force acts as a kind of stabilization for the single-columned body text, lending it an architectural quality. This early version further stresses the text's architectural nature by calling the judases "pierres," stones that have been detached from the column.[94]

Two black-and-white pictures, which will be cut from the complete editions, accompany the *L'Arc* text. After "What is a refrain?," a picture of the gênet, the mountain flower, appears on page 7. At this moment Derrida has just taken up Genet's play with his own name, the "act of nomination" that appears to sign but in fact "feigns" through signing endlessly. The appearance of the plant, then, is this act of nomination, which names both the process *of* naming and a "Genet" variation. Both the first and second pictures are placed on the recto, but the second picture, of a guillotine, takes up an entire page.[95] Appropriately, the guillotine cuts through a word, "la ri-gidité" (stiffness), during a quotation from Genet. Derrida has turned the discussion to banding erect/falling to the tomb (*tomber*), and this double movement is depicted by the gênet and guillotine, which supplement the text and one another: the upward motion of flowering threatened with cutting. Their effect is funereal.

Besides the columns and visuals, other minor differences are present in the *L'Arc* edition. In the periodical format, there's less particularity about white space and the nuances of punctuation and paragraphing. For example, the line "'(offerte aux greffes, la mythologie blanche).'" appears in UNL and Galilée as "(Offered with grafts, white mythology"—forgoing the quotation marks and period and leaving the parentheses unfinished.[96] The *L'Arc* continues with the Genet column alone, cutting off with a leader at what will eventually be page 14 in the UNL and picking the thread up again at UNL's page 118. The extended products of the Galilée or UNL thus are composed of a major section (those one-hundred-plus pages) grafted into the

middle of this original version. From here until the end, the *L'Arc* text reads as conventional paragraphs, lacking the judases that will appear in the later UNL and Galilée editions, such as asides on "parenthesis" and "prosthesis," as well as *sanglot*, sob, and Ganymede.[97] The offset word "galalaith," which "rings all alone" twice in the Galilée and UNL editions, does not appear in *L'Arc*, nor does an offset line of body text ("In this day and age, they would sell you anything").[98] The differences among these versions suggest that the patterns of thought are, at heart, branching. Like the broken tablets or tables, the judases, not the columns themselves, are the foundation and composition of the text. The "pierres" prove to be the stones that build *Glas*'s architecture.

The *Glas* network also includes decidedly noncanonical work, its interest in countersignature and the visual combining in two drawings based on the book. Originally titled *Studies for a Drawing after* Glas, Italian artist Valerio Adami's 1975 drawings incorporate handwritten text that bleeds off the canvas "page." In a quixotic move, Derrida considers and renames these works in an essay for an issue of *Derrière le miroir* organized around Adami's exhibition *Le Voyage du dessin*; Derrida would later republish the essay as "+R (Into the Bargain)" in *The Truth in Painting*. Renée Riese Hubert notes that "Adami replaces the double-columned page by a double-faced drawing."[99] Additionally, one of Adami's *Glas* drawings is two-sided, a serigraph. Turning Adami's interpretation into his own self-portrait, Derrida provides names for these two sketches, the chiastic "ICH" and "CHI."[100] These titles form anagrams (faintly echoing the mention of Saussure's anagrams) in which one title points at itself by way of the other. The χ (chi) is also the X of signature, the "I" of ICH.[101] The signature obtains in the crosshairs of the page.

Any text taken directly from *Glas* is not to be found in these drawings. The *ICH* sketch, a fish that, like the suspended glas, "never holds ... either in the water nor out of the water," instead fishes up a memory of a "shipwrecked galley" in "+R":

> In the beginning it was the first line of a bad poem I published, aged seventeen, in a little Mediterranean review since gone under—I abandoned my only copy in an old trunk in El-Biar.
>
> I only retain, wary of it, the memory of that first line.[102]

The galley, that unfinished proof that is a *glas* between writing and publication, is "shipwrecked," lost to *Glas*'s (Genet's) sailors. Like holy

scripture, its loss must be glossed. The review itself has also "gone under," submerged in the Mediterranean. (In a trunk: despite the quality of the "bad poem," these lines contain a hint of treasure, the remains of memory.)

On the other side of *CHI*, Adami draws a ladder as if to Harcamone's scaffold: "A ladder is a scaffold, it was also a synonym of *potence*," one of two words to "get big letters" (be completely capitalized) in *Glas*.[103] As Drucker says, it is "self-evident" that "large size proclaims its own importance" and "text is effected by the space it claims."[104] Size might suggest power and presence, but the other capitalized word in "+R" undoes these associations. "CHIMERA" serves as "title for the fable of the three drawings."[105] Thus, Derrida *qua* Adami extrapolates from *Glas*'s majuscules, stitching the two "big lettered" words to the drawings.

The first version of "+R," in the artists' magazine *Derrière le miroir* (published by Maeght Éditeur, Paris, in 1975), also considers the spatial page. In a folder, four unbound eleven-by-fifteen-inch signatures accompany ten sheets of black-and-white prints by Adami. The type for this text is large—around 18 point. And, strikingly, it fills the page: the essay obeys no margins (a fact referenced in the *Dissemination* reprint), instead running from left to right and top to bottom. Images are reproduced without captions, suggesting greater integration with the text; they vary in size ("ICH" takes up an entire recto, for instance; the Galilée cover is also reproduced in a smaller size). Page numbers are not always present. Such typographical design clearly prioritizes the body text, especially with aggressive margin treatment. Hubert points out that *The Truth in Painting* foregrounds "the deliberate transgressions of borderlines, margins and frames," in subject as well as in the suggestive lines on the page.[106] She argues that this work directly explores Derrida's spatial concerns, seen especially in *Glas*, "substituting for the standard format of the page spatial columns, cylinders, bifurcations, and other means of subdivision."[107] Margins in *Derrière le miroir* force Derrida's text as close to Adami's work as possible; the page itself becomes ceaselessly overwritten. In conjunction with his drawings, Adami suggests that "margins, ruptures, chiasmas, and frames, must upstage all other aspects of the work."[108] Here, these frames are broken down: if Adami reads a kindred spirit in *Glas*'s transgressing margins, their joint(ed) transgression causes us to lose sight of the margins altogether.

Adami and Derrida overlap themselves and each other as writer, artist, and signer in these works. Their visuality feels apt for the *Glas* that spans multiple editions, sometimes constrained by genre and format, always challenging the conventional form of the page. Regardless of edition, the remains organize according to their own logic: the white space that defines and enables writing, before it becomes written over.

The Book('s) Remains Activated

The book to come, Derrida argues in his essay of the same name, cannot be the same book that was to come for Mallarmé, with his all-encompassing *livre* of the future, or even for Blanchot, whose essay "The Book to Come" is a precursor to Derrida's own. If the book to come can never be realized but always belongs to the future, we still can't help but envision an awaiting shape. Derrida sees an inevitable kind of future in "the new space of writing and reading in electronic writing, traveling at top speed from one spot on the globe to another, and linking together … any reader as a writer, potential or virtual or whatever."[109] "Linking together," in this much newer piece, acknowledges the digital realm as restructuring not only our modes of writing production but the kinds of language we use, where links become the primary mode of connection. The digital promises these connections between concepts and readers while further destabilizing the spaces in which such connections happen. There is a hint of bemusement, fascination but also trepidation, in the unknown "whatever." The unknown can frighten, but it is also, undeniably, a source of potential: the book's remains activated in a book of the future. Aaron Cohick begins his *Manifesto* on bookmaking by stating: "The book is a dangerously unstable object.... Now that the book is dead we can begin to divide up its remains."[110] Remains have an afterlife in this formulation. The future book will be material, too—the material of the digital.

Given its intertextuality and citationality, as well as the layout that creates readerly indeterminacy, *Glas* has assumed the mantle as a kind of proto-hypertext—a hypertext *avant la lettre*, as Norbert Bolz characterizes it.[111] Both *Glas* and hypertext are products of similar *kairos*. J. Hillis Miller calls *Glas* and the advent of the digital "aspects of the same sweeping change," noting in 1991—seventeen years after its original publication—that "[b]oth work

self-consciously and deliberately to make obsolete the traditional codex linear book and to replace it with the new multilinear multimedia hypertext that is rapidly becoming the characteristic mode of expression both in culture and in the study of cultural forms."[112] George Landow agrees, expanding on this harmony between literary theory and computer science. Both poststructuralism more generally and hypertextuality, Landow argues, concern themselves with dismantling conventional reader-writer relationships and hierarchical knowledge strategies. From this point of view, an emphasis on rhizomatic, networked structures easily maps onto the functionalities of hypertext.[113] Likewise, Gregory Ulmer writes that Derrida's texts "already reflect an internalization of the electronic media."[114]

This first wave of enthusiasm recedes a bit as more contemporary scholars examine these readings. While Alexander Starre locates a shift from early to late Derrida in this explicit recognition of the importance of material form, he counters that Landow "misreads Derrida's experimental book *Glas* as an expression of the wish 'to escape the confines of print.'"[115] Starre produces (yet another) statement by Derrida on the making of *Glas* in which the author prefers "the constraints of paper" to the possibilities offered by the computer.[116] Regardless of Derrida's shifting attitudes toward process, however, it seems clear that *Glas*'s columns still offer its reader what feels like a proto-hypertextual experience, with multiple possibilities set side by side on the page. Alternatively, Mark Poster concludes that "in the end, Ulmer is unsure if Derrida already heralds the new age of writing or if he only glimpses it but does not really come to terms with it."[117] In contrast to Starre, Poster treats Derrida and deconstruction in general as needing to be "extract[ed] … from the context of logocentric philosophical and literary texts and reinsert[ed] in the social context of computer writing" in order to "contribute to the work of critical social theory."[118] But Poster does not dispute that Derrida's work anticipates hypertextual concerns. The links of signifiers in *Glas* correspond to hypertext links; the movement of the reader from one column to another will be replicated *ad infinitum* when we begin reading the many columns on a webpage.

Yet these scholars tend to neglect that the network *Glas* builds, a spiderweb that recalls the digital web, also relies on space—the "screen" is also a "veil," the space between columns. A careful reading of *Glas* reveals the tenuousness of its network; the implications of the term "CHIMERA" go further, suggesting that a network of representation ends up representing

only itself. The *glas*-machine reminds us how the digital machine pushes us ever forward in the ghostly world of the internet, a space of shifting signifiers. It's not just hypertext as linking and oscillating, citational and intertextual, but also the fragility of our interactions with it that *Glas* points out. *Glas* insists on the provisionality of these interactions, in which the signified is endlessly deferred.

Remains are also in sight here. Readings that locate *Glas* as a hypertext ancestor share an affinity: a desire to activate *Glas*'s remains so fully that they cease to be remains at all, instead becoming fully absorbed into the totalizing dream of an infinite hypertext. In *Déjà Vu: Aberrations of Cultural Memory*, Krapp identifies two dominant tendencies in readings of referentiality and functionality in *Glas*: the "completely immaterial," which emphasizes the "differential movement" between the columns at the expense of all else, and the "fully manifest," which treats *Glas* as a new arrangement of old ideas.[119] In the first kind of reading, reading itself is practically erased, the specificities of the text subsumed under a radical methodology. In the second, *Glas* functions as a knowable system—a searchable archive—in the face of its blatant refusal of the totalizing or synthesizing impulse.

Krapp cautions against subsuming *Glas*, and Derrida more generally, under the rubrics that surround the potentialities of hypertext and new media. In fact, he argues, *Glas* destabilizes these rubrics even as it partakes in them, not simply exemplifying the concerns of hypertext but critiquing or amending them. Along with the potentiality of referentiality and linking, multiplicity and archivization, hypertext must also inherit the necessity of that which cannot be indexed, archived, or remembered. "Perhaps a reading of *Glas* as hypertext will be able to acknowledge the resistances and remainders without wanting to nail them by making them either completely immaterial or fully manifest," Krapp muses.[120] Considered as a material argument, *Glas* offers a caveat to the promises of transparency and totality envisioned by hypertext: the inevitability of remains.

In the Geoffrey Bennington and Derrida print collaboration *Jacques Derrida*, Bennington expresses a desire to expand his contribution, the "Derridabase" that runs along the top of the page, into the digital realm. Bennington states: "The following text is the linear version of a book without prescribed order of reading, written in Hypertext, to appear subsequently in electronic form."[121] The annotated, open, ergodic, hypertextual Derrida that Bennington gestures toward, however, is the Hydra,

established in 1994 as a repository of Derrida scholarship online. While it can still be accessed today, the quaintly titled "Colophon" reads: "As of February 2009, this legacy site is now at the University of California, Irvine, but without having been much updated."[122] The Derridabase project, meanwhile, appears to have been forgotten. An internet search reveals only a single page hosted on the Hydra, which links back to Krapp, its designer.[123] A glance at the page's source reveals its use of HTML 3, outdated even in 2009. ("I am not promising anything to those urging me to redesign the site to bring it into the 21st century," Krapp states.) This information is readily available to anyone viewing the source—a functionality built into desktop browsers—but there is no pertinent information hidden away here. Three links, at the bottom of the screen, promise to lead to a site search, an index, and the Hydra itself. Like tablets, they are all broken, revealing error messages instead of content.

The Derridabase has become its own exemplar, an archive abandoned, a set of signifiers pointing to nowhere, a digital tomb. *Glas*'s remains—its white space—are materially specific; by definition, they cannot translate into another medium without fundamentally altering. But a new kind of remains appears, still functioning according to the logic of noise. The gaps and spaces on the page are the static of the digital network, which has taken over the Derridabase. Yet static is endemic to any network, which, even when awakened by its reader, can only reach so far.

3 De-Black-Boxing Media: The Technological Feminine in Avital Ronell's *The Telephone Book*

"I've been sleeping with the telephone" [Je m'étais couchée avec le téléphone], the first chapter of Avital Ronell's *The Telephone Book* ends.[1] Ronell is quoting Francis Poulenc's *La voix humaine*, a one-act opera in which a woman's words to her absent lover on the telephone are related, while the other interlocutor remains silent. Woman and telephone are linked in the opera, even as the woman wraps the cord around her neck, its wires supplanting her own voice. This drama of desire, blurring the space between technology and person, is rehearsed once more in the final chapter of *The Telephone Book*, in which Ronell responds directly to Marguerite Duras's words on the page, calling herself "an answering machine."[2] Both instances begin to construct a definition of the feminine as split—distributed among self, other, and technology—and multiple, requiring (at least) two voices and a third line that connects, separates, and even infiltrates the communicators' subjectivities.

Furthermore, both instances are typographically set on the page in an unconventional way. Whether or not directly quoted, text is italicized as if a whisper, something said under one's breath. The title "La voix humaine" is aligned in two columns with the left and right margins, the space between them suggesting an unbridgeable gap or silence. The chapter title "Last Call: F.—Duras," in contrast, is centered as a single column. Heavy, bold underlines emphasize certain words and phrases in the text, calling back to the dash in "F.—," the name that is present only as absence. These two moments remind us of the connections between silence as a (tele)phonic attribute and space as a typographic one. In fact, *The Telephone Book* connects these attributes in the two technologies of its title: it is a book, and it is a book about the telephone. Its subtitle, *Technology, Schizophrenia,*

Electric Speech, further points to the networks structuring this book. The book's lines of inquiry are wires often crossed, requiring substantial critical patience to tease them out. Moreover, they partake in multiple discourses: like all artistic arguments, they are technological and typographical as well as philosophical.

So it would be a mistake to focus on the philosophical at the expense of the technological and typographical—to treat this as a book simply *about* technology. Besides its intentional design, it is potentially, as mentioned in the introduction, the first book to be designed entirely on the computer. Poised at the historical moment when by-hand techniques give way to digital layout, it proudly foregrounds this hinging moment through its self-conscious design. Its production history gestures toward a robust collaboration, in which each page is designed as a manifestation or elaboration of its subject. Even its front matter stresses a sense of collaborative creation, listing the "Textual Operators" in order: "Richard Eckersley (Design), Michael Jensen (Compositor), Avital Ronell (Switchboard)." (Foreshadowing the technological-feminine link, Ronell assigns herself the place of "switchboard.") Like other artistic arguments, *The Telephone Book* presents as multiple from the beginning, a network of lines converging.

Because of its subject matter, explicitly about communication technology, *The Telephone Book* stands out among artistic arguments by offering a unique perspective on noise, and speaking even more directly to current concerns in media studies. This work specifically interweaves media theory and cyborg feminism, combining technology and gender under its lens. It reminds us how technology often operates under a dictum of invisibility, in which we request a result and receive it without understanding the complex procedures of the chain of action. Following information theorist Claude Shannon's well-known 1948 diagram—a flowchart of boxes that represents a general communication system (see fig. 3.3)—media studies has taken for its goal what we may think of as the "de-black-boxing of media technology," a thorough investigation that properly categorizes and organizes the elements of communication, eradicating noise in the process. Committed to situating and explaining these terms, even media theorists as different as Friedrich Kittler and Wolfgang Ernst share similar aims, turning to varying definitions of media to translate the communication process into legibility. These translations are often critiqued for their erasure of social factors; in particular, cyberfeminists, such as Donna Haraway in her early work, have

attempted to locate the place of gender in the black boxes of media and communication.

For *The Telephone Book*, which combines aspects of technology, communication, and gender, these overlapping contexts offer vocabularies that help disentangle its network. But the book occupies a singular place relative to these discourses as well: its material form points to the tendency to eradicate noise on which de-black-boxing relies, and highlights that tendency as a fallacy. *The Telephone Book's* pages are designed at a micro level to reflect their individual subjects, obeying an internal and sporadic logic rather than the conventional logic of type hierarchy, formatting, and replication of text forms that, in a standard print text, make it easy for readers to ignore the material conditions of their reading. The book instead creates illegibility directly on the page through its creative and unusual typography, interrupting communication between book and reader and drawing attention to the ways in which design and typography, generally construed, shape that communication. Meanwhile, illegibility slowly takes on a gendered shape, a "technological feminine" in which both terms (of gender and of technology) are reconsidered. Bringing noise back into the idea of the black box, the technological feminine is the expression of nonsemantics in this work. Typography functions as noise, both enabling and deterring reading.

Like other forms of noise in artistic arguments, the technological feminine can be viewed as a kind of excess. It exceeds and overwhelms the channels through which the book conveys meaning, while on a semantic level, it exceeds the rubrics that it invokes. The technological feminine cannot be reassimilated into cyberfeminist codes of gender or technological codes of media. Instead, it insists on noise qua noise, with a distinctly Serresian inflection. In this chapter, the technological feminine reminds the reader that there are limits to de-black-boxing.

Toward a Construction of the Black Box

Media studies offers us a starting place to understand what and how the black box signifies, but the figure of the black box spans different kinds of media and even disciplines. The book, too, despite our familiarity with it, is a black box: the question "What is the book?" animates many lively discussions in the digital era, while the material components and processes involved in the print codex are unknown to most of its users. An all-black rectangular

paperback, *Telephone*'s material form references and resembles a black box when closed. Moreover, mimicking its namesake technology, the book's cover is embossed with twelve boxes arranged like the keypad of an analog telephone. A tiny red box marks where the zero would be on a telephone, subtly suggesting that reading places us in a precarious position where we may require assistance.

Ronell's chapter titled "Black Box" elaborates one potential danger within the black box of the telephone: the disaster of loss. "To avoid the crash whose site is your ear, you hang up together, you deny the **click**. This way, the Other is not gone but survives the telephone, just as she was prior to it," she writes.[3] Making the call puts the self, puts oneself, on the line, in direct connection with another. But the opacity of the black box ensures that we cannot be assured of a response from this other, or reassured that she will not abandon us after answering. The potential of loss, inherent in any call, is inscribed in a traditional phone book as a "Survival Guide" or "Emergency Care Guide" that lists the phone numbers for assistance, such as the number for Poison Control; loss is embodied, the potential for the body to break down. In "Black Box," Ronell deems such a "Survival Guide" the "Autobiography of Telephony."[4] How we will survive the inevitable loss upon hanging up is an urgent matter, whose urgency characterizes the ur-scene of the call. Ronell's work proposes that what is at stake in the figure of the black box is the tenuousness of connection, the possibility of sudden loss.

In an existential sense, the real disaster is not the loss of self but the always-lingering threat of the other's departure, which is signaled by noise: the "click" or the "crash." (Such noise also recalls the breakdown of the technological black box, or the hard drive.) Ronell situates the crash of hanging up in the ear—the "site" that homophonically stands in for an impossible sense of sight, which could penetrate the recesses of the black box. The telephone as medium is tied up with a "terror of loss" suggested by the audiospatial moments at the beginning and end of the book, Poulenc's unresponsive lover or Duras's withholding of names.

The potential of loss leaves us in a position of fundamental uncertainty. The black box of the telephone is thus a domain of ghosts, caught between presence and absence. "Black Box" continues: "Already heterogeneous, the self that speaks into the phone or receives the call splits off from its worldly complexity, relocating partial selves to transmitting voices in the

fundamental call for help."[5] The self on the telephone first encounters, then becomes, a ghostly voice among other ghostly voices or "partial selves." These partial selves are heterogeneous as well; the telephone is a site of schizophrenia. Ghostly voices fill the lines with their desire to be heard or answered. Desire and fear of loss thus struggle in the black box, which itself, like Ronell's "partial selves," has a multiple constitution. Whether conceived as schizophrenic or as Deleuzian bodies without organs, the many occupants of the black box drift along a spectrum from presence to absence. In contrast to the de-black-boxing common to media studies, which locates and stabilizes factors, Ronell's investigation of technology holds these multiples and apparent paradoxes—living and dead, here and gone, being and not being—in indefinite suspension.

Laurence A. Rickels offers another dimension of the black box in his reading of Ronell. Rickels points out, "By virtue of its topological structure, the apparatus that transmits or produces meaning makes no sense in itself as apparatus."[6] The black box "apparatus" requires a context in which its work makes sense, a network spanning objects and concepts. Multiple and fluid, Ronell's telephonics blur the edges of the black box, providing a counterpoint to the solid differentiating lines of Shannon's diagram. Nor is the black box limited to describing only a technological apparatus. Michel Serres writes, "We live in that black box called the collective."[7] The "collective" is a system, and so the black box is that which appears to contain the inner mechanisms of a system. But because a single system determines what is inner and outer, the black box can never quite contain its mechanisms. In addition to its boundaries being blurred, any black box is always already subject to leaks.

In fact, the black box of any communication must contain some static. Serres's mechanism of noise, at work in all artistic arguments, applies particularly aptly to *The Telephone Book*, with its aural medium as its subject. His word for "parasite," *hôte*, signifies this necessary static, a "third man" between two would-be communicators that provides the backdrop for communication. Far from antithetical to communication, noise is a prerequisite for it, even as any successful communication then strives to minimize or banish noise. Echoing the "partial selves" or ghostly voices that are both present and absent in Ronell's telephonics, *hôte* hinges both ways for Serres, meaning both "host" and "guest."[8] Likewise, noise or static both enables and places stress on communication.

As we read the black box of *The Telephone Book*, Serresian typographical illegibility produces static, which is critical for understanding the network of Ronell's telephonics.[9] "Static" or "third man": Serres uses these phrases interchangeably, suggesting a negligible distance between person and thing. From its opening gesture in which neck and telephone cord entwine, *The Telephone Book* takes up Martin Heidegger's "The Question Concerning Technology" to investigate the distinction between person and thing. For Heidegger, the essence of technology is not instrumental: it lies in *Gestell*, or "enframing." This term has humble origins: "According to ordinary usage, the word *Gestell* [frame] means some kind of apparatus, e.g., a bookrack."[10] Like Rickels's "apparatus," *Gestell* is the black box that we must probe to discover the essence of technology. Heidegger's choice of examples also resonates: a "bookrack" is a technological apparatus that links readers to books.

Heidegger's fear is that man will unthinkingly accept, or has accepted already, the "ordering" of *Gestell* as the primary access to truth—that technology will make us over in its image.[11] Man is, categorically, not a thing. But what about woman? In "The Origin of the Work of Art," Heidegger refers to a girl as a "young thing," emphasizing her youth and so emphasizing her nature as unfinished, unfulfilled, never catching up to itself qua self.[12] Ronell locates the "young thing," occupying this unfinished space, as a source of unease in Heidegger. The young thing's "thingly feature is the jointure, that which joins and, one supposes, separates," like the blurry boundaries of the black box.[13] Technology, too, "in some way is always implicated in the feminine. It is young; it is thingly."[14] Both the feminine and the telephone hinge between these two statuses. They are what Ronell terms "parasitical inclusions" in communication, revealing static's character as feminized, which by turns encompasses other marginalized social designations.[15]

Contrary to media theory's inheritance of Shannon's black boxes, Ronell begins her investigation of technology in the nebulous space where, defined by usage, it interacts with the person. This space proves to be riddled with static that expresses itself as feminine, even as the feminine as category is destabilized. Through typographical illegibility, the technological feminine arises directly on the pages of *The Telephone Book*. Its presence poses a challenge to the de-black-boxing of media studies. Because Serresian static cannot be fully articulated or explained without losing its status as intermediary—"If the relation succeeds, if it is perfect, optimum, and

immediate; it disappears as a relation"—de-black-boxing can never reveal a full inventory of contents.[16]

An Illegible Feminine

The Telephone Book's illegible typographical ruptures, creating static that troubles the line connecting reader to book, reflect and create what I am calling the technological feminine. But the idea of the feminine is also multivalent, appearing in *The Telephone Book* as, for example, the Heideggerean "young thing," Carl Jung's schizophrenic Miss St., and Alexander Graham Bell's deaf mother, who provides the model for the corporate Ma Bell. These figures are linked by their deviance from the established (masculine, able, articulate or semantic) norm. As such, the technological feminine also touches on terms of disability. In *Culture—Theory—Disability*, Anne Waldschmidt identifies a "cultural model" of disability, which "considers impairment, disability *and* normality as effects generated by academic knowledge, mass media, and everyday discourses."[17] Modifying the social model of disability, the cultural model claims that "both disability and ability relate to prevailing symbolic orders and institutional practices of producing normality and deviance, the self and the other, familiarity and alterity."[18] Locating "prevailing symbolic orders and institutional practices" as the engine driving categories of disability and ability, Waldschmidt denaturalizes these categories while granting power to cultural factors like media. As in *The Telephone Book*, categories are leaky black boxes, and the deviant or the other precedes the normal or the self as category.

The resonances between the technological feminine, which is unwilling to be reassimilated into conventional rubrics of understanding, and representations of disability that also push back against assimilation into the dominant paradigm are richly suggestive. Such analogies apply at textual levels and in wider communities, too: as David Mitchell and Sharon Snyder write, "Being and identity themselves are devices for technological manipulation," and "technology has always grounded its value in the ability to resuscitate and revitalize an imperfect body."[19] Mitchell and Snyder, writing about "narrative prosthesis" in their book of the same name, delve into the complex relationship of prosthesis—itself a central term for Ronell—to body, where prosthesis is a double marker of disability and its apparent overcoming or disappearance in literary and social senses.[20] If "the effort

to narrate disability's myriad deviations is an attempt to bring the body's unruliness under control," then the nonnarrative—the nonsemantic—resists normalization and insists on "unruliness" without concessions.[21] For now, we will only gesture at the possibilities for a much more developed treatment of *The Telephone Book*'s interactions with disability. Still, what's critical here is to recognize how *The Telephone Book*'s foregrounding of its nonsemantics as the technological feminine also allows disability, in the form of schizophrenia or deafness (themselves radically different forms of disability), to be present, to demand interpretation on nonnormative terms. The schizophrenic, the ghost, and the operator, framed as others, all become agents—or, borrowing from Bruno Latour, actants—in Ronell's network, gathered under the guise of the feminine.

Like the feminine, "illegibility" is a malleable term: the book is legible in the most technical sense in that it still *can* be read. Here, illegibility describes a spectrum of difficulty in reading. It can be felt in the deliberate flaunting of typographical convention, such as the incorporation of images that interrupt the body text and the ever-changing shape and size of paragraphs. Tracing the line separating quantitative from qualitative difference, the extreme end of the spectrum presents text that is difficult or even impossible to read. Exemplifying Serres's imperfect relation, these illegible moments make us aware of the tenuous connection between book and reader. Likewise, Ronell calls the telephone "a technical object whose technicity appears to dissolve at the moment of essential connections."[22] The book's illegibilities can be loosely sifted into categories in which we locate these "dissolve[d] ... moments of essential connections," dramatizing its argument through even the most minute typographical choices.

Book designer Richard Eckersley states that *The Telephone Book*'s "style is very eccentric and deliberately discontinuous."[23] In places, the book engages in typographical movements that create its own kind of continuity, briefly nodding to telephone book conventions at beginning and end. At the beginning, "Directory Assistance" (the table of contents) separates chapter titles with phonebook-like dot leaders, while the endnotes are printed on an orangish stock, reminiscent of the yellow pages at the end of a phone book. The bulk of the text, however, forgoes such conventions, substituting its own instead. Chapters vary drastically in length, setting a halting, stuttering pace for reading. One recurring tendency is the call-out word, set within body text in substantially larger type, as though an interrupting voice on

the line: "GUILT," "Joke!," and "slapped down again," for example, appear in larger Helvetica.[24] Chapter titles are often set vertically, sometimes with vertical title words facing one another, a constant experiment in redrawing the grid of the page that suggests the subject matter's refusal to be contained within a uniform structure. Often, a chapter's last three lines will move down the page toward the spine. The book is a network that breathes but still orients itself toward its central nervous system, obeying the motion toward binding. Along with these deliberate discontinuities, *The Telephone Book*'s illegibilities cluster in groups that can be appraised with a careful eye. As typesetter Michael Jensen writes, the sections have "internal integrity, as [does] the book as a whole."[25] At a microtypographical level, *The Telephone Book* creates illegibility through paragraphing, quotation, images, and shapes, and also through kerning, letterspacing, and leading. Within each specific typographical category, Eckersley and Ronell—who worked together closely on this and other projects—create patterns for every chapter that are apt to mutate and morph. Ronell describes this relationship in *Remembering Richard*: "Thanks to Richard, *The Telephone Book* breaks up the sovereignty of the Book and becomes a child of *techné*.... We went over every page, every icon, every blank drawn around a conceptual breath."[26]

The Telephone Book's paragraphing takes a surprising variety of shapes. Paragraphs are designated by markers (like the traditional pilcrow or ubiquitous tiny black boxes that replicate the black box at the smallest of levels), space in the middle of a line, highlighted (and italicized) text, or lines drawing in from the left margin, to give only a few examples.[27] This paragraphing provides diversity for the reader, prompting awareness of the page as communication medium and taking on a subtly different timbre at the pause where paragraphs end and begin. One specific and compelling example of paragraphing appears as Ronell develops the figure of the mother. This figure begins in Heidegger, moving to Sigmund Freud vis-à-vis Derrida. Heidegger's call from mother to son in "What Is Called Thinking?" is recalled or ghosted in Freud's *fort/da* analysis, producing a detachable mother—"Hang on to this detachable part," Ronell implores us.[28] Between Heidegger and Freud, the mother is first the caller, then the called. Occupying this between-space, she waits, a dial tone whose presence implies absence. The chapter "Being There" unfolds in this between-space. In this chapter, Ronell casts a mother who "endlessly attempt[s] reconnection," like a telephone, into the role of a ghost, a blindness, negative space.[29] The

mother's Freudian lack, her "invaginated ear" that calls the child back to the womb, is present only in or as absence.[30] This absence, the connection to nothing, is a maternal static marked by desire. (Such a call will later be rehearsed in Alexander Graham Bell's supposed first words to Thomas A. Watson: "Come here, I want you!") The telephone, a "detachable part," feminized and sexualized, becomes supplementary: a prosthesis. The detachable mother, conceivable only in relation to others, inverts Deleuze, becoming an organ without a body, a piece of a disorganized system that nonetheless requires the prosthesis to function.

Throughout "Being There," the paragraph placement shapes this charged space of the mother. All paragraphs are set flush left, but their placement changes with every page, suggesting the varying origin stories of mother as caller and called. At first, paragraphs are each presented in two separate and narrow columns, with ample margin space, the last line of the first column placed flush with the first line of the second. On the chapter's fourth page, two columns become three, unequally distributed. The columns overlap, resisting a neatly subdivided page and moving with seeming disrespect for one another. They expand to as many as nine columns, always unequally distributed, body text turned into parts and disconnected from one another.[31] The reader's eye wants to place them into two columns but is subtly thwarted by beginnings that, like the telephone's, never line up. Meanwhile the paragraphs become shorter, jumpier, and prone to violating margins (the upper margin on page 101, the lower and left margins on page 102).

In tandem with these troubled beginnings, the body text forms shapes on the page, dark ink standing out clearly against a white background. But the reader is also able to read the white space back onto the page in its own right. This reading prioritizes negative space, exerting a mounting pressure on the paragraphs, which gradually break into smaller parts and drift over the page's landscape without direction. The layout engages us in the "paradox of seeing not what is there in its materiality but what is missing."[32] In presenting paragraphs as shapes as well as text, "Being There" encourages us to read the negative space—to find in the ghost, absence, or feminine lack a shifting pressure exerted back on the Freudian argument. To continue the paradox, the premise of "Being There" is what is *not* there—the feminine. Of course, from a Serresian point of view, this is not a paradox at all.

The paragraphs suggest that it is the static, the feminine—in this moment, too, the white space of the page—that makes the call possible.

In "Being There," the shapes and movements of paragraphs subtly resist a stable reading pattern. The next chapter, "The Nervous Breakdown," begins with an explicit injunction: "It is no longer a question of adducing causes to the telephone, assigning its place, and recognizing in it a mere double and phantom of an organ (like Woman, reduced to the phantom of a missing organ). ... The radicality of the transaction takes place to the extent that technology has broken into the body."[33] "Technology" becomes metonymic for white space, the technology of the codex, that breaks into the "body" of the text, a prosthesis that makes it legible but also holds its own nonsemantic possibilities. This "transaction" is set in opposition to "assigning [the] place" of the telephone, itself a contextually dependent network connecting various times, people, and places. The boundaries of the telephonic black box echo the fluidity of these pages' typography.

These unfixed boundaries, like the slowly drifting columns, also stress multiplicity. Rather than turning to the cyborg, a figure of enhancement and power, to figure the "technology [that] has broken into the body," "The Nervous Breakdown" instead introduces the schizophrenic, in whom Ronell sees a figure of "exemplary access to the fundamental shifts in affectivity and corporeal organization produced and commanded by technology."[34] The many selves that operate semi-independently of each another model a kind of hyperactive reading and medial immersion. This access is granted in this chapter in part by the body without organs, which resists "corporeal organization," and Deleuze and Guattari's *coupure-reste*—literally, "remainder cut"—which "produces a subject alongside a machine."[35] Like Lecercle's remainder, the *coupure-reste* asserts a necessary place in our conception of the machine. Every letter *o* throughout the first two pages of "The Nervous Breakdown" is accordingly printed in Helvetica Bold, studding the text like hollow organs. Schizophrenia straddles the distance between man and machine, exemplifying the diffuseness of subjectivity. The *o*s also read as feminine, even vaginal, clearing the way for an equivalency between schizophrenic and feminine that will be developed in the next chapter.

Faithful to the thematics of multiplicity, the paragraphing alters twice. Spaces within the body text suggest the *coupure-reste* by providing breaks, spacing, within a line of text. As the text states that "schizophrenia is

never itself but invariably put through by an operator," new paragraphs are marked with large, open curly brackets, also known as braces.[36] These brackets begin on a new line every time, but they begin at different points within that line, creating moments of discomfort for the reader, and a closing bracket never appears. Schizophrenia cannot be itself because it cannot be singular, a thing. Even historically, it poses problems of nomenclature: Ronell traces its beginnings as "dementia praecox," quoting a contemporary professor who claims that the group of illnesses is "too young for us to give ... a closed description."[37] The open brackets mirror the impossibility of "closed description," which, like schizophrenia (and the body without organs), "exhibit[s] resistance to totalization."[38] Meanwhile, the idea of youth further links disability to the feminine "young thing."

The Telephone Book's treatment of quotation also contributes to illegibility and noise. Echoing the relationship of typographical space and aural silence, quotation is the visual representation of speech, a translation dear to Alexander Graham Bell as well as to Ronell. The variety of quotation and citation (here used interchangeably) emphasizes the variety of voices spliced into the network of the book. Quotation is often subject to exaggerated typeface size or style (Helvetica Condensed and Bold) and exaggerated leading; it is set off from the body text on the page, and sometimes even set across an entire spread, as in the conversation on Nazism between Heidegger and his interrogator from *Der Spiegel*, suggesting a sizeable gap between questioner and questioned.[39]

Ronell continues to develop the figure of the schizophrenic largely through quotation. In "The Case of Miss St.," schizophrenia, the state of many voices, "is made to read technology's omphalos."[40] The schizophrenic Miss St. describes her heard voices as "telephones" to Carl Jung, thereby becoming an operator. "I came first as double," Miss St. proclaims. She considers herself "the Emperor Francis" and also "his wife." Still, "in spite of that I am female." Ronell concludes that Miss St. "is a telephone, compacting a double gender" of self and other, caller and called, speaker and listener.[41] However, this double gender is defined "in spite of that" as female. The feminine accords with the situation of being multiple.

As Miss St. testifies, telephonically connecting her heard voices with "ineffaceable loss," her quotation is italicized and spread out across the page, discrete units of language studded with spatial aporia in the text.[42] ("Ineffaceable loss" takes on a less existential sense as well, as loss of hearing.) In

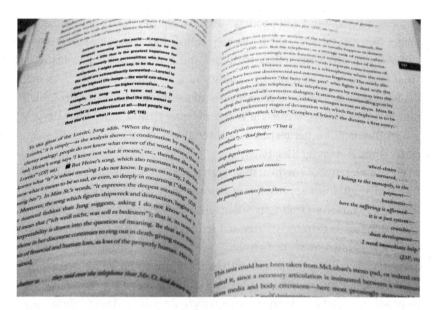

Figure 3.1
Miss St.'s testimony, with leaky black boxes as paragraph markers, pp. 126–127.

contrast to her text, set in the serif Galliard, Jung's analysis is presented in blocks of sensible Helvetica. Jung's quotations are also resolutely centered, indicating his testimony's goal of unification and explanation. Meanwhile the small black boxes that serve as paragraph markers extend hairbreadth lines—leaky black boxes, suggesting Miss St.'s testimony as uncontainable and riven with noise, the multiplicity of her feminized voices troubling easy categorization.

Quotation also shapes the mother in *The Telephone Book*'s second half, which focuses on Alexander Graham Bell, beginning with the "Birth of a Telephone." The son called by the (m)other in Heidegger, and Freud's inverted "detachable mother" who calls, materializes or maternalizes into Watson, Bell's assistant. Bell's articulation ("Watson, come here! I want you!") puts "desire ... on the line." At the same time, this desiring call "phantomizes you. I want that which I do not possess, I do not have you, I lack you."[43] Speaking as and through Watson, the spectral and feminized "you" becomes the object of desire. Placing the father of the telephone on hold, Ronell begins with the "second," the object of desire that is called.[44] Watson's autobiography describes his fascination and interactions with

ghosts and his "tenderest anxiety" for his mother.[45] This autobiography places him "in what might be loosely called an effeminate light," Ronell comments.[46] His connection with the spirit world and his sensitivities "make him a keen soul-sister to Laing's Julie or Jung's Miss St."[47] As such, his hold on any gender is tenuous; he tends toward feminine, in Ronell's multiple and elusive sense. He is the necessary third man, like the poet, schizophrenic, or other technological feminine, manifesting on the book's pages through playful illegibility.[48]

At the margins of the hearable, perhaps where the living connect with the dead, quotations approach true unreadability. In "Birth of a Telephone," subtitled "Watson—Dead Cats," Watson's story is told through long block quotations with extremely extended letterspacing.[49] Sentences are spelled out with significant space between every word and even every letter; as Watson relates his experiences with séances, his monologue is slow, as if reaching us from the afterlife. Our first call to Watson provokes a delayed response, text diffused with space in which absence and presence are both weighty on the page. As Bell assumes his role in the story, Watson's quotations change in form. In the next chapter, "Tuning the Fork," Bell explains his telephonic "apparatus" to Watson, calling attention to vibrating reeds that often misfire. Much like Serres, who queries whether the system existed before its breakages, Ronell asks, "Isn't mishearing, missing the point of the missive/message, not from the start of their relationship built into the thing?"[50] It is perhaps notable that Ronell herself appears to mishear Bell's words, quoting them as "Watson, come here! I want you!,"[51] when Bell's lab notebook actually transcribes, "Watson, come here! I want to see you!"[52] Desire here occludes the visible, making it invisible, and making itself the subject speaking. At this point, Watson's quotations change size with every letter, taking on the shape of a sound wave.[53] The space between letters has disappeared, and Bell's presence gives these words direction.

The typography in the two consecutive chapters that describe Bell and Watson's relationship makes it clear that our words are pulled inevitably toward a listener. We cannot speak without anyone to listen, even if that other is another form of ourselves; speaking is predicated on waiting static. The misfiring reeds—the mishearing or missing the point—are built into the structure of not only the machine but also communication in general. Watson is the figure who listens to misfires: "I, perhaps, may claim to be the first person who ever listened to static currents," he notes, or as Ronell puts

it, "the first convinced person actually *to listen to noise*" (emphasis in original).[54] Perhaps this accounts for the "noise" on page 262, where, in partial conjunction with the sound wave treatment, the type is kerned too closely together to be readable at all. (Fortunately, the semantic content echoes itself, repeating with legible typography immediately after.) The illegible type appears again on page 267 and at the chapter's final moment, ending with an offer to the reader that plays on the sonic and on the present page: "You may still want him. Come, hear."[55] We may want him, but we must be prepared to hear, here, on his terms, the homophone again combining spatial and aural language.

Watson is one depiction of the technological feminine, while Bell—treated primarily through his mother, Ma Bell, and Bell's deaf wife—is shaped by it. The technological feminine is his premise, underpinning, or shadow. Ronell prioritizes this shadow-index by incorporating Catherine MacKenzie's biography of Bell, positioning MacKenzie (not Duras's "F." but "M.," doubling again from "feminine" to "mother") "squarely at the receptionist's desk, fielding the calls, diverting some of them while screening or silencing others."[56] As with the schizophrenic, the operator—recalling early women "computers"—is female. Bell "tries to double for his father," but it is his mother who bears heavily on the narrative and the technology.[57] Bell's father begins the telephonic experiments with his development of "visible speech ... a speech that the deaf might see," which attempts to replicate the mouth's shapes in alphabetical form.[58] Along these familial lines, Bell's partially deaf mother provides the main impetus for Bell's experimentation: "The first discursive repetitions were designed to the ear of a partially deaf mother."[59] These repetitions take the shape of a device that sounds, uncannily enough, the cry of "ma-ma," words that Eckersley bolds and sets off on the page.[60]

All this background prepares us for the first page of "The Returns: The Deaf—AGB," which, like the opening page of "God's Electric Clerk," is completely illegible, as if aurally inflected. Letterforms are blurred beyond distinction. Here "visible speech" translates to unhearable type. The illegible page completely breaks down the distinction between image and text, becoming the image of type that resists reading. Again, we must redial: noise gives way to text, which is repeated on the next page. The play between visible speech and unhearable type posits deafness as a force unto itself, much as the negative space of the page exerts pressure back onto

Figure 3.2
"The Deaf," p. 327.

the body text in "Being There." Deafness produces static, the background against which telephonic communication is born: another beginning in noise. Bell's attempts and failures are presented through disjointed letter-spacing and leading, indicating the halting, stop-and-start progression of technology. Nonsemantic space on these pages becomes integral to semantics as Ronell "situates telephonics within an order of deafness."[61] The telephone, after all, is a result of Bell's failure to make the deaf hear. His

quotations, and M.'s quotations about him, are first set with exaggerated leading.[62] Meanwhile, a paragraph of exegesis is subjected to almost nonexistent leading, ascenders in one line cutting into the baseline above.[63] The chapter ends with more exaggerated leading and indecisive line breaks as Ronell reminds her reader of "the mother's vampiric energy … in storage, left coiled up in the telephone."[64] This feminine, vampiric (or parasitic) energy breaks through the surface of the page, resisting audible articulation.

Such energy marks the figure of Ma Bell, who is present as deafness, as another form of the technological feminine. Her position is compounded by her son's desire to make deafness hear, to successfully call, which, because it requires a listener, is a desire destined to go unsatisfied. (Even her name occupies the space between person and object, standing for both Bell's mother and his corporate assemblage.) Ma Bell also connects back to the telephone as an "invaginated ear," or the "paterno-maternal space of a perforated ear."[65] The ear is the calling apparatus but also the called: the receiver, perforated with holes through which meaning slips, as through the space between words on these pages.

Finally, typography that deliberately invites an image also manifests in the next chapter, "The Bell Nipple," where the oversized curly brackets of "The Nervous Breakdown" reappear as paragraph markers. This time, however, all the curly brackets are closed, perhaps suggesting rough bookends to the book's halves. "The Bell Nipple" relates Bell's obsession with breeding sheep possessing multiple nipples.[66] The nipples are synecdochic with Ma Bell, the nurturing maternity of the telephone. They also locate the moment that maternal signifiers transform into technological ones: "The history of positive technology is unthinkable without the extension of this maternal substance into its technologized other."[67] The curly brackets, overgrown, uncannily recall a breast and nipple. But they also recall the invaginated ear, the telephone as the feminine technological prosthesis. Like the ear, their whorls perforate the text in heavier ink. Speaking to one another across a few hundred pages, these curly brackets suggest the mathematical form of a "fuzzy set," one that is nonbinary and incomplete.

Static, the ghost in the black box of the telephone, haunts the text, from the voices of Miss St. to Watson's séances. "The Bell Nipple" locates ghostliness in the mouth: "We have felt the *parasitical* inclusion of a crypt, always double and doubling, duplicitous like the ear, inhabiting the haunted telephone" (emphasis added).[68] Where there is communication and static, there

is loss, that which can't be communicated. This loss is "a place of absence, where the Other speaks in the absent tense of its many voices, engaging multiple path transmissions of disfigured tracings."[69] The other, "multiple" and "disfigured"—a detachable ear, a prosthetic meant for use—is present as "tracings." It is a Serresian parasite, inherent to communication. It is the space between thing and man, illegible on the page—a technological feminine that revises the terms of its femininity.

De-Black-Boxing Communication and Media

Developing the technological feminine through semantics and nonsemantics, *The Telephone Book* blends elements of gender theory and media theory, collapsing some distinctions and constructing others. Ronell's investigation of the telephone as medium becomes an investigation of medium in general, of the substance and conditions of communications that include technologies like the codex, and of the resulting reflections on how subjectivity is created. Telephonics, then, enter into conversation with communication technology and contemporary digital media at large. At the same time, *The Telephone Book* poses a challenge, or offers a corrective, to the attempts in media theory "to design a system that can simulate all the realized and realizable documentary possibilities—the possibilities that are known and recorded as well as those that have yet to be (re)constructed," as Jerome McGann writes.[70] Contrary to this fantasy of a knowable totality, the illegibility of the technological feminine reminds us that noise can never be eliminated from the system.

Continuing Bell's lineage, in 1948 a Bell Labs mathematician and cryptographer named Claude Shannon published "A Mathematical Theory of Communication" in the *Bell System Technical Journal*. Shannon's work is foundational for communication or information theory, defining "in mathematical terms what information is and how it can be transmitted in the face of noise. What had been viewed as quite distinct modes of communication—the telegraph, telephone, radio and television—were unified in a single framework."[71] Shannon begins a process of separating and distinguishing: meaning is distinct from information, which becomes the subject of communication. Message, likewise, is separate from channel. These edges define the black box, the inheritance of contemporary media theory.

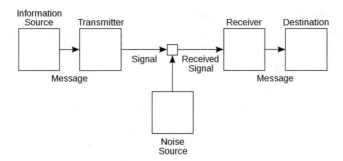

Figure 3.3
Claude Shannon's diagram of a generalized communication system. From *The Mathematical Theory of Communication*. Copyright 1949, 1998 by the Board of Trustees of the University of Illinois. Used with permission of the University of Illinois Press.

Of course, Shannon's theory must account for noise. In his introduction, Warren Weaver characterizes these "unwanted additions [such as] distortions of sound (in telephony, for example) or static (in radio), or distortions in shape of shading of picture (television), or errors in transmission (telegraphy or facsimile), etc. All of these changes in the transmitted signal are called *noise*."[72] The system forms a solid basis, and change is relegated to the status of outsider. This basic status informs literary, as well as technological, ideas of communication: McGann notes that "The vehicle of transmission is thereby sharply distinguished from the 'message,' and textual study devotes itself in the main to the pursuit of channels (and the *idea* of channels) that are free from noise" (emphasis in original).[73] In a context where meaning and information have been neatly divided, information sees noise solely as hindrance, but meaning becomes potentially free to associate with noise. "When we imagine texts as transmitters we are not wrong in our imagination, but we *are* narrow," McGann argues (emphasis in original).[74] Acknowledging noise as potential in the system relaxes the rules for what might constitute interpretation. It also, however, threatens the idea of de-black-boxing, unpacking the contents of a medium or technology and defining its functionality.

"Instead of simply accepting Shannon's five black boxes," media theorist Friedrich Kittler writes, "it seems more important and more rewarding to trace back through history how their evolution must have proceeded in the first place."[75] Kittler takes a historical approach to de-black-boxing communication in *Gramophone, Film, Typewriter*.[76] Beginning with the dictum

that "media determine our situation," *Gramophone* lays the groundwork for a historical survey of discrete moments in technological history, its analysis highly influenced by Michel Foucault (and to a lesser extent by Jacques Lacan and Derrida).[77] For Kittler, according to his translators Geoffrey Winthrop-Young and Michael Wutz, "language is not some nebulous entity but appears in the shape of historically limited discursive practices."[78] These discursive practices are inevitably tied up with military development and issues of power: "The entertainment industry is, in any conceivable sense of the word, an abuse of army equipment," for example.[79] Militaristic power structures enable and produce the technology that, in turn, figures our environments and ourselves. Kittler explores the complex interplay of technology and death in a manner reminiscent of Ronell, where the igniting spark is lit not by Bell but by Thomas Edison. Electricity causes "our realm of the dead [to] withdraw from the books in which it resided for so long," instead seeking "ghostly" shapes through the sound of the phonograph.[80]

However, the "ghostly" shapes of static or noise must be stabilized, assigned to the realm of presence or absence: "The realm of the dead is as extensive as the storage and transmission capabilities of a given culture" writes Kittler.[81] Kittler's intent to situate Shannon's black boxes in a militaristic-technological historical framework includes gender as a factor; in fact, *Gramophone* attempts to correct Marshall McLuhan's agendered technological vision, accusing the "Gutenberg Galaxy" of being "a sexually closed feedback loop."[82] At the same time, under the umbrella of de-black-boxing, Kittler necessarily delimits gender. His argument, expanding what constitutes "media" outward from a McLuhanesque definition, must stabilize these conditions and factors, ultimately treating gender as another black box in its own right. In contrast, *The Telephone Book*, tracing the influences of feminine and ghostly figures on one another, emphasizes their instability rather than relying on gender as a sociological category.

The legacy of Shannon's black boxes also appears across the spectrum of media studies in the work of Wolfgang Ernst, often considered the father of media archaeology. Medium and message can be treated independently of each other, but Ernst considers the medium in an especially substantial way, emphasizing a primary role for technological objects as agents of change. For Ernst, "a medium is defined as the physical passage, or place, that mediates something codified and gets decodified at the other end."[83] Focused on the physical, Ernst's black-box delineation, hewing close to Shannon's own,

runs the risk of what Jussi Parikka calls "hardware-fetishism."[84] Any manifestation of political or social factors, including gender, occupy uncertain positions in such a systemic. Instead, it is in sound, specifically its relationship to archivization, that Ernst finds a telephonics-like space of instability. Acknowledging the historical prioritization of "visible and readable" archive materials, Ernst suggests, "History as a cognitive notion of organizing past data will never be audible but only readable in complex textual argumentation; the historical method will certainly be extended to sonic articulation as well—and even be pushed to its margins."[85] He argues that media archaeology is uniquely situated to explore historical "sonic articulation," accessing not only the symbolic notation of, say, music, but also the "noisy memory" that troubles transmitting channels.[86]

Ernst concludes that noise speaks to materiality rather than the "readable," making materiality "poetical": "The media-archaeological exercise is to be aware of the fact that at each technologically given moment we are dealing with media not humans, that we are not speaking with the dead but dealing with dead media that operate."[87] These modulating shifts in language are worth careful attention. The uncanny term "dead media" assumes an incantatory timbre set against a kind of naïve reading, a Watsonian approach: humans and technology must be distinguished from one another, no matter how interdependent we all may appear. Ernst is wary of prosthetics. As we are charged (slightly paranoically) with remembering, there is no question of séances or "speaking with the dead." But the "poetical" noise—that which is not "visible" or "readable"—persists as a space of possibility. For Ernst, a work like *The Telephone Book* can exist only on the "margins" of the argument, not as a media-archaeological exercise but as a "poetical" one. These margins are also boundaries of the black box, where the technological feminine becomes visible, broadcasting its unreadability.

The technological feminine escapes the black-box definitions and delineations of media theory, even in cases in which media theory and gender are more directly in contact. As gender-technology theorists Mary Flanagan and Austin Booth note, the "utopian myth of a gender-free cyberworld" persists in much media theory and writing on new media, which tends to marginalize or neutralize social factors such as gender, race, and class, as well as associated questions involving access and labor.[88] Donna Haraway's famous figure of the cyborg, a "coupling between organism and machine," sets the tone for many feminist critiques of "utopian myths."[89] Yet the

figure of the cyborg still risks reifying the categories its hybridity relies on. The cyborg resists "organic wholeness," attempting to avoid the dichotomy of masculine-technological and feminine-organic (or its inversion), but the argument's legacy partakes of two categories that, like the black boxes of media theory, must retain their general boundaries for the system to work. In a different context, Flanagan and Booth express a similar caution: "The task at hand, while critiquing old stereotypes, must be to avoid a new kind of essentialism: that is, an essentialism that posits women as 'naturally' akin to multitasking, fluidity, and networks."[90]

Ronell's technological feminine, manifesting as diffuseness and illegibility, certainly avoids the risk of essentialism. On the page, it does not indicate cyborgian hybridity; a more suggestive cue might be found in Haraway's comment, at the end of "Cyborg Manifesto," that "cyborg politics insist on noise."[91] The technological feminine traces how noise structures relationships between technology and the other at rhizomatic microlevels, stressing the mutual interconstructedness of these categories. In doing so, it never arrives at the fully constructed categories of a manifesto. Its diffuse telephonics create ghostly multiplicities that even fall short of a more Irigarayan performance or enactment of gender. Nonsemantics remain illegible.

Meanwhile, new media theory navigates its black-box inheritance, seeking ways to understand the precarious terms that underwrite connection. In *Always Already New: Media, History, and the Data of Culture*, Lisa Gitelman states the problem up front: "In each case, history comes freighted with a host of assumptions about what is important and what isn't—about who is significant and who isn't—as well as about the meanings of media, qualities of human communication, and causal mechanisms that account for historical change. If there is a prevailing mode in general circulation today, I think it is a tendency to naturalize or essentialize media."[92] This essentialism works to maintain the black box's delineations, which have acquired the force of fact through historical convention. Eva Horn also identifies blackbox problems with discussions of media as such: "The notion of 'medium' reduces to a fragile and even ephemeral state of 'in-between-ness,' as much a moment (let alone an object) of separation as of mediation, a moment taken by a virtuality becoming an actuality, a moment of structuring and encoding and thus of the creation of order, but also the source of disruption and 'noise.'"[93] Technology's "objects" are not solid, in Horn's assessment. Their conditions are noisy, noise to which they themselves also contribute.

The term "in-between-ness" suggests an affinity with Ronell's shifting and multiple telephonics, which establish "disruption and 'noise'" alongside order. Horn's title ("There Are No Media") also reminds us of Dworkin's *No Medium*, which characterizes media as entirely socially constituted. The social may not be a factor at all, in these accounts, but the very premise from which technology develops. Investigating the boundaries of the black box, new media theorists who seek the destabilization of media also implicate the destabilization of the system.

Standing some distance from these discussions, Bruno Latour's concept of the black box nonetheless offers insights for both media studies and Ronell's unique telephonics. Latour, whose scholarly work exemplifies fuzzy sets and fluid boundaries, takes aim at "black box" explanations, stressing instead a "tracing of associations" (or the Heideggerian term "gatherings").[94] Such terminology echoes Serres's theory of the parasite, which carefully emphasizes "positions" over "persons," "relations" over "contents."[95] For Latour, a black box "happens when a complex, unique, specific, varied, multiple, and original expression is replaced by a simple, banal, homogenous, multipurpose term under the pretext that the latter may explain the former."[96] Conflicting vectors and mechanics are neutralized inside the black box until the term itself risks a kind of stabilization or nominalization, collapsing many contexts into one. The black box, by definition, reduces and homogenizes.

Latour's explanation takes place in a sociological context, attempting to retrace the associations that give rise to the black box of the "social." He argues that black boxing allows sociology to take the premise as the conclusion: sociology sees a certain narrative directing a case because it seeks that narrative. Sociologists thus cast their results in preset terminology, reducing the complexity of the actual. Latour's actor-network theory (ANT) stresses instead "the tracing of associations" in which the social "does not designate a thing among other things ... but a type of connection between things that are not themselves social."[97] The social is constructed from these associations and their movements.

Replacing the black box with "connections" between disparate, irreducible "actors," which can be living or nonliving, is another way to potentially dismantle the stability of gender or medium.[98] As some writers have noted, ANT's emphases—the tracing of connections, the importance of material objects as actors, and precise description rather than translation into

meta-terminology—speak to points within media theory: Kirschenbaum, for example, mentions ANT's influence in *Mechanisms: New Media and the Forensic Imagination*, and Parikka acknowledges similarities in Latour's and Ernst's "object-centered focus."[99] The associative bonds developed by disparate actors speak to the fluctuating and far-reaching conditions of media, as Gitelman notes: "Protocols express a huge variety of social, economic, and material relationships." Gitelman's "telephony" example includes "the salutation 'Hello?' (for English speakers, at least), the monthly billing cycle, and the wires and cables that materially connect our phones" as actors in the network of the telephone.[100] In *The Telephone Book*, Ronell demonstrates that the telephone as medium is even more disseminated and capacious, spanning philosophy, history, and poetry.

Still, Ronell and Latour depart from one another at a point beyond the irreducibility of so-called black boxes. *The Telephone Book* always incorporates noise—semantically explored, nonsemantically expressed—into its communication system. By contrast, Latour's goal is to explicitly "reassemble the social," a multifaceted viewpoint that reconciles the earlier "dispersion" of the forces creating a coherent object.[101] For Latour, objectivity results from accounting for the plurality of viewpoints.[102] Critically, noise is again erased from a picture in which additional contextualization can ultimately provide a full explanation—a black box transformed into a box of indexed contents. Static must be neutralized.

In explaining its terms, media theory relies on the silencing of noise, seeing static as an impediment to the more critical work of communication without realizing its necessity to that same work. Such a reading of *The Telephone Book*, likewise, might prioritize its textual argument over its design, seeing the latter as mere ornamentation or accessory to the text. Yet this design contributes to the book's meaning nonsemantically, creating a technological feminine directly on the page. As it critiques the processes involved in de-black-boxing, *The Telephone Book* recalls the concerns of media theory and its intersections with gender, partaking in these discussions while refusing to be subsumed under any discourse other than its own. Specific and unique, the illegibility of the technological feminine eludes integration into preexisting narratives and theories. Any attempt to finally de-black-box media and technology, it reminds us, will always fail in the face of static.

4 Mark C. Taylor and Shelley Jackson's Texts of Skin

An often-overlooked part of a book, the front matter of Mark C. Taylor's *Hiding* asks us to linger for a moment on its striking design.[1] After a thick dark endpaper, the first title page printed on the recto displays a title that is partly obscured. Lower-case gray text reads "hi[]ng," where *d*, *i*, and part of the *n* are missing. The title page lodges a silent "din" in the middle of the word, a cunning paradoxical movement—and one that especially resonates with noise—that will play out at length in the book's thematics. The "din" is replaced by a white rectangle in the center of the page, a shape suggesting a representation of the page itself. Already, meaning is produced through material: the white rectangle interrupts reading to remind us of its enabling medium.

Meanwhile, authorial and publication information is withheld until the next spread. Mark C. Taylor, Jack Miles (author of the foreword), and the title appear, this time on the verso inside another white rectangle. Holding the page up to the light reveals identical registration of both rectangles from the head and foot of the page, with sides that differ slightly. While small, this difference is significant, pointedly leaving enough space for the second page to overlap a single letter on the first page: the *i*. The *i* of identity is made precarious; it emerges from the "din" of the page's potentialities, suggesting mysteries that are *Hiding*. Moreover, the emergence of the *i* necessitates touch, a sense common to reading, employed unconventionally to hold the page up to the light. When read at a normal angle, the *i* is lost to view.

Even in these first few pages, *Hiding* is already concerned with how the two-dimensional space of the page appeals to the embodied aspect of reading through nonsemantics. The following pages introduce a riot of color,

abruptly changing typography, and a variety of paper weights and finishes, but these elements always call attention to themselves as what the book's designers designate, in skin-inflected language, "a space for an elaborate typographic tattoo."[2] *Hiding* is a text of skin, in which nonsemantics display across its brilliant surface. What I am calling a "text of skin" has one origin in the link between Deleuze and Guattari's "body without organs" and their "book without organs," both marked as multiple, variable, and nonlinear.[3] While these qualities have been evident throughout all artistic arguments, the text of skin goes further in its antipathy toward a depth model of reading: "All multiplicities are flat," Deleuze and Guattari write.[4] Books without organs are surface texts, moving quickly, skimming from subject to subject across smooth space, making a Deleuzian "voyage in place."

A "book without organs" is an assemblage, in which "a book has only itself, in connection with other assemblages and in relation to other bodies without organs."[5] As assemblage, it is not held together by an overarching theme or *telos*, but instead resists a centralizing or unifying tendency. At the same time, a book without organs emphasizes connection and relation rather than depth and hierarchy. It is distributed, acéphalic in a Bataillean sense, or networked like Ronell's telephonics. Revising the rhizome, *Hiding* develops its own terminology for texts of skin through its "rules of nontotalizing structures that function as a whole," which indicates structures that are distributed, associative, and subject to change.[6] These "nontotalizing structures" help clarify the shape of artistic arguments, inviting comparisons to an internet, with nodes of information and access, rather than a computer with a central processing unit.

Surface-oriented, texts of skin take their status as "assemblage" seriously, reaching beyond print media to more unusual forms. *Hiding*, as well as its accompanying multimedia piece *The Réal, Las Vegas, NV*, released simultaneously, and Shelley Jackson's tattoo story *Skin* (2003) determine in this chapter how texts of skin function. Each piece is designed to challenge the reader: *Hiding* is printed with full bleeds of neon color, different weights of paper, and experimental typography that overlaps, reads sideways, or stretches across the entire spread; *The Réal* is a digital collage of fragmented narratives that utilizes sound and video as well as text and image; and *Skin* is a story tattooed word by word on the skin on 2,095 volunteers, who then assume the title of "words" themselves. These multimedia works are also heterogeneous in content, resisting traditional definitions of genre.

Like other artistic arguments, *Hiding* does not present a single philosophical argument but journeys along many lines of thought which, like a "nontotalizing structure," function as a single book work. *The Réal* is a radically nonlinear pastiche of narratives that refuse to cohere, and *Skin* is an ongoing story event spread out in space and time over several living people.

As artistic arguments, these three works characterize questions of meaning as questions of function. They follow Deleuze and Guattari's suggestion that, for a book without organs, "[w]e will never ask what a book means.... We will ask what it functions with."[7] Especially in the case of texts of skin, a materially specific reading posits an embodied reader, one who responds to the thinness of the paper, the vibrancy of color, or a music sample of a synthesizer, all nonsemantic elements that work by engaging the senses. Texts of skin shift emphasis to the interaction between reader and surface, lending weight to what demands to be looked at, touched, listened to.

Skin is the locus of meaning. Early in *Hiding*, Taylor writes: "If the question of skin and bones is the question of hiding and seeking, and if the question of hiding and seeking is the question of detection, then might the question of skin and bones be the question of the possibility and/or the impossibility of knowledge and self-knowledge?"[8] The structure of "skin and bones" is mirrored in the material form of the book, where the surface of the page continually draws attention to itself rather than allowing us to read through it. The page becomes a skin that signifies both the book's meaning and itself as page to the reader as "detective." (Even the choice of "detection," rather than "reading," speaks to the senses.) *Hiding*'s theory of book structure is also the structure of "skin and bones"—even the old mystery of "self-knowledge," the *i* from those first few pages—and book structure or argument structure is also structure in general: Taylor is fascinated with "dis-covering" (a favorite verb in this book), recalling the "laying bare" associated with Bataille's nonknowledge. For texts of skin, surface assumes a tactical insistence, structuring conceptions of reading, the body, and identity.

Critically, the surface is heterogeneous. As skin, it rehearses multiplicity, a nodal model thickening what may seem like flatness. In *The Five Senses*, Michel Serres, discussing the senses as means of knowledge, provides another anchor for texts without skin. Provocatively, Serres reads the skin as the site of the soul: "Observe on the surface of the skin, the changing, shimmering, fleeting soul, the blazing, striated, tinted, streaked, striped,

many-coloured, mottled, cloudy, star-studded, bedizened, variegated, tor-
rential, swirling soul."[9] The adjectives, doing and undoing themselves in a
progression that also recedes, describe a gently shifting network of skin and
self. Texts of skin exist within this zone of operations. Serres also delicately
links the "cosmic" and the "cosmetic," keeping us on the surface of the
skin. Its makeup is akin to a mesh or membrane, heterogeneous and perme-
able. Skin is not a medium, Serres stresses, but a mixture or a "mingling":
"A medium is abstract, dense, homogeneous, almost stable, concentrated;
a mixture fluctuates."[10] Fluctuation is key to skin, a definition that casts
multiple states as fluid and destabilizes the boundaries separating inside
from outside, self from other.

The corollary to the text of skin is the touch of the reader. Touch is
materially implicated in how we read, as Andrew Piper argues: "Through
the feeling of touch, we learn to feel ourselves. Touch is a form of redun-
dance, enfolding more sensory information into what we see and there-
fore what we read."[11] Piper is specifically referring to the print codex, but
his claim holds across varieties of media and the variations of touch they
engender. In texts of skin, the boundary between text and reader becomes
porous, and considering materiality becomes considering mingling. After
all, it is touch through which "we learn to feel ourselves." Thinking read-
ing or interpretation through embodiment, Brian Massumi asks: "In what
way is the body an idea, and the idea bodily? In what way can probing one
extend the other?"[12] *Hiding* foregrounds reading as embodied through print
nonsemantics, while the digital media of *The Réal* engages the realm of
sound as well as sight through user manipulation. Jackson's *Skin* proposes a
radical simultaneity of the touch of both reader and writer through words
tattooed directly onto the skin. In all cases, these works make us aware of
ourselves as reading bodies, enlisting the senses to draw our attention to
the variabilities of media.

In texts of skin, noise becomes loss, and the material networks of these
works remind us that despite technological advances there is no lossless
network. Loss presents both materially and thematically here, from the loss
of the senses and even the death of the body to the more wide-sweeping
concept of entropy. Entropy—a concept first introduced by Claude
Shannon—posits that lossless information, in which data can be retrieved
and processes reversed, is impossible.[13] Loss is made material in texts of

skin, appearing as black pages, blank screens, and the decay that is associated with the lives of human "words."

In phrasing questions of structure and meaning as questions apposite to skin, the irregularities and malleabilities of texts of skin trouble the ways we tend to look for meaning, returning us to their glittering and noisy surfaces. Here, as for all artistic arguments, nonsemantics cast glitches in the channels between reader and work not as problems but as opportunities for interpretation. They point to how skin is susceptible to the ravages of time; identity, ever changing, bears markings, tattoos, scars. Skin's irregularities, these textual illegibilities, become moments of loss that make apparent the inevitable gaps in the network.

Hiding on the Skin

"We can no longer write merely with words but now must learn how to think and write with images and sound," Taylor insists in a 2004 interview.[14] As Taylor and other visual theorists argue, there is no stable boundary between words and images, where the semantic ends and the nonsemantic begins, because all these elements signify. In their 1994 book, *Imagologies*, Taylor and coauthor Esa Saarinen describe "imagology" as a "media philosophy" that "insists that the word is never simply a word but is always also an image."[15] Accordingly, *Imagologies* explores some of its tenets through its design of high-contrast black-and-white typography, diverse sizes and faces, and digitally altered text that references the digital conditions of its making. This investment in material and design is radically realized in *Hiding*, an assemblage of not only image and text but physical material and, when including *The Réal*, different media.

Hiding was designed not by the publisher, University of Chicago Press, but by an independent agency, 2x4, which had collaborated with Taylor in an earlier issue of *ANY* magazine (1993).[16] The designers declare their decision to "compose the pages to exaggerate the two-dimensional qualities of the relationships rather than create the illusion of depth or transparency. We wanted these pages to be flat."[17] At the same time, the designers integrate "a pastiche of typographic genre; the university press book infiltrated by the newspaper column, the scientific tome, the comic strip, the tabloid, the glossy magazine, the dime novel" to produce a book that "toy[s] with

the structure of traditional academic texts.[18] If "all multiplicities are flat," *Hiding* embraces multiple genres and styles while constantly referencing its own two-dimensionality as a print book. As Jack Miles writes in the foreword to *Hiding*, "To read this book right, you have to read it wrong ... getting lost in what is superficial or merely charming about it—its interesting examples, its striking illustrations, its literary style, the way the print looks on the page."[19] The "superficial" or "merely charming," which, in Miles's description, is deliberately nonsemantic, is the apparent noise to which we must attend.

As the surface of the page branches and proliferates across styles, Taylor's writing, too, attempts to avoid depth. He shifts smoothly from subject to subject, sometimes in a single page: from Hegel to Nietzsche to Tschumi. Subjects vie for space on the page, where they can be typographically set side by side or even overlap. The chapter "Ground Zero," for example, presents an ongoing discussion of Las Vegas, designed around "car and sign," on the top half of pages divided like a highway.[20] Below, Taylor argues that structuralism—also concerned with the sign—is a doomed attempt to "cover [the] ground zero" that is the real nature, ever-changing, of signification.[21] The "pastiche of typographic genre" that Rock and Sellers describe applies also to genre more generally, as Taylor abruptly veers into personal narrative or incorporates text from fashion magazines without attribution, creating sites of mingling. These subjects appear to be shifting metaphors, but they resist the fullness of metaphoricity. The writing, as well as the book's design or materiality, operates like the nerves of skin, expanding to cover many subjects from linked yet differentiated areas without collapsing them into a single argument.

As Taylor reminds us on the final pages, "nothing is hiding."[22] Every component of the book's materiality—from the oversized colophon at the beginning to the white thread that can be glimpsed near the binding—offers itself up for contemplation or manipulation. Following the precept of "imagology," what is readable becomes what is viewable. Rather than a typical list, the table of contents displays the page layout for each chapter, effectively diagramming the shape of the book. As well as process, the book invites us to read the significations of color. Neon colors, used throughout, reflect the Vegas lights of the "Ground Zero" chapter as well as pop-culture advertising, while the ostentatious glossiness of fashion photography is

replicated in the middle chapter, "De-/sign/ing." Aside from the full-color "De-/sign/ing," each chapter is structured around the use of a single color: orange, gray-green, blue, bright green, pink. Subtly linking the first and the final chapters, the pink cover becomes orange when a translucent yellow book jacket veils the book, performing as a visually permeable membrane. Its material is a plastic known as vellum, historically made of calf hide, whose name suggests another play on hiding.

The first chapter, "Skinsc(r)apes," is an especially dramatic display of reading color. It opens with traditional black text on white paper, while a single line of neon orange text that travels across these first spreads suggests an oncoming contamination or explosion. Four black pages abruptly turn out the lights, presenting a background against which neon, as a principle, begins to operate in earnest: "a neon sign ... a sign that is a matter of light ... a sign whose matter is light," reads the text on the last black page.[23] The spread then splits into two sections: black text running head-to-foot, and white text inset horizontally on the recto, against a full bleed in orange. The orange is unevenly patterned on these pages, mimicking

Figure 4.1
Psoriatic spread from "Skinsc(r)apes," pp. 38–39. Reproduced from *Hiding* by Mark C. Taylor by permission of the University of Chicago Press. Copyright 1997 by the University of Chicago.

Taylor's discussion of psoriasis, a disease he describes as a "sign both visible and tactile" for its bearers.[24]

Another blank black spread "cures" the psoriasis, leaving the reader with smooth orange pages. This typographic blackout happens twice more, once as Taylor begins an autobiographical section and once to signify the chapter's end. For the bibliographer, black pages, or mourning pages, recall the tradition of printing a black page *in memoriam*, especially popular in seventeenth-century sermons or verse.[25] For the general reader, they might bring to mind Laurence Sterne's interpretation of the mourning page in *Tristram Shandy* (1759): "Alas poor Yorick!" In "Skinsc(r)apes," Taylor discusses Paul Auster's postmodern mystery *City of Glass* (1985) before relating the deaths of those close to him, including his father and mother.[26] In this context, the black spreads that interrupt the text clearly rehearse a mourning tradition. During a chapter that treats mysteries, death provides the final mystery, presenting the reader with a page on which nothing can be read.

The mottled and mutable paper skin in "Skinsc(r)apes" makes visible *Hiding*'s obsession with tracing skin's histories and variations, even to the point of the unreadable. Pages that "bleed" like skin remind us that the skin's limit is not a hard or discrete boundary, but a mingling with the world. Toward this end, Serres discusses tattooing as another kind of mingling, one that combines sight and touch. This boundary offers an alternative to the often-asserted primacy of the visual, positing identity vis-à-vis touch that "favors topology and geography over geometry."[27] The psoriatic orange pages of "Skinsc(r)apes" suggest interpretation through feel, the "tactile" inscription of disease mirrored on the mottled page.

This malleable space of skin can be marked by the psoriasis of Taylor's "Skinsc(r)apes," but Taylor also directly considers the tattoo in his chapter "Dermagraphics." Extending Serres's line of thought, Taylor treats the skin as text, "a text that can be read if one knows the subtext or decoded if one knows the code."[28] The alignment of semantic content and book design with skin and tattoo feels especially apt in this chapter as, in the designers' words, "the paper gives way to a cheap, thin stock. The verso cannot defend against the recto images bleeding through."[29] Full-page bleeds, which feature prominently throughout the book, are translucent in "Dermagraphics." The layout—images on the verso, text on the recto—remains consistent for the entire chapter, which tattoos the pages with images of

tattoos: "the world's most tattooed man," the Fukushi museum of tattooed skin in Japan, and tribal tattoos.[30] Meanwhile, the tissue-like stock requires the delicate manipulation of fingers, subtly emphasizing our skin as the site of experience. Taylor's earlier claim that it's skin all the way down, "dermal layers that hide nothing ... nothing but other dermal layers," is borne out at a material level.[31] The full-page bleeds in "Dermagraphics" and other chapters seem to implicate the reader, whose fingers leave marks on the lustrous pages. From a production angle, too, full bleeds are the product not only of ink but of trim: oversized sheets are printed and cut down to page size. In *Hiding*, Taylor, a tailor, cuts away a page that bleeds, much as a tattoo artist incises skin and draws blood.

From the perspective of skin, both psoriasis and tattoos are forms of ornamentation or alteration. We tend to think of the body's architecture as a skeleton ornamented by skin, two discrete entities of interiority and exteriority. According to Taylor, the philosophical consequences (or correlates) of this dichotomy have historically reigned. Following Hegel, Taylor points out a tendency to think that "[w]hen philosophically comprehended, truth is purified of all traces of materiality."[32] Yet this supposedly skinless truth itself can be skinned, he argues, revealing further skins. The "flatness" of modernism and its elevation of a purified truth reveals itself as another affect, one that is eventually reassimilated into ornament. Even a well-intentioned "struggle to avoid ornament ends by making the art object itself ornamental," Taylor claims.[33] Serres's link between cosmos and cosmetics is reaffirmed in Taylor's conclusion: "Nothing goes as deep as decoration, nothing goes further than the skin, ornamentation is as vast as the world."[34]

Psoriasis and tattooing, inscriptions on the skin, are also marked by pain. Taylor writes: "What draws in the drawing is loss, radical loss that ends with the loss of self."[35] "Drawing" with ink requires a "drawing" of blood, which gestures toward a broader "loss of self." The skin can be expanded, physically and figuratively, along these lines of loss. From tattooing, "Dermagraphics" further explores the realm of sensation through the work of performance artist Fakir Musafar. Known for hanging from flesh hooks, among other body modifications and mutilations, Musafar writes of an "out-of-body experience" achieved through unbearable pain.[36] Taylor characterizes this acéphalic experience as "A head ... an out-of-body head that roams in a fluid space ... and a fluid time."[37] At the point of extreme pain, skin mingles with world until the boundary between these has disappeared

and sensation becomes identity; a "fluid space and time" overtake language, which falls away with Musafar's "out-of-body head." The "body without organs" returns as well. Deleuze and Guattari characterize the body without organs as a body that undergoes masochistic activities ("sewing and flogging," among others) to be "populated by intensities of pain."[38] The limits of consciousness or selfhood are accessed at the limits of skin.

Flesh hooks hook into the skin, and the rest—mind, body—follows. Serres, too, insists that at this point nothing less than subjectivity is at stake: "The soul inhabits a quasi-point where the I is determined."[39] But this meeting, for Serres, always retains something of the painful, violent, mortal, or dangerous about it, even without the extremity found in Musafar's performance art. Serres maintains that the "I," exposed to danger, finds itself without a need for words, or that "[t]he body knows by itself how to say I."[40] The skin, interfacing world and body, becomes aware of itself as and through feeling. As sensation increases, proximate to danger or even the possibility of death, awareness supersedes language, which is lost.

Taylor connects Fakir Musafar to Stelarc, another artist who takes the body and its boundaries as his subject. Stelarc's projects, including suspensions, bypass the language of escapism to confer interest instead in what Massumi calls "the body as a *sensible concept*" (emphasis in original).[41] As with Serres's "I" found through sensation, Massumi argues that, regarding Stelarc's work, "it was only after the manifestation of the ideas began in the body that they were able to be disengaged enough from it to enter speech and writing."[42] Language, "speech and writing," is premised on the noisy mass of entangled sensations. In Fakir Musafar's bid for an "out-of-body experience," sensation leads to loss of language, while Stelarc's treatment of his body as "sensible concept" attempts to move from sensation to documentation in the form of texts, images, and video. These moments of bidirectional translation emphasize the potential for loss (of language, or, more dramatically, consciousness) inherent in the skin.

Stelarc's work, particularly with robotics, also considers how the body mingles with the technological world to such an extent that we cannot separate subject and object (much like the previous chapter's prosthetics). For Stelarc, the world as information unbinds the body: "The body inhabits a hostile landscape of undigested data."[43] As in reading, the body consumes this data in a mutually affecting exchange. Stelarc's digital prostheses and proto-virtual reality machine call attention to the blurring between

skin and world. Likewise, Taylor sees in "cyberspace" a marked similarity to Musafar's fluid "space-time."[44] The Serresian mingling that characterizes the skin is deeply reminiscent of the body's interaction with the virtual, what Alicia Imperiale, discussing the virtual-body relationship and the fundamentally "unstable" surface of skin, describes as "a series of evanescent overlapping images."[45]

The flickering connection between skin and world, with virtual implications, returns more fully in *Hiding*'s last chapter, "Interfacing," which begins by quoting Paul Virilio: "Each surface is an interface between two environments that is ruled by a constant activity in the form of an exchange between the two substances placed in contact with one another."[46] Here and elsewhere in *Hiding*, Taylor's insistence on surface as substance also emphasizes substance as dynamic, inviting, and promoting change. Virilio's oddly prescient moment also anticipates the digital touchscreen interface, in which touch prompts a change on-screen. The touchscreen interface, as Rachael Sullivan notes, obscures the hardware's forensic materiality while foregrounding an approachable formal materiality.[47] The touchscreen appears as a series of surfaces manipulated by fingers, much as the pages in *Hiding* do. Such mingling, whether the "environments" are digital or print, characterizes interfacing and "Interfacing."

"Interfacing" dramatizes the dynamic temporality of interfacing through its page design. In the preceding chapter, the body text makes room for a white rectangle (another representation of the page) that begins small and progressively enlarges from its prominent position in the middle of the spread.[48] A full ten pages after this spread-in-spread starts, the text of "Interfacing" begins.[49] Or, as the designers put it: "Finally chapter 5, impatient to start 'Interfacing' with the rest, detonates, obliterating the site of 'Ground Zero' [the preceding chapter]."[50] Virilio's "constant activity" produces and destroys—even produces through destroying—a network branching once it's been breached. The page as surface as interface continues to make its presence felt, even after the rectangle that represents the page has been completely incorporated into the main page that we read. Some quotations appear in their own interfaced page spread, which overlays the main spread, a smaller page that is unmistakably a version or alternate of the larger page. Both pages share the same running header and page numbers.[51] Yet the body text on these smaller interfaced pages, contrary to expectations, is larger than the encompassing body text. The larger text size signals that the

Figure 4.2
Interfacing pages in "Interfacing," pp. 266–267. Reproduced from *Hiding* by Mark C. Taylor by permission of the University of Chicago Press. Copyright 1997 by the University of Chicago.

material being quoted should not be considered as sublimated and seamlessly incorporated into the main text. Rather, it insists on the interfacing nature of multiple texts on the page. Simultaneously, other boxes provide splashes of neon pink on the page, interspersed with images of technology and its intersections with the human body. Imperiale's virtual of "overlapping images" feels apt here, further synchronizing the link between digital and print.

In its interfacing pages, "Interfacing" discusses a model of distributed subjectivity, incorporating contemporary philosophy of mind, computer science, and neuroscience. These models, emphasizing the body and mind as ever-changing network, express a Serresian mingling of the body with technology and externality that is the logical extension of the tattoos and flesh hooks of "Dermagraphics," as well as the cyborg aspirations of Stelarc. Such subjectivity is necessarily embodied—and this embodiment, too, is distributed according to the logic of permeable skin. As with the tattoo, there is no proper material which either belongs to the body or lies firmly outside of it. Taylor quotes artificial life pioneer Chris Langton, who stresses

the difference between man and machine as "the logic of organization. *It's not the material.* There's nothing implicit about the material of anything.... Life, in other words, is defined as a property of the organization of matter rather than a property of the matter that is organized" (emphasis in original).[52] Attributing substance to surface, we arrive at a network indefinitely extending. Talking about the body becomes talking about the book, corps and corpus intimately interfacing and mingling through both sensation and thought, reflecting one another. Following Langton, these pages attribute a rhizomatic structure to the structure of life, and, particularly, of the body. Discussing Daniel Dennett's theory of mind, Taylor claims that "the notion of the brain and its operations as centralized and hierarchical is currently as outdated as the claim that mind and body are dualistic opposites."[53] The brain is "structured like a network or web," and even at a microlevel, quantum mechanics offers a potential model.[54] The model of knowledge is accordingly networked, involving bodily or sensory awareness.

As we discuss multiple environments, in which the body mingles with technology and, specifically, with the technology of the book, loss returns as an unavoidable component. Despite our best efforts, loss is present in these interfacing networks, much as it is in the mingling of skin with world. Wherever there is communication, there is static. Taylor examines such loss at a neurological level, where the signaling of neurons is governed by a logic that is continually in flux. What is "incalculable is incommunicable," he determines.[55] As the chapter draws to a close, the text block—that interfaced page that "detonated" and silenced the previous chapter—begins to face pressure from the margins, a rectangle decreasing in size on the printed page. Background and foreground colors, page and interfaced page, flicker back and forth between pink and white until the ever-increasing pink margins force the interfaced page to disappear entirely. The combination of color and margin becomes a persistent but "incommunicable" element, nonsemantically bearing down onto the readable text. Finally static takes over, leaving us with silence at the end of the book.

From Text to Hypertext

"Interfacing," *Hiding*'s final chapter, introduces Taylor's "rules of nontotalizing structures that function as a whole."[56] These include, among others, "association"; "distribution"; "allelomimesis," which signifies coordination

without unification; "nonlinearity"; "emergency"; "volatility"; and "vulnerability."[57] Similar to the qualities of texts of skin, these attributes describe structures that are predisposed to change, emerge from shifting conditions in multiple combinations, and form and dissolve relations without hierarchies. Most broadly, the nontotalizing structure is Taylor's reconfigured concept of the network, one that attempts to ground more traditional deconstructive insights in contemporary contexts. Like skin, this network would link and differentiate the multifaceted, political, aesthetic, uneven real through these rules or attributes.

Hiding's exploration of sensory knowledge has consequences for print and digital work alike. In a context that mingles the boundaries between analog and digital, some of Taylor's rules have clear correlates in digital hypertexts or digital literature. N. Katherine Hayles's nine major aspects of digital hypertexts in "Print Is Flat, Code Is Deep" serve as an illuminating point of comparison. Her first point, "Electronic Hypertexts Are Dynamic Images," describes the beams of light that give digital marks the "illusion of stable endurance through time."[58] This characteristic speaks to Taylor's description of the "volatility" of the network, which is always unstable, promoting "vulnerability." Her third point, arguing that "fragmentation and recombination are intrinsic to the medium," correlates to Taylor's "emergency," or flexibility, as well as "association."[59] Hayles claims that digital hypertexts are also "[m]utable and [t]ransformable," echoing Taylor's "allelomimesis," in which room to "mingle" produces changes in a network.

But a major difference separates these two inventories of the network. For Taylor, print and code are *both* flat. Or to be more precise, depth itself is another mode of flatness. By contrast, Hayles consistently relies on a depth model. As she writes: "Text on screen is produced through complex internal processes that make every word also a dynamic image, every discrete letter a continuous process."[60] In contrast, Taylor points out that oppositions such as internal/external are always "oscillating interfaces that are constantly reconfigured."[61] Hayles's "multiple layers" that underwrite what the user sees on screen are not, in Taylor's view, layers but nodes in a network which are always available for review.[62] Matthew Kirschenbaum's distinction between forensic and formal materiality, referenced earlier regarding the touchscreen, returns in force here. The interface that appears to the casual viewer—what Kirschenbaum terms "formal materiality"—is often thought

of as hiding a deeper level of code, one that is intangible and hopelessly inaccessible. But forensic materiality is a matter of a different perspective, not of depth, available to those who know how to use the tools to read it. Like skin, the forensic materiality of the digital is "a text that can be read if one knows the subtext or decoded if one knows the code."[63] Taylor's non-totalizing structures, characterizing texts of skin, also clarify thinking about digital hypertexts in general.

Keeping in mind Taylor's rules and Hayles's points, we can easily move between print text (*Hiding*) and hypertext (*The Réal: Las Vegas, NV*). Like other artistic arguments, texts of skin, conceived as multiple surfaces, interface with other media. Taylor and artist José Márquez collaborated on *The Réal*, an electronic artist's book published in 1997 and released as a CD-ROM in conjunction with *Hiding*.[64] In an NPR interview on the release of these two works, Taylor refers to *The Réal* as a "complement" to the way *Hiding* "tries to push the book in the direction of a multimedia hypertext," a "pastiche" of genre and design expressed through nonsemantics.[65] *The Réal* unfolds as a scrapbook found buried in a sand-covered Las Vegas of the future. Text, image, sound, and video combine in an immersive experience for the user as multiple stories start and stop in an uneven cadence. The work begins with a video of sand covering the screen, as a voiceover describes how "sand filled every crevice" in an apocalyptic Vegas. Immediately following, another voiceover reminiscent of a recorded interview describes the origins of this digital scrapbook: "We met him in Vegas before the hot sand swallowed it whole. He was a janitor in a roach motel...." Beginning at year one, which is also the razed "ground zero" of catastrophe, the scrapbook both contains remains of this lost time and functions as a kind of Lecerclean remainder to *Hiding*.

From a contemporary perspective, the user interaction with *The Réal* is fairly basic, its interface dramatizing haptic interaction. After the first screens of sand, an image of a book titled "Hotel Registration" appears, designed to save the user's name and location. Beyond this, the interface remains constant: a slot machine that frames a variety of media, with a screen mimicking slot machine symbols (which range from innocent cherries to ominous nuclear symbols) separating each segment, or "room."

Clicking the "You Are Here" icon in the upper right-hand corner triggers dimly flashing lights that show how far you have progressed through the fifty-two rooms of the motel. The main user interaction focuses on feeding coins

Figure 4.3
Screenshot from *The Réal, Las Vegas, NV*, by Mark C. Taylor, Columbia University, and José Márquez, media artist.

from the bottom of the screen into the slot, illuminating the words "Tip" (for blue coins) and "Deal" (for red), which can be selected.[66] The slot machine digitally represents the chance that rules the story—there is no linear option to progress through the scrapbook, which moves randomly. *The Réal* exemplifies Taylor's (and other texts of skins') network considerations of "emergency" and "nonlinearity" as well as Hayles's "fragmentation and recombination." It also frames its media through the dubious machine technology of the slot machine.

This multi-mediation exacerbates the sense of uncertainty surrounding the narrative. Each room introduces snippets of sound, fragments of characters' narratives, and torn newspaper clippings that all interface with one another. The effect is a cryptic, never completely legible artifact, a collection of mingling stories whose connection to one another is never clear. The modality of these media is as variable as the content. The concept of "reverse remediation," in which one medium (typically the digital) simulates another,

confuses our sense of the real. In *The Réal*, reverse remediation often plays with the illusion of depth. Photos are carelessly piled on screen, like a picture of a telephone over one of a standing man whose identity remains a mystery (room 4), or Scotch tape at the corners of other photographs (room 44), while tokens can be glimpsed under a black-and-white farmhouse photo (room 2). Some photos are blurred or obscured almost beyond recognition: what appear, disturbingly, to be handcuffs in room 30; or a washed-out shape that we perceive to be a racket alongside a newspaper clipping referring to tennis (room 28). Room 1 contains an almost biblical news story about wandering in the desert for 40 days before finding the Motel Réal, with a faded advertisement for Excedrin glimpsed on the verso. Pages from a letter to Johny from a cocktail waitress (room 47) pile up on the screen, revealing a blood stain in the process. The plethora of evidence suggests violence in many cases, but the noirish case remains unsolvable, recalling text set by itself on a black spread in *Hiding*: "All clues. No solutions. That's the way things are. Plenty of clues. No solutions."[67]

The Réal is richly auditory, and sound, too, takes many modes. Music or noise accompanies many of the rooms: sometimes old or campy tunes, a plucked bass (room 11), cowboy music (room 18), or a radio show mystery (room 2). Other times the music is electronic, a 1980s throwback that reads as homage to early cyberculture in the context of a late-1990s CD-ROM (rooms 13, 23, 31, 37). The quality of the music varies as well: from noiseless recordings of acoustic instruments to a MIDI organ that plays the beginning of Beethoven's *Für Elise* over and over, always hitting a false note in the same place (room 8). Static is often present, whether in music or in voice recordings, as when the beep of an answering machine precedes a man's nearly unintelligible messages: "This is fucking weird.... Just walked in.... What's going on here? Something's going on ..." (room 48). In room 49, the audio is almost completely blown out, leaving us with an eerie sense as we strain to hear what sounds like a telegram message. As with *The Réal*'s images, we catch only pieces of what is happening, pieces that refuse to be reconciled. It is tempting to seek a narrative in which these pieces are interconnected, but coherency eludes the user. Each piece expresses itself rather than fitting into a larger narrative puzzle; general thematics of loss and instability offer the sole logic.

In addition to this auditory static, loss in *The Réal* takes on another valence as Bataillean loss. For Bataille, loss is an end in itself, excessive

expenditure that is at the root of any economy. If, as Taylor claims, "Vegas is about loss," this is mirrored in "information culture ... [that] entails a certain kind of loss."[68] In room 2, a newspaper headline reads "Bored Billionaire Plays to Lose," with an article about a man who claims that "Losing is sheer ecstasy." Elsewhere a tip reads: "You go to Vegas to learn to lose." The Vegas economy thrives on excessive loss, but *The Réal*'s economy is even stranger, inverted so radically as to create a feeling of weightlessness. In one clipping, a psychic "makes her customers tell all" by reading her own palms for luck (room 12). Another story (room 19) describes an illegal cigar smuggling operation that appears to run from Havana to Vegas but, in a "shocking double cross," the cigars turn out to be made in Nevada before being smuggled to Cuba and smuggled back into the United States.[69] In room 33, we encounter an auctioneer who sells fabricated items from Vegas to people in their original cultures, creating a fiction of a material simulacrum. These economies stray far beyond the point of efficiency or even logical production. Rather, they are thwarted or perverted economies, predicated on excessive, absurd losses of time and energy.

The skin of the slot machine also interfaces with the skin of the user. In *Hiding*, Taylor writes: "As media etch themselves into the flesh, circulatory systems become fiber-optic lines and neural networks become worldwide webs," explicitly linking screen to skin.[70] The didactic tip in Room 46, "Staring at a screen is less productive than staring at a mirror," questions the difference between the two surfaces. The mirror reflects us back to ourselves, providing a mediated image in a closed feedback loop. A screen, though, appeals to the tactile and auditory as well as the visual, opening up the feedback loop to user manipulation and making the boundary between user and work even more porous. It's easy to lose track of oneself in such an immersive situation. Perhaps, *The Réal* cautions, the loss of language or of self that *Hiding* explores is also made possible through experiencing the screen (which is also, here, the soothing repetitions of the slot machine). It may be "less productive," but after all, Vegas is founded on nonproductivity, waste, and excess.

Time, decay, and loss are present as semantic considerations in *The Réal*, but they are also materially present in a way Taylor could not have anticipated. Like its subject matter, *The Réal* requires an excavation from the sands of time into which it has already sunk. Overlooked by the canon of electronic literature, it is not part of any collection and is not the subject

of digital criticism. It can run only on outdated technology, Windows 95 or pre–Mac OS X (PowerPC), which means that running this program, in its most accessible guise, entails finding a computer running Mac 10.4 (or earlier) in order to access Classic. This is a pre-OS X environment or "abstraction layer"—itself a term used to refer to something that abstracts from, or hides, the nuts and bolts of how it works. *The Réal* is, from a forensic perspective, hiding from the contemporary user, a situation that can be remedied only by accessing another mode of hiding. Either way, loss is inevitable in the program, whether measured by a technological yardstick or by the data decay inevitable to all new media.

The Réal is about loss in material or nonsemantic ways as well as semantic ways: the loss of the digital, Vegas's Bataillean economy predicated on financial loss, and the sense of being lost or immersed in media. But, as Taylor insists, "the theme of nothingness runs through a lot of the Motel," and loss also takes on another, more personal dimension.[71] *The Réal* claims that "the secret is that there is no secret" (room 43). Despite the chance operations that structure the experience, though, the last two rooms (51 and 52) are fixed in place at the game's end, and they further complicate the thematics of loss. Room 51, which bears the title "The Secret Family Photo Album of the Motel Réal's Janitor," shows a black screen on which is chalked: "This is what you've been PLAYING for all along." The top of the screen reads: "Hello, my name is Mark C. Taylor." Taylor was fifty-two years old in 1997 (the release year of both *Hiding* and *The Réal*), thus casting each room as a year of his life. In a hypermedia piece concerned with and experienced through excess, the janitor is an unstable *bricoleur*-as-author, collating scraps of waste, remainders, into a scrapbook.

These two final rooms present a meditation on loss in Taylor's own life, in which the play of shifting realities is compounded through a play of identities. Taylor digitally signs the scrapbook-within-a-scrapbook, in which the pictures of the janitor are unmistakably of himself. These pictures center on a specific loss, a Beckettian "unnamable" or nameless that is the death of Taylor's mother. In Room 51, chalked handwriting set to a solo cello laments: "Though I have tried to paint with brushes, sticks with words, nothing clings to the nameless." On this screen, a photo of a grave indicates "Thelma C. Taylor, June 22, 1910–Dec. 20, 1988." Recalling Taylor's description in *Hiding* of his mother in the hospital, "being kept alive by a formidable array of machines," the scrapbook reads: "When she awoke,

the news was not good. I'm sorry … we did everything we could."[72] She died five days before Christmas.

The Réal's earlier investigation of the screen's merits is recontextualized through the loss of Taylor's mother. If despair is the "sickness unto death," as Kierkegaard, one of Taylor's favorite subjects, phrases it, our condition vis-à-vis Vegas might be called diversion unto death, even while diversion turns out to be another form of despair. "This scrapbook was to have made a difference—but it did not. It never does," reads the chalked text. "Distractions do not distract. Diversions do not divert." *The Réal* offers a richly sensory experience to its reader, but at its end an existential nothingness, loss not of the self but of a loved one, qualifies this experience. Taylor, in reaching out directly to the reader, highlights the tension between our position and his, presenting *The Réal* as a work of mourning.

Less, then, that the secret is that there is no secret than that the secret is nothing—that nothing is hiding, that "Nothing makes a difference." This is a substantial or urgent nothingness that makes a difference, too. In Room 52, the final room in the motel, a voiceover articulates: "It's over now. That's it. There's nothing else, nothing more. It has after all only been a game. Even when it seemed to be a matter of life and death … we leave having learned to lose. Disappointed? Why? What were you expecting? We discover that there's nothing to lose because nothing lasts." In the face of diversion or play, *nothing* lasts, outlasting attempts at diversion or entertainment. No photos are present in this room, no images or visuals, only a black screen that mortifies our sense of sight. Death is precisely such overwhelming nothingness.

In *Hiding*, Taylor relates his difficulty producing an essay focused on questions of mortality, which was requested immediately after the death of his mother: "Still suffering from the experience of the preceding weeks, I neither wanted nor knew how to reply."[73] His response ultimately returns to Auster, rewriting *The Invention of Solitude* (1982) with his mother in place of Auster's father. Throughout the resulting essay, "Unending Strokes," Taylor replaces the missing body with bracketed language: "The news of my [mother's] death came to me [two] weeks ago."[74] Being embodied means being subject to loss, which is also the loss of the sayable. Referencing the tomb of Jesus and the nothingness it encloses, Taylor writes: "The gospel according to Mark 'ends' with the silence of three women. 'They say

nothing....' In the wake of death, there is nothing left to say."[75] Where the body disappears, language falls away. "The crypt that renders language cryptic is the crypt of the mother," and it is empty, devoid of language and devoid of a body.[76]

Like the tomb, the pyramid, too, encloses nothing. In *The Réal*, ancient Egypt and modern-day Vegas occupy an unsteady synchronicity. Pyramids as tombs recall *Glas*, which focuses on the crypt of the father rather than of the mother; for both Derrida and Taylor, though, these are empty. The crypt holds "no center, no heart, an empty space, nothing."[77] "How to build a void without avoiding building?," *The Réal* asks. "Ground Zero," the chapter that splits the page in further homage to *Glas*, scrutinizes the pyramid as a "figure of signification" of linguistic knowledge or its possibility. Following Bataille and Nietzsche, however, Taylor ultimately concedes the possibility. The pyramid's tip has been removed, making it another acéphalic figure. Such a move, for Taylor, signifies the irrecoverability of time and the impossibility of any transcendental signifier.[78] What's left is the play of signs, theoretically "unending," around nothingness.

The body or corpus of *The Réal* thus becomes the body or corpse of the mother. Throughout the motel, a story that would unite the nonsemantic elements proves impossible. We are left with the noise of dead ends and excessive waste, the traces of an irrecoverable body. That loss haunts us as we gaze upon the final black screen that recalls *Hiding*'s mourning pages. Embodiment and finally language fall away, leaving us with a ponderous and weighty nothing.

Skin and the Entropy of Material

Taylor's two texts of skin evoke meaning through sensory apperception of their materiality and design as well as semantics. In Shelley Jackson's *Skin* project, the text of skin becomes literalized as a skin of text. Jackson, known for her early hypertext fictions like *Patchwork Girl* (1995) and *My Body* (1997), among other print works, creates an extreme rendition of hypertext fiction in *Skin*, a tattooed story that treats the body as substrate, inscribing its surface. As Taylor locates identity in "dermal layers that hide nothing ... nothing but other dermal layers," one version of *Skin* asks: "Is this who we are, just skin wrapped in skin wrapped in skin?"[79] *Skin* radically exhibits

the qualities of texts of skin, distributed, multiple, and nonlinear. It is also deeply concerned with loss and mortality; as the subtitle on Jackson's website, "Ineradicable Stain," declares, it is "a mortal work of art."

Skin's social circumstances are integral to its content. In *Cabinet* magazine (summer 2003), Jackson published a press release about the work, entitled "Author Announces Mortal Work of Art." This press release describes the structure of the *Skin* project, a story tattooed individually on 2,095 participants who are then themselves referred to as "words." The story in full is made available only to the "words" once they have sent a photo of the tattoo to Jackson.[80] Along with these conditions, *Skin* stipulates particular material and design constraints, such as black ink and a classic book font like Caslon or Garamond. The formal requirements suggest a novel kind of reverse remediation, the resituation or re-presentation of a book typeface on the skin, which solidifies the relationship between skin and paper. Following the modernist tradition that Taylor teases apart in *Hiding*, Jackson refuses ornamentation: "no decorations or embellishments of any kind."[81] Ornamentation is meant in a narrow sense here, "decoration" defined as that which does not linguistically signify. What signifies—the tattoo— forms an intimate relationship with, or on, the skin and self.

Taylor's insistence that "nothing is hiding" assumes a new timbre in *Skin*, which involves itself with the play between what is seen and what is hiding, what is known and unknown. Jackson is clear that the story is available only to the participants: "The text will be published nowhere else, and the author will not permit it to be summarized, quoted, described, set to music, or adapted for film, theater, television or any other medium."[82] For the "words," the story is experienced through the direct contact of ink tattooed on the skin—a story told through bodily feeling. Such contact extends to the social milieu of the "word," viewers who are then able to access a minute part of the story. Outside these strata, however, *Skin* in this form cannot be seen and so cannot be deciphered. We can glean words only from context—provided mostly by the internet—"like letters in words we don't know yet," as one version of *Skin* coyly reads ("Ineradicable Stain"). *Skin* is a tactile story, deeply felt by its participants, but its narrative is invisible or unavailable to outsiders, defined by an excess of distributed inscription that, like other expressions of the remainder, cannot be recuperated.

The question of what is hidden is also the question of what is lost to the potential reader. The tension between what is seen and what is hiding

is replicated even in the documentation that the "words" are asked to provide, which includes "a photograph of the participant in which the tattoo cannot be seen at all," and the constraint that words naming specific body parts must be tattooed anywhere but the corresponding body part. These site-specific rules remind us of Robert Smithson's "non-site," which the artist defines as "a three dimensional logical picture that is *abstract*, yet it *represents* an actual site" (emphasis in original).[83] In other words, the non-site functions as a kind of metaphor, based not on resemblance but on a kind of symbolic logic. Like the virtual, the non-site is "more analogical than descriptive."[84] In Smithson's own work, a non-site exists as a place where the thing which makes it that place has been removed, a sort of spatial paradox. For Jackson, the word that designates, say, "elbow" points to the elbow from its non-elbow position. The word is situated analogically but not representationally: tattoo as non-site. We look for a word in its place, a photograph of an embodied "word" on which the inscribed word cannot be seen, or a word inscribed on its correspondent part, but there is nothing. As in *The Réal*, a coherent narrative hides, here on the human "hides" that form its substrate.

Skin, distributed among several people who are living in time, also dramatizes the fluidity of texts of skin, their susceptibility to change. Because the "words" age, the text is never stable, even at the word level. The story is spread out in space and in time, and the moment of inscription is impossible to pin down. Continually editing itself or rewriting itself at the level of skin, the story also rewrites its own origin as it progresses: Jackson as author replaced by the tattooist, in turn replaced at the moment a recipient identifies as their "word." The boundaries between story and not-story are permeable, authorship a mingled state of being.

Tension also stretches between word and living "word." Conditions stipulate some terms of the piece's form, but each tattoo is individualized both by choice and by default in the context of a unique body. This double movement mimics the doubleness of the Derridean signature: the word inscribed must be separated from the person to be read, even as it relies on this person for (and as) its existence. Context becomes critical and flexible, too, when the words come into contact with one another, as they do in Jackson's online appendix, "Footnotes." Thoughts on words by "words," organized alphabetically, open the words to myriad contexts. These notes range from personal to poetic; they have nothing at all or

everything to do with their denotative definition. "Footnotes" extends Gertrude Stein's "composition as explanation," proposing that inscription is explanation—some words describe the circumstances of their making, or discuss explanations the words give to other people about their tattoos, which may or may not be true. "When the sign becomes embodied, the body becomes a sign," with a sign's accompanying instability.[85]

Despite its claims to take a single form—an idea that seems prima facie impossible, given its medium—part of *Skin* also appears in another guise. In a translation that shifts emphasis from the haptic-visual to the audiovisual, Jackson's video for the Berkeley Art Museum (BAM) recasts the words as or in a new story. In the video, 191 words from the original story read (or are read) aloud a new version. (The video, made available online as a "net art" exhibit from March 1 to May 31, 2011, is currently available on YouTube and on "Ineradicable Stain.") The translation among media recasts *Skin* in the context of what BAM's website calls "post-Internet art," meaning work that "ignores the boundaries of on- and offline and assumes the conditions of networked culture into its content as well as its material makeup." Media mingle, technology encouraging "words" to rearrange in a video or simply commune with one another. *Skin* exemplifies the distributed model proposed by Dennett or Langton in which body and technology network as ever-changing skin. Body of network, network of bodies: exploring the affordances of skin as material, *Skin* speaks to and through the senses to its "words" and their readers, making them aware of their roles in a literally embodied network.

Loss also attends the "mortal work of art." As the press release concludes, "Only the death of words effaces them from the text. As words die the story will change; when the last word dies the story will also have died. The author will make every effort to attend the funerals of her words."[86] The loss of language to which Taylor alludes after the death of his mother, or even the loss of text in *Hiding*'s black mourning pages, finds a particularly idiosyncratic sense of embodiment in Jackson's piece, where the loss of language is the death of living "words." "The funerals of her words" is doubly striking, not only in the sense of these words as alive or dead, but in the sense that they are Jackson's own. Shifting contexts and meanings, *Skin* irrevocably mixes and mingles positions of author, reader, and bearer, while time only brings into sharper focus the impossibility of separating one from another.

In *Skin*'s network, materiality is mortality. For us, as we experience texts of skin through the senses, we become aware of the body as another material. Existing in time, the body is as subject to change, decay, and loss as any material these works utilize. As Smithson's concept of the non-site enhances Jackson's *Skin* project, his concept of entropy further clarifies the relationship of loss to texts of skin.[87] In Smithson's land art works, the land is a nuanced, changeable surface, a Serresian skin, offering itself up for reading. Arguably Smithson's most famous piece, the Utah earthwork *Spiral Jetty* (1970) is "continuous ... even coterminous with the real world"; much like *Skin*, it treats time as "tangible and material reality," according to Jack D. Flam.[88] In "Entropy and the New Monuments," Smithson perceives a fraught relationship between time and art: "Time as decay or biological evolution is eliminated by many of these artists [e.g., Dan Flavin]; this displacement allows the eye to see time as an infinity of surfaces or structures, or both combined, without the burden of what Roland Barthes calls the 'undifferentiated mass of organic sensation.'"[89] Surfaces proliferate as a static "infinity" in Smithson's assessment; in contrast to his own work, "time as decay" is sifted out. Moreover, entropy is inextricable from the "burden" of "organic sensation," which also characterizes Serres's "I"—although not necessarily as a burden. Because it is embodied—even, in a sense, embodiment itself—the "I" is necessary entropic.

Smithson's concept of entropy applies to all material, then: the reading and experiencing "I" as well as the artistic and literary texts it experiences. From this point of view, the architecture of Vegas hotels is doubled in the "sands" and "dunes" of the desert, and *Réal* sand recalls the real sand of non-site artworks. Taylor notes a sensation, upon viewing land art, that "even though the work is undeniably material, the earth itself seems to dematerialize in art."[90] Keeping in mind the entropic conditions of material, we can rearrange this observation more precisely. The earth does not "seem to" but *does* dematerialize, or, to be more precise, irrevocably change state. What we call art (or language, or text) is the material trace or effect of this change. Like the tattoo, land surface is a skin, in which one state is lost only to be replaced by another state. And like all texts of skin, land surface functions according to Taylor's "rules of nontotalizing structures"; it is volatile, vulnerable, and prone to change. Surfaces mingle, which means loss between them is inevitable.

At the site of reading, entropy cannot be read through but references only itself through its material effects. Smithson locates a return to suprematist Kazimir Malevich's "non-objective world" through entropy, a world where "there are no more likenesses of reality, no idealistic images, nothing but a desert!"[91] What, then, does the desert produce? It produces decay, *The Réal*'s scrapbook of waste, or other remainders, which reveal the "crystalline" nature of surface structures.[92] There is no external referent to which entropy refers; it is a vector of slow movement, the readable only traces. Smithson notes: "Beyond the barrier, there are only more barriers.... These façades hide nothing but the wall they hang on."[93] Like Taylor's consideration of "hides that hide nothing but other hides," Smithson conceptualizes the wall that, like the page, is at once a material fact and another in a line of façades.[94]

Entropy suggests an overarching link between loss and the literary or artistic in these texts of skin. Echoing Marinetti's "Futurist Manifesto," Smithson complains that "museums are tombs," which resonates in the context of empty crypts and pyramids that spark endless attributions. By this reckoning, art and language, too, are tombs, "museums of the void" that create monuments around and from nothingness. We attempt to preserve writing from time, but time works on writing that is always material. Alongside the potential for loss of self is the potential for loss of language: black pages, blank screens, or inaccessible stories, a silence as deafening as noise. What is potential becomes inevitable with time. Entropy belongs to both the body and language, the double loss of Jesus's empty tomb to which Taylor points in his work of mourning.

Smithson's "Provisional Theory of Non-Sites" ends with an acknowledgment that its claims, like all claims, are provisional: "Theories like things are also abandoned. That theories are eternal is doubtful. Vanished theories compose the strata of many forgotten books."[95] Both texts of skin and other artistic arguments foreground the changeability of their "nontotalizing structures," suggesting that abandonment is inevitable: the new requires the old from which it can arise. Artistic arguments, with their networked, emergent, fluid surfaces that shift and disintegrate, are all subject to noise and loss, technological obsolescence and the effects of time. Their material qualities make this apparent. As artistic arguments appeal to the senses, we become aware of entropy even as it relates to ourselves, the necessary presence of loss.

Conclusion: The Noise in the Machine

The shape of artistic arguments finds its networked beginnings in the *Da Costa*, its formless heterogeneity "like a spider or spit," and travels to texts of skin, determined by "rules of nontotalizing structures that function as a whole."[1] These shapes allow for a range of nonsemantic significations, whether more formal, like the *Da Costa*'s semisemantic or slipping words, or more material, like the black mourning pages in Taylor's *Hiding*. Nonsemantics posit that artistic arguments, as a category, are driven by self-conscious materiality and function. They suggest that what we tend to think of as argument is, to echo McGann, not wrong but simply narrow, indicating a potential scope of signification well beyond printed words on a page.

In this last chapter, we venture past the boundaries of the argument genre, following the ways artistic arguments work and their investment in nonsemantics, remainders, and noise to two recent artists' books, Johanna Drucker's *Stochastic Poetics* (2012) and Susan Howe's *Tom Tit Tot* (2013). Generally, criticism on Howe's work has been the product of literary scholars, while Drucker's work (perhaps because of her own hybridity as a producer and scholar of new and old media) tends to be the subject of digital or media studies criticism. When brought together, though, these poetic works resonate with each other and with other artistic arguments. If work by Derrida, Ronell, or Taylor begins in theory and migrates to poetics, Drucker and Howe invert this trajectory, beginning with the expressive or explicitly poetic and reminding us of its role in conceptualizing noise. After all, experimental and avant-garde poetics are intimately linked with material specificity. In *Stochastic Poetics* and *Tom Tit Tot*, Drucker's and Howe's codices share similarities through their small-edition, letterpressed format. Highly self-reflexive, these two works also extend from the letterpress to other, more contemporary media. Like other artistic arguments,

they are citational, even heteroglossic; pose challenges to reading through their practically illegible text; and—perhaps more than any other work under consideration here—make arguments about production and reception through their material forms. Taken together, they elegantly sketch the ways in which old media and new continue to inform one another, and provide a last opportunity to contemplate the noise of material.

The "nontotalizing structures" of texts of skin find a literary formulation in McGann's "rules" for textual spaces, areas of heteroglossic activity from which interpretation emerges. "Textual fields are n-dimensional," McGann states.[2] In the rendering of this key word in *Stochastic Poetics*, the concept is appropriately loosed from its original context and set as a stuttered text, its six *i*'s and four *E*'s a motley array of upper and lower cases: "N-diiiiiimEEEEnsiONaL." Thanks to this stutter, we are made to linger on the word as material, its letterform dependent on ink, paper, and impression. Drucker's letterpressed language thus suggests a semantic and material n-dimensionality, its dimension on the page mimicking its meaning, which gains additional nuance due to its borrowed context. Or, to read those "i.e."s back into the text, the word becomes its own exemplar.

As textual fields multiply, interpretation, too, becomes fluid. McGann elucidates how n-dimensionality affects reading: "Every move to reveal or evaluate the record changes the entire system not just in a linear but in a recursive way, for the system—which is to say, the poetical *work*—and any interpretation of it are part of the same codependent dynamic field. Consequently, to speak of any interpretation as 'partial' is misleading, for the interpretive move reconstructs the system, the poem, as a totality" (emphasis in original).[3] McGann's description reconceives the "system" of the work as construed anew in each interpretation, every interpretive act implying a new whole. What is "partial" becomes potential as well as "poetical" in *Stochastic Poetics*, which freely rearranges these terms, producing pages as fields of possibilities rather than equations with a single solution. N-dimensionality also recalls Deleuze and Guattari, who write: "*Flat multiplicities of n dimensions* are asignifying and asubjective" (emphasis in original).[4] Like Bataille's nonknowledge, the asignifying resists productivity and integration under a stabilizing rubric. N-dimensionality seizes on that resistance as Drucker and Howe explore nonsemantics, especially semisemantics, on their pages. Both works argue against the idea of a definitive reading, instead insisting on their status as quantum, constantly being redrawn.

The shape of artistic arguments manifests as n-dimensionality in these two works, which produce an excess of noise on their pages. As in every artistic argument, noise itself is not discrete but indicates a spectrum of meaning. The sites of heteroglossia, citationality, and typography in *Stochastic Poetics* form a continuum defined by the space between stutter, like the multiple *i*'s and *E*'s of "N-diiiiiimEEEEnsiONaL," and noise, illegible clusters of letters on the page. Noise in *Tom Tit Tot* is more spectral, framed as echoes through material remnants of a past time. Both works use clusters of letters out of which readings form and reform; as Serres writes, "Order sometimes comes only from an explosion of noise."[5] Drucker and Howe mine the space between legibility and illegibility, making noise through *paragonnage*, "combining different fonts, sizes, and styles in the same words and sentences."[6] As different threads of thought unspool in different typefaces, writing is never abstract but always staged through artifact and printing.

There is no stable reading on these pages, but these works also self-destabilize through their medial forms. Both artists' books dramatize the process of letterpress, deliberately flaunting its traditional ideals of perfect replication. Howe's letterforms perform brokenness, displaying a manufactured wear and tear that signifies moveable type even as it produces shapes that moveable type does not allow. *Stochastic Poetics* likewise breaks the rules of printing, foregoing the locked-up form that keeps letters stable while printing and enables consistent editioning. Drucker releases the type to move—literalizing the concept of "moveable type"—to create an edition in which no two copies are the same. Moreover, the letterpressed artist's book is only one version of these works, each of which takes other print, digital, and even audio forms. Through their n-dimensionality, *Stochastic Poetics* and *Tom Tit Tot* reprise core attributes of artistic arguments, producing textual fields of noise that span semantics and nonsemantics, materiality and process.

Stochastic Poetics's Stutter and Noise

As its rephrasing of "n-dimensionality" suggests, *Stochastic Poetics* explicitly draws on initiatives Drucker and her colleague McGann developed as part of their SpecLab work at the University of Virginia. The stakes for translation between digital technology and old media pose a central question

for the work, but *Stochastic Poetics* also takes into account more traditional artist's book predecessors like Mallarmé's *Un coup de dés*, which Drucker argues "produces meaning probabilistically."[7] In *Stochastic Poetics*, Mallarmé's "Nothing will have taken place ... except perhaps a constellation" is rearranged to become "Constellationary living / language" and, later, "MOOmeNTARY CoNsTeLLaTiOn."[8] *Stochastic Poetics* exists in this field of "taking-place," forming "constellations" of letters that refuse to resolve into a single interpretation, either within a copy or across the entire edition. *Stochastic Poetics* propels its Mallarméan "probabilistics" into the realm of chaos theory, in which reading emerges from fields of language, proto-Babels, on the page.

Drucker's oeuvre as a hybrid maker and critic comes to bear on this work, her self-professed final letterpress book. Structurally and formally, *Stochastic Poetics* is a clear descendent of earlier Drucker works such as *History of the/my Wor(l)d*, *The Word Made Flesh*, and *Prove Before Laying*, all books in which product strongly implies process. *Stochastic Poetics* is a small-edition codex (thirty-nine copies), 9¾ by 12¾ inches, letterpress-printed on white Mohawk Superfine paper in black ink. The book is unique among her works, though, in that it is what Drucker calls a "completely inconsistent edition" due to its partly locked-up form, which prints inconsistently as pages are run through repeatedly.[9] "Stochastic," from *stokhos* ("aim") in Greek, suggests an ever-moving target—a quantum measure. The book's covers, etched aluminum, echo its quantum interest vis-à-vis the recently invented quantum-logic clock, the world's most precise clock, which relies on an aluminum ion. This quantum-logic clock is self-reflexive, pointing toward the future while questioning concepts like "toward the future."[10] The aluminum covers of *Stochastic Poetics*, meanwhile, signify the particularity of each copy of the book as the output of a given moment in time, and meditate on the ways in which technology shapes understanding.

In "Diagrammatic and Stochastic Writing and Poetics," an essay originating as a talk at the University of Iowa, Drucker asks: "How does poetic language register against the larger field of language practices?" or, alternately, "How does the figure of poetic work emerge from the broader field of linguistic potential?"[11] This "broader field" is riven with noise, which threatens our ability to hear and understand poetry. Her question manifests on the overprinted page as an "active, generative field of language, as a kind of primal mass of letters, [that] creates a randomly moving cloud from

which words emerge and back into which they dissolve."[12] Through these fields of language that amass and "dissolve," *Stochastic Poetics* dramatizes the difficulty of locating a signal in a noise-filled space.

In "The Stutter of Form," Craig Dworkin writes: "Form, when recognized *as such*, is always the stutter of content" (emphasis in original).[13] The necessity of attempting to consider form *as such*, critical to understanding artistic arguments, here reveals a literalizing of semantic content's stutter. Stutter is stochastic: letters repeated within words, words and lines repeated on the page, often overlapping one another. In the first ten pages of *Stochastic Poetics*, for example, line repetitions occur at least five times, and words repeat pages later; the title page is a cloud of letters out of which can be read at least three overprintings of "Stochastic" and six *p*'s that precede "Poetics."[14] Stochastics are scientific, but they are also n-dimensional, routed through more than one theoretical lens, and Drucker brings Aristotle to bear on stochastics as well. Aristotle's dictum of artistic pleasure is based on imitation; still, "if you happen not to have seen the original / the pleasure will be due not to the imitation / but the exEcution, the coloring or other cause."[15] Because there is no, properly speaking, "original" of *Stochastic Poetics*, Drucker's citation slyly winks at Aristotle's decree, suggesting our pleasure must be gotten elsewhere—perhaps in the "exEcution" of the piece that, like an .exe file, is a set of data waiting to be executed by a reader. Aristotle's notion of imitation is put under pressure by the edition's inconsistency, expressed through stuttering repetitions. Language appropriated from Aristotle, Mallarmé, and McGann complicates the concept of stutter by suggesting repetition that goes beyond the page at hand to repeat the words of others. These are a few sources among the many that thread throughout the piece, as the colophon reveals.[16] The text foregrounds this citationality, reconfiguring Aristotelian imitation in an avant-garde or conceptual context. True imitation or repetition, though, that perfect edition, is an illusion: Aristotle's original use of "comedy" and "tragedy," for example, mutate into "levity" and "gravity," the latter of which also assumes the scientific meaning of "gravity" midway through the book. Citation, imitation, and repetition are always being troubled, stutter marking the distance from the original to the stochastic context.

As *Stochastic Poetics* continues, its citational stutter proliferates on the page, creating heteroglossia.[17] In *SpecLab*, Drucker posits "heteroglossic processes" as an alternative to "discrete representations" that presuppose

"static artifacts."[18] In contrast to the idea of language as representational, "heteroglossic processes" arise from quantum functions, implicitly critiquing the idea of a stable referent (an n-dimensional interpretation of the shifting signifiers we see in *Glas* and elsewhere). Heteroglossia—"[e]ach word passed/through many/mouths tongues cross tongues"—translates aural into visual as multiple typefaces vie for attention on the page.[19] The mélange of serif, sans serif, and varying sizes and weights accumulate into typographical cacophony. This accumulation suggests that the sonic dimensions of heteroglossia are inevitably present, especially in light of Drucker's admission that any part of this citational text might be transcribed speech. As well as visual repetition, then, the text often plays with auditory pairs, near-homonyms or rhymes describing a moving target. The first "stochastic poetics" phrase, for example, overprints or is printed over by "scholastic poetics" and then "STOCHASM," which a few pages later morphs into the overprinted "stochasm / slowchasm // stopoem / slowpoem."[20] Sonic-spatial logic constellates these words, in which Mallarméan "constellationary living / language / Each word passed through many / mouths cross tongues" wends its way to "polyvocal corruption / eXploited."[21] The capitalized *X* sticks out of the word like a "cross tongue," while the lines suggest crossed or "corrupted" auditory and graphical word pairs. "Poem," spatialized, becomes a "chasm" or chiasmus (χ) that links and differentiates textual fields.

Heteroglossic stutter reaches a fever pitch as overprinted words vie for space on the page. Dense overprinting, in conjunction with inconsistent alignment and spacing, forecloses any possibility of situating meaning in an unchanging order. Every reader reads differently; as stutter approaches noise, unreadable morasses of text in turn give rise to more reading even within a single reader. Describing a logic reminiscent of Serres, Dworkin notes how "the stutter structures language in two opposing directions, both blocking certain speech and impeding the facile consumption of language, while at the very same time permitting or producing literary compositions based on its formal characteristics."[22] In *Stochastic Poetics*, typographical stutter presents a barrier to reading when it approaches a point of total noise, but it is these clouds of noise that produce "literary compositions," like the poetic or expressive language that characterizes the remainder. Again, the text tells us how to read it: "Noise and confusion. [] Disorienting at first. Unclear agenda." appears near the top of a page; lower on

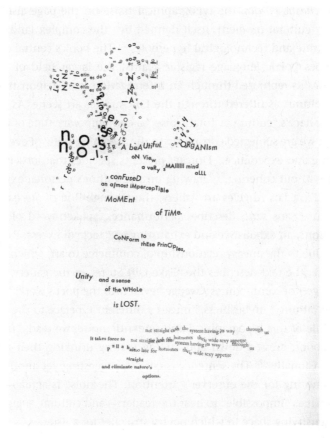

Figure 5.1
"Noise" on p. 45 of *Stochastic Poetics*. Image courtesy of The Poetry Collection of the University Libraries, University at Buffalo, The State University of New York.

the same page, the letters "noise" can be picked out of a small cluster of letters.[23] Slowly the word "noise" begins to coalesce out of this cloud: on page 32 and again on 34, another, smaller cluster contains the same letters. On page 36, as the superfluous letters recede, this cluster has become simply "noi," and our expectation of reading must fill in the blank. What appear at first to be "two opposing directions" are actually two sides of the same movement—the constraint that allows for creativity, the static against which the poetic text communicates. "Disorienting at first," the text is a "slowpoem," slowing down the process central to all artistic arguments and dramatizing communication between the reader and the work.

In *Stochastic Poetics*, the typographical noise on the page also mirrors a specific cultural moment, itself defined by "the complex landscapes of noise culture and technological hyperbole."[24] The book's central question, "How does poetic language register against the larger field of language practices?," is rephrased through an interrogation (and demonstration) of "noise culture" as filtered through the Los Angeles art scene. As in David Foster Wallace's "culture of Total Noise," a contemporary state of existence in which we are subjected constantly to the "seething static of every particular thing and experience," Drucker presents specifics that loosely suggest a scene without cohering.[25] Drawing on the author's personal experiences at L.A.C.E., a Los Angeles art gallery, the through-line of *Stochastic Poetics*, set in a sans serif, describes performances, spoken-word pieces, and installations, an exhaustive and exhausting spectacle of excess. Part of this noise is due to the uneasy relationship of commerce to art, which is also at stake here; the text describes the "Fake Gift Store" of the gallery, how the "swift edge / of commodities / wedge" even into the poet's work: "Poemfliers / mytraining / mybusiness," muses a different typeface to the side.[26] In the middle of this typographical and semantic noise, we read, "the crowd milled about, dressed down and talking texting drinking their attention only occasionally."[27] The sentence is cut off, suggesting yet another diversion clamoring for the observer's attention. The noise is actual—Drucker describes it as "impossible" to hear the readers—and cultural, suggesting an ever-intensifying space in which poetry struggles for a listener.

Yet this same noise is, of course, that which allows for the possibility of communication at all. Noise generates interpretation, a word which, in *Stochastic Poetics*, multiplies into "generative" and "generation," even "genitals."[28] Generation as a concept is multivalent, leading to a big bang of poetics that manifests directly as letters on the page—"fffroM such / poetics / llliife shA11 spRiNG," where the number ones in place of the letter *l*'s suggest a first cause or origin; it also leads to a more suggestive type of bang.[29] Drucker sets up the second valence by oscillating between "stochastic poetics" and "stochastic poetix" or "poetix" near the work's beginning.[30] On page 22, "poetics" repeats in different sizes and weights, producing the mingled text "sxss / sxss / sxss." As a poetics of generation, this is also a poetics of sex. The L.A. line progresses, and a cluster containing "YES" and "sex" is read next to "Blog and hips [] Lips / Blonde in lingerie dress YES / Sex in public on a pool tab[le]."[31] Such Barthesian *plaisir du texte*, in

conjunction with the sense of excess endemic to the art scene, takes on the timbre of spectacle for the viewer. Sex is "in public" and for public consumption, even if it fails to register meaningfully, as in "faking a fake gone flat on the stage."[32] Spectacle and genesis: both begin as, and in, an explosion of noise.

Ghosts in the Archive in *Tom Tit Tot*

Noise in *Tom Tit Tot* draws on a radically different set of materials from that of *Stochastic Poetics*, while obeying a similar set of citational principles. Where Drucker uses bits of transcribed speech to create "noise culture" on the page, Howe turns (as she often does) to the archive in *Tom Tit Tot*, exploring a wide historical range. Her process in creating *Tom Tit Tot* began with cutting and pasting typed lines, photocopying, and refining until the final product, which was then letterpress-printed by the Grenfell Press (which also printed her *Frolic Architecture* [2009] and *The Nonconformist's Memorial* [1992]). Collaborative from its inception, *Tom Tit Tot* is designed by Howe's own daughter, visual artist R. H. Quaytman. Like other artistic arguments, the book's production is distributed across its creators, material through-lines that also manifest in its citationality and its reception across multiple editions and media. Despite the foregrounding of visual as critical, Howe states her concern with both "how it's structured on the page as well as how it sounds."[33] As in *Stochastic Poetics*, sound and noise are entwined with visibility.

Like Mallarmé and his ideal *Le livre*, Howe's relationship to the page insists on its material status without relinquishing the possibility of more transcendental possibilities. She notes that if her work were a painting, "[i]t would be blank. It would be a white canvas. White," professing her interest in the "space of the page apart from the words on it." Similar to Jabès and others' fascination with the blank book, she adds, "I would say that the most beautiful thing of all is a page before the word interrupts it."[34] This sense of the material page is present throughout all of Howe's work, whether scholarly (as in perhaps her best-known critical work, *My Emily Dickinson* [1985]) or poetic (in which an abundance of historical, even local, primary sources are arranged deliberately, often as the centerpiece of a page). As is true for Drucker, the critical and creative mutually inform one another. Howe, who began her career not as a writer but as a visual artist, recalls creating room-sized installations

based on collage, "walls of words" that then moved into book objects.[35] While her page is always precisely composed, the collage techniques that begin in *Singularities* (1990) reach a pinnacle in Howe's later works, such as *Frolic Architecture* and *That This* (2011).

Tom Tit Tot serves as an exemplar among other collage works in that it is Howe's only entirely citational work. Chance, integral to the stochastics of Drucker's *Poetics*, also plays a part in the network of references that compose *Tom Tit Tot*. Its colophon states its "arrangements [are] shaped both by control and by chance," Howe's hand on the die. Besides the dizzying array of source material, most notably Childe Roland, named in the work's bibliography, there is also the titular fairytale, a version of Rumpelstiltskin. In fact, it's chance that produces citation: Howe also recalls "chancing on *Tom Tit Tot*" in the Columbia library.[36] The sense of the library as both source of material and invitation to chance discovery hovers around the engraving at *Tom Tit Tot*'s beginning. "The Temple of Time" is based on an illustration for the book *A Guide to the Temple of Time and Universel* [sic] *History for Schools* (1849) by women's education advocate Emma Hart Willard. The spine of Howe's book is embossed in a gold pattern that echoes the edges of plywood panels Quaytman uses in her work—a spine that references other spines, design indicating material. Meanwhile, the frontispiece's startling color, set against the backdrop of the black-and-white letterpress printing that dominates the rest of the book, suggests a world arising from the diverse books depicted. The image describes a library while also functioning as a sort of conceptual table of contents, suggesting the sources within and emphasizing their visual nature. Different times, spatialized, sit next to one another as texts on the page.

The books that form Howe's material span both original and secondary sources, which are mingled and remediated. Unlike Drucker's fascination with immediacy in *Stochastic Poetics*, which extends to the transcription of spoken words, *Tom Tit Tot* considers only written (published or printed) work. As the frontispiece indicates, it is a book of other books, and it stresses the book as form by treating not just a work's so-called subject but its marginalia, colophon, front and back matter, and even bibliography, what McGann would also certainly consider "overlooked textual material." In working with these secondary, often paratextual, elements of the book, *Tom Tit Tot* makes a subtle argument for treating all language as material

and potentially significant, enacted in text blocks such as "*A document*, the parasitic / [i]nvolve a structure of layer / age placed on top of anoth[er]," where the lines layer on top of one another, new strata for potential reading parasiting from other layers.

The work twines two main threads, those of "Tom Tit Tot" and "The Pied Piper," a tale in which musicality is a source of enchantment. Howe's materials are specific, and her Pied Piper is no exception, finding its source in visual artist Paul Thek's *Personal Effects of the Pied Piper*, an eerie 1975 bronze sculpture of Pied Piper–related pieces, including mice. (It also echoes, faintly, in Howe's foreword to *Debths*, which describes a kind of inverse Pied Piper scenario where Howe's parents leave their reluctant child at a forested camp.) Besides framing the fairytale, Thek's piece enacts an odd recursivity: much like the Piper in the story, the foundry that cast the work never saw payment.[37] In *Tom Tit Tot*, naming the Pied Piper thus calls up this historical path or past, in which material and story constantly exceed their boundaries. What begins as a story quickly escapes to infiltrate its surroundings, much as citations on the page infiltrate and interrupt one another, or the book enacts its ideas through its form, layers that infiltrate other layers of interpretation.

Story is material and material is magic: one snippet of text, obliquely describing a paper fortune-teller in language that recalls its nonlinear structure, refers to "folded pages in accordance with a num[ber] / a friend until a secret fold at the centre is / you will marry, the number of times you." Richard Flood notes that Thek's inadvertent assuming of the Pied Piper mantle would "haunt" him until his death, and ghosts, as well as magic, are everywhere in *Tom Tit Tot*. The piece is in part an homage reverencing the dead, including Thek (whose name, crossed with "pied," surely resounds in the "mottled Theck" that appears in some of the sliced text) and Isabella Stewart Gardner, the Boston collector whose museum provides another source of inspiration for Howe. Combining the spectral with noise, the name of Rumpelstiltskin owes its etymology to *Rumpelgeist*, or "rattle ghost." In contrast to Drucker's linguistic generation, her use of living voices, Howe exhumes the voices of the dead, lingering over printed materials and Thek's and Gardner's many objects. In *Spontaneous Particulars*, she notes a "visionary spirit, [a] deposit from a future yet to come, [that] is gathered and guarded in the domain of research libraries and special collections."[38] The

past and present intermingle, each animating the other, and "spirit" arises from materiality: "the portrait of history in so-called insignificant visual and verbal textualities and textiles. In material details."[39]

Howe's citationality deliberately presents itself as an act of what she calls "spectral telepathy," in which the writer inhabits the space of another, linked by an object. Often, as in *Tom Tit Tot*, the space of telepathy hovers somewhere between the writer and the written, creating a text that inhabits, and is inhabited by, the space of other texts. As Howe argues, archives as "the material—the fragment, the piece of paper—is all we have to connect with the dead."[40] Through these ghostly encounters, the author-collaborator (for these texts become cosigners, much as the designer or printer does) enchants material into speaking.

Marjorie Perloff focuses on this phrase in her essay "Spectral Telepathy: The Late Style of Susan Howe," in which she characterizes *Tom Tit Tot* a "poem as textile," looping back, for us, to *Glas*'s obsession with the connection between *texere* as weaving and as text. Howe has explored collage as epitaph before, especially in *That This*, an elegy for her late husband. In *Tom Tit Tot*, collage triangulates mourning with weaving. Besides the mention of the "underworld," there is more than one mention of "certain Shrouds." The text, shared, is also shroud. In this light, the second image in the book—a black unbound page—reads as another interpretation of a mourning page. Primed by these moments, the third and final image in the book first appears as another shroud before the colophon clarifies it to be a baby sock. A prominent knitting needle, still attached to the sock, points toward violence, ominously linking ghostly rattle to baby rattle.

The ghostly rattle returns us to the sonic dimensions of the visual, and the sonic potential of the archive. As Perloff argues, "The intricate textual threads that hold such disparate items together are sonic as well as visual and semantic."[41] Here, too, the heterogeneous is heteroglossic, including snippets of ancient Greek, Middle English, and mathematical equation. Different typefaces, sizes, even letters, as in *Stochastic Poetics*, stumble across the page. A series of overlapping and abbreviated *T*'s mimic the triple tongue-tripping of the title. Howe even extends the work's aurality directly into the musical realm, collaborating with the composer David Grubbs to produce *WOODSLIPPERCOUNTERCLATTER*, a title that also appears as a word in the book's text. Language can be powerful, magical; in "Rumpelstiltskin," after all, everything depends on the name of the protagonist being spoken. Or,

as Howe immediately notes following the description of the paper fortune-teller: "Name-calling is / MAGIC THROUGH."

The Quantum Mechanics of *Stochastic Poetics*

Stutter, noise, and other sonic dimensions in *Stochastic Poetics* and *Tom Tit Tot* appear through an excess of typography, of potential readings, on the page. Both works proceed somewhat according to the "'patacritical method," Alfred Jarry's concept that Drucker, in *SpecLab*, characterizes as taking "exceptions as rules that constitute a de facto system, even if repeatability and reliability cannot be expected.... The exception will always require more rules."[42] Like new systems that arise from breakages, every exception leads to new constraints that are then revised. Shifting readers and readings mean the system is also always shifting: "It all depends on the position of the observer," writes Serres.[43] Drucker adds: "Every circumstance produces its own logic—as description rather than explanation."[44] Likewise, in *Diagrammatic Writing* (another self-reflexive work), Drucker insists: "Above all the apparently static page must be understood as dynamic."[45] These works draw and redraw their own logics, often with prior language still present, printed over or sliced through, semiarticulate.

Both Howe and Drucker also engage with time's effect on language and media, albeit in very different ways. Where Howe turns to the archive, the shifting systematics of *Stochastic Poetics* are directly related to Drucker's concept of quantum mechanics. At a semantic level, Drucker develops her conception of poetic field as quantum field through appropriated citational texts about chaos theory and gravity. These texts, adding another wrinkle of mediation, are borrowed and altered not from primary sources, as in scientific papers (which, of course, still posit an observer), but from secondary sources for a more general public, such as the Wikipedia entry on chaos theory and a *New York Times* article on theoretical physicist and string theorist Erik Verlinde, who claims that gravity is not a force of its own but a consequence of entropy. (Entropy, so critical to understanding texts of skin, takes on additional nuance in a context that links gravity and the irreversible toppling of moveable type. "Think of the universe as a box of Scrabble letters," the article urges us.)[46] In *Stochastic Poetics*, poetry and chaos are textually interchanged: Wikipedia's "the chaotic motion of a free particle" becomes "Th[e] poEtiiic motiiiiiOn of a free paRticle," for example.[47] A

dense section such as, "While the Poincaré-Bendixson theorem shows that a continuous dynamical system on the Euclidean plane cannot be chaotic, two-dimensional continuous systems with non-Euclidean geometry can exhibit chaotic behavior," becomes, in Drucker's text, "Continuous Dynamical syStems oN ttthe EUCliDian PPPlane cannot be chaoTIII[c]C. oooonLy exhibit beHaviors, [] unless tHey aRe N-diiiiiimEEEEnsiONaL."[48] Here the original is subjected to stutter and echo, the cited text at a distance (like action at a distance or "spooky action," another quantum concept) from the original. The main alteration for us is the key phrase "n-dimensionality," which references the printed chaos from which the reader makes meaning.

Quantum poetics' noise provides a destabilized background against which all readings emerge:

> The figure
> The figure
> The figure
> The figure
> of poETic languAge EmerGes from the general field.[49]

The actor, "the figure" of language, enacts its own emergence through repetition in this moment. Such dramatized emergence marks a double destabilization for both poet and reader, who herself becomes a kind of poet through reading that which contains an element of composition. In *SpecLab*, Drucker, following Humberto Maturana and Francisco Varela's theory of autopoiesis, describes a "codependent emergence between entity and system" and asserts that "the act of reading calls a text into being," much as McGann explains his concept of n-dimensional texts.[50] *Stochastic Poetics* exemplifies a textual field of productive static, in which the text continues to emerge as it is read. In fact, a strong candidate for the first word in *Stochastic Poetics* might be "EMERGING," which emerges from the pages of textual chatter or noise that, alongside the title, open the book.[51] Language emerges from a field, and the book emerges from the page out of a cloud of noise. At times, the letterforms themselves perform this emergence: beginnings of lines are unstable, toppling or toppled over, stabilizing as they continue.[52]

As "the emergent figures / barely cohere against / the competition / of the frenetic ground," these figures—letterforms, readings—resist and resituate gravity or even the grounding of a baseline, recalling Verlinde's provocative hypothesis.[53] The *Times*, paraphrasing Verlinde's theory, states that "gravity

is a consequence of the venerable laws of thermodynamics.... [T]here is something more basic from which gravity 'emerges.'"[54] In Drucker's text, the phrase "the force we call gravity is simply a byproduct of nature's propensity to maximize disorder" itself becomes disordered, unsteadily overprinted four times:

> The force we call GRAVITY is a byproduct of
> nature's propensity to maximize DISORDER,
> LEVITY propels
> and delightens. Nature likes
> options,
> the incident occurs.[55]

Aristotle's terms return here, but gravity is unseated as the more aesthetically pleasing option. Pleasure, instead, is found in "DISORDER," which provides an array of "options" that include "LEVITY." Pleasure also recalls the "sex" through-line; along these lines, it suggests "delightenment" rather than "enlightenment," a slipping or semisemantic word that, in a manner Bataille might approve of, assigns pleasure as the end of the "clearing up" (*Aufklärung*) that is reading.[56]

Under Verlinde's hypothesis, gravity is produced by entropy, "nature's propensity to maximize disorder." Accordingly, Drucker posits that "poetics is thermodynamically irreversible."[57] Viewed from this angle, the entropy of Serres's logic of noise becomes apparent: we focus on the creation of new systems while breakages leave old systems incomplete, half-grafted, failed. The arrow always travels in one direction as it creates new conditions.[58] *Stochastic Poetics* reflects this idea by describing and enacting the Total Noise against which a distinctively contemporary poetic language struggles to make itself heard. The general stochastic rules of this poetic or textual universe yield specifics of time and place, substantiating Drucker's claim that poetry "is fundamentally stochastic along a historical continuum."[59] The fluid dynamic between reader and page, the work as product of its moment of time even as it creates that moment, are exchanges still tending toward entropy.

Production as Poetics

The nonsemantics of these n-dimensional works is present in their collaged citationality and heteroglossia, which cause readings to emerge from their pages. A nonsemantics of production is also at play, and the multiple

Figure 5.2
Spread from *Tom Tit Tot*. Image courtesy of The Poetry Collection of the University Libraries, University at Buffalo, The State University of New York.

readings available on the print page are compounded by other self-reflexive medial forms offering potential readings. *Stochastic Poetics* sets up a network of new media and technology, SpecLab and stochastics, translated or trans-mediated into the "old" media of letterpress printing. *Tom Tit Tot* finds its analog in weaving, the textile that recalls text and shroud, as manifested in collage, lines basted or pasted together on the page. Both works, though, stress the materiality and varying material of language, process marks and visible edits on their pages.

In *Tom Tit Tot*, Howe lets these marks and edits stand. Solid lines suggest words crossed out in the process of revision, while insert marks point to emendations. The first text printed is a mathematical equation from C. S. Peirce's notebooks, itself a kind of semisemantic language, while the first readable line begins, in quotations,

> they are crowded with o
> and reworkings. […]
> Scattered marks and loop
> off words from images twi
> from their original source.

(Like *Stochastic Poetics*, *Tom Tit Tot* is unpaginated, a subtlety that keeps the reader submerged in the time of reading.) These lines suggest an *in medias*

res, referring at once to Peirce's notebooks and to *Tom Tit Tot* itself, a piece that refuses standard beginnings and endings. "Loop" also echoes "lop," as in "lopped off," and "twi" suggests "twining" (as thread, textile or weaving) and "twinned," although neither quite makes sense in this context, which seems as if it should indicate "torn" from original sources. Such a substitution indicates that in place of removing and resituating, we have endless twists and turns of language. To the side, an all-capital "INTRODUCTION" can be gleaned, letterforms sliced along the x axis. In fact, text is often sliced along the x axis in *Tom Tit Tot*, which doubles the kinds of process involved: not only letterpress, but cut-and-paste, as these shapes would be impossible to set using moveable type. (The resulting collages were made into polymer plates, from which the book was then printed.)[60] In addition to the sliced type, *Tom Tit Tot* uses letterforms with ostensible damage—wear and tear associated with old type—that belies their origins: plates, created especially for the book, would print evenly.

Stochastic Poetics, by contrast, relies on activating the "moveable" quality of moveable type. Drucker allows her type to shift and even topple during printing, with the result of a non-self-identical edition, which undercuts letterpress printing's original goal and draws our awareness to the miniscule differences within reproduction. The process of making *Stochastic Poetics* reflects the same quantum concerns present in its semantics: "process is a random field, whose region of domain space a random fun / ction whose / arguments are drawn from a range of continuousLiy changing values."[61] Quantum letterpress—resulting in the fact that "no lines in the book conform to the rules of quadrature that are the fundamental requirements of letterpress"—demonstrates another destabilization of gravity.[62]

Despite their shared use of letterpress printing technology, then, Howe's and Drucker's different attitudes toward composition can be read directly on the page. Both texts forego the stabilizing presence of the baseline, instead presenting lines and words that move at angles. Howe's process, however, assumes more weight prior to printing (the cut-and-paste stage she refers to), while Drucker's process is intimately tied to being at the press. *Tom Tit Tot*'s product implies a braided chain of processes, going back to physical paper text assembled, in turn, from what we might assume are digital printouts, perhaps from scans of old material that was letterpress-printed in its time. Composition as collage feels apt in Howe's case, given the edit lines that run at the unsteady angles of the hand-drawn, and the materials that cut-and-paste requires, whereas Drucker must process individual

letters of her adopted materials through her hand-set type. In these books, new and old media mingle, leaving clues to and traces of their related but distinct histories. What appears to be a simple return to a traditional printing method reveals the method itself to be prone to variation, revealing instabilities in what we consider old and new media.

Tom Tit Tot and *Stochastic Poetics* also signify through other components of their materiality. *Tom Tit Tot* is undoubtedly a fine-press book, with a slipcase, gold tooling on the cover and spine, and thick off-white paper stock. *Stochastic Poetics*, by contrast, displays smudges and other signs of the press shop on its pages, which are standard text-weight paper. The etched aluminum covers that recall the quantum clock also wear down the endsheets, leaving the mark of their brute physical fact on the pages. While aluminum is not part of the alloy used in lead type, here its dullness and thickness recall leading, used in typesetting to space lines of text. It might even contain a reference to rule, which is similar to leading but high enough to print—ironic, in that rules are exactly what Drucker's process breaks. These material differences contribute to muddling classification: at the University at Buffalo, for example, *Tom Tit Tot* is in the rare books collection, while *Stochastic Poetics* (its main title also altered to *Stochastic Poetix*) is labeled as an art object.

The book form of *Tom Tit Tot* also makes a subtle argument about the changing nature of research. Rare books and artists' books often rely on the support of (usually academic) libraries, and *Tom Tit Tot* reflects what is most likely to be its surrounding environment in its material form. Like an ordinary library book, its gold embossed title is set conventionally on the cover, and its binding—green Japanese buckram—deliberately recalls library bookcloth. As one seller notes, buckram is "a very heavy weight and durable book cloth. It is often referred to as 'Library Cloth' because it is used as a cover material for library and heavier books," and it is "well suited for gold stamping."[63] Even the black page, that unbound mourning page, has a small white fingerprint on it: an inversion of the carbon paper it calls to mind, with its tendency to smudge onto fingers.

Howe's attachment to the library is well known. *Spontaneous Particulars* serves as a kind of love letter, in fact, to this institution: "In research libraries and special collections words and objects come into their own and have their place again," she notes.[64] Still, "[a]s they evolve, electronic technologies are radically transforming the way we read, write, and remember. The

Figure 5.3
Spine and cover of *Tom Tit Tot*. Image courtesy of The Poetry Collection of the
University Libraries, University at Buffalo, The State University of New York.

nature of archival research is in flux," due to the ever-emerging digitaliza-
tion of work.[65] Her bibliography in *Tom Tit Tot* (an element found in her
other recent work) recognizes this by its very presence: earlier Howe works,
such as *Singularities*, used source material without signaling its origins.
Because Howe uses a substantial amount of historical documents that are
now in the public domain, the contemporary reader has the option of turn-
ing to the internet to locate at least some of the appropriated sources. The
inclusion of a bibliography, then, signals Howe's acknowledgment of the
changing nature of locating material, even as the book itself is supported
by the presence of the library. This inclusion also has the effect of shifting
the reader's focus away from the work of semantic interpretation, which
might send a reader out of the book or even out of the library, back to the
surface of the page.

Commingling material dimensions, *Stochastic Poetics* and *Tom Tit Tot* describe a range of structural and material affinities and differences that nevertheless organizes itself around noise. Stutter, citationality, heteroglossia on the page create emergent readings. Instability, characterizing reading, also encompasses process and material. Our definitions of media, these works remind us, are also in flux, subject to noise.

The N-Dimensionality of Form

In "The Stutter of Form," Dworkin writes: "When language ... refers back to the material circumstances of its own production, we can hear the murmur of its materials."[66] Under this logic, making process available for reading may be a necessary correlative of any nonreferential use of language—and indeed, Howe and Drucker have both been affiliated with Language poetry of the 1960s to 1970s, which stresses the materiality of language. *Tom Tit Tot* and *Stochastic Poetics* meditate on their processes, mediations that extend into other media. Semantics and nonsemantics, production and reception, create an n-dimensionality of forms.

Both artists' books are also available in places more readily accessible than a rare books collection. While only thirty-nine copies of *Stochastic Poetics* have been letterpress-printed, the book is available, at no charge, as a PDF online at Drucker's own website and as an "ubu edition" at Ubuweb. Given the black-and-white PDF, a contextless reader—one who skips the colophon at the book's end—might well be unaware that the work is letterpress-printed at all, leading us to question: what is the measure of critical difference between this piece as printed and this piece as, say, created with Adobe InDesign? Embracing digital distribution, *Stochastic Poetics* circumvents the problem of access that often plagues artists' books, but it risks sacrificing an awareness of the process on which the text depends. This awareness is critical to our discussion and understanding of the text, but the work's open-endedness means it is impossible to say whether a lack of awareness leads irrevocably to a "wrong" reading, so to speak. In PDF form, *Stochastic Poetics* acknowledges the possibility of being read with a severely curtailed awareness of its medium—read at odds with itself, given the importance of medium to its content.

The edition history of *Tom Tit Tot* is just as nebulous. The *Tom Tit Tot* under discussion here is the Museum of Modern Art book, first exhibited

as a series at the Yale Union in October 2013. There is another *Tom Tit Tot*, however, a group of related poems printed in collaboration with Andrea Andersson. Additionally, some of *Tom Tit Tot* was exhibited at the 2014 Whitney Biennial. Finally, the MOMA book has been released as part of a trade collection, *Debths*, by New Directions in 2017, which also includes other new work. Like *Stochastic Poetics*, the trade edition undoubtedly sacrifices the material impression of the letterpressed MOMA edition. But *Tom Tit Tot*'s main genre-bending, as this inventory suggests, is between the art and literary worlds. *Tom Tit Tot* is treated variously as art object, exhibition, and literary work, without comfortably fitting into any of these categories. Perloff calls it a "differential text," a work for which "there isn't one definitive version"—a term that equally applies to Drucker's work.[67] Perloff also points out that despite its adherence to old technology, "*Tom Tit Tot* could not be what it is without the current possibilities of digital production and distribution."[68] Like *Stochastic Poetics*, *Tom Tit Tot* comments on the accessibilities and limitations of new media while also using it.

Both works also have lives off the page. Perhaps unsurprisingly given texts so obsessed with noise, Drucker and Howe have performed these works, adding another dimension to their forms. Their illegibility poses problems for anything like a straightforward verbal reading. In *Stochastic Poetics*, the thicket of letters on the page may appear the visual measure of aural noise, but the text insists on an unredeemable tension between its terms even while it relies on them. A reading by Drucker at the 2015 &NOW festival at CalArts attempted to capture the spirit of the noise, the author trilling and swooping through the text and maintaining a sense of being off-the-cuff. Howe, by contrast, departs from the text entirely in a much more studied performance in *WOODSLIPPERCOUNTERCLATTER*. A major part of this performance is Grubbs's accompaniment on the piano, framing the audio work as an independent, carefully considered project. As with the composition of the print works, different moments in the performance process bear different interpretive weights.

Noise manifests in many dimensions in Howe's and Drucker's works. At the level of the page, readings emerge out of clouds of text or from within sliced and edited text pieces; at the level of the book, *Tom Tit Tot* is distributed over multiple editions, while *Stochastic Poetics* is not even identical with itself across a single edition. Both pieces work both sides of the so-called print-digital divide during their processes and in their products,

describing a network that includes semantics and nonsemantics, print, digital, and audio. Their multifaceted nature embodies Barthes's "irreducible plural."

Stochastic Poetics and *Tom Tit Tot* offer us another lens through which to consider the shape of artistic arguments, the idea of n-dimensionality. This idea clarifies Bataille's concept of *l'informe*, formlessness, in the context of artistic arguments, and applies Taylor's rules of nontotalizing structures across different media. N-dimensionality captures artistic arguments' collaborative, distributed nature, from the *Da Costa*'s many contributors and phases to Ronell and Eckersley's co-creation to Taylor's digital literature. These pieces forego the idea of a single work or text in favor of a work spread out in space and time, often as a collective enterprise. Considered as single artifacts, they are no less extensively networked, demonstrated by *Glas*'s judases of quotations or Howe's collages from her source material. At the same time, artistic arguments demonstrate their keen investments in intermediality, spanning the visual and aural, and appealing to the senses, treating reading as embodied and experiential. They go beyond semantics to present material noise, which takes the shape of the *Da Costa*'s heterogeneous nonknowledge, Derrida's remains, Ronell's technological feminine, or the entropy and loss present in texts of skin. N-dimensionality allows us to read the nonsemantic as integral to the artistic argument, to read the material noise that escapes semantic argument.

Despite being situated outside the traditional genre of theory, Drucker's and Howe's artists' books explore critical-creative hybridity or mutuality. Posing theoretical arguments about emergent reading and about media, their concerns reflect those of other artistic arguments, suggesting again the malleability of genre. Their work demonstrates that the insights revealed by artistic arguments extend outside simply reading theory. As Drucker maintains, "whatever else it may be, a book is always an argument about what a book is."[69] This holds regardless of genre, which becomes even more tenuous when perceived as a set of functions rather than of identities. Like Lecercle's remainder, artistic arguments point to the "unavoidable return" of noise we tend to ignore.[70] Far from ignoring or suppressing it, in fact, they insist on noise's critical role for communication.

This insistence on noise is the distinguishing factor of all artistic arguments. Moreover, it is their primary insight, as they comment on and critique how their specific media—and the media that it influences—function.

The *Da Costa* appropriates not only the encyclopedic form, but the techniques of the broadside and newspaper, its aim the primacy and possibility of objective knowledge. It also sketches the beginnings of a networked shape of argument, a shape which *Glas* re-forms in its bicolumnar image. This bicolumnar shape provides an opportunity to consider how *Glas* anticipates hypertext, while its remains remind us of hypertext's inevitable limitations. Likewise, Ronell's technological feminine draws attention to the relationship of gender and technology, ultimately pointing at the limits of de-black-boxing technology. Texts of skin, especially Taylor's *The Réal*, foreground the entropy that accompanies technological advancement. Finally, *Stochastic Poetics* and *Tom Tit Tot* survey both old media (letterpress printing) and new media (digital dissemination or digital archive), demonstrating an n-dimensional self-reflexivity about their mingled media.

It's not just new media or old media, but media in general that is unstable, prone to change and fluctuate and prone to noise. But this instability is nothing to resist, even if we could, these works argue. Dworkin writes: "For that idea of the machine to function smoothly and efficiently in turn it must distract our attention from the friction and energy of real machines."[71] We tend to consider mechanization at an idealized level, forgetting that "real machines" break down in unpredictable ways, are altered by entropic and social processes that are constantly changing how they can be used and how we use them. We adapt without realizing it, overlooking how these breakages lead to new systems, which are always emerging from individual constraints and restraints. After all, noise is what makes communication possible. The material noise of artistic arguments reminds us of the chatter of real machines, the rattle within media and archive.

Notes

Introduction

1. Jonathan Rose, "From Book History to Book Studies," Acceptance Remarks of Jonathan Rose for the Society for the History of Authorship, Reading and Publishing (SHARP), American Printing History Association, accessed October 23, 2018, https://printinghistory.org/awards/page/8.

2. Rose, "From Book History."

3. Craig Dworkin, *No Medium* (Cambridge, MA: MIT Press, 2013), 32.

4. Johanna Drucker, *The Century of Artists' Books* (New York: Granary Books, 1995), 1.

5. Drucker, *Century*, 3.

6. Clive Phillpot, "Some Contemporary Artists and Their Books," in *Artists' Books: A Critical Anthology and Sourcebook*, ed. Joan Lyons (Rochester, NY: VSW Press, 1985), 101.

7. Betty Bright, *No Longer Innocent: Book Art in America 1960–1980* (New York: Granary Books, 2005), 3.

8. Keith Smith, *Structure of the Visual Book* (Rochester, NY: Keith Smith Books, 1984), 23.

9. *Book Art Theory* (blog), College Book Art Association, last updated January 1, 2019, https://collegebookart.org/bookarttheory.

10. Susan Viguers, "Does Text-to-Be-Read Belong in the Artist's Book?," *Book Art Theory* (blog), College Book Art Association, September 30, 2015, https://collegebookart.org/bookarttheory/3426333.

11. Levi Sherman, "Book Thinking," *Book Art Theory* (blog), College Book Art Association, December 31, 2015, https://collegebookart.org/bookarttheory/3722798.

12. Bright, *No Longer Innocent*, 257.

13. Electronic Literature Organization online, accessed October 23, 2018, https://eliterature.org/about.

14. Marcel O'Gorman, *E-Crit: Digital Media, Critical Theory, and the Humanities* (Toronto: University of Toronto Press, 2006), xiii.

15. N. Katherine Hayles, "Print Is Flat, Code Is Deep: The Importance of Media-Specific Analysis," *Poetics Today* 25, no. 1 (2004): 69.

16. Hayles, "Print Is Flat," 72.

17. Johanna Drucker, "The Self-Conscious Codex: Artists' Books and Electronic Media," *SubStance* 82 (1997): 93.

18. Johanna Drucker, *SpecLab: Digital Aesthetics and Projects in Speculative Computing* (Chicago: University of Chicago Press, 2009), xi.

19. Manuel Portela, *Scripting Reading Motions: The Codex and the Computer as Self-Reflexive Machines* (Cambridge, MA: MIT Press, 2013), 10.

20. Avital Ronell, "Conversations with Eckersley," in *Remembering Richard: Richard Eckersley as Remembered by His Friends and Colleagues*, ed. Richard Hendel (Lincoln: University of Nebraska Press, 2006), 23.

21. Ronell, "Conversations," 24.

22. Geoffrey H. Hartman, "How Creative Should Literary Criticism Be?," *New York Times*, April 5, 1981, http://nytimes.com/1981/04/05/books/how-creative-should-literary-criticism-be.html.

23. Renée Riese Hubert and Judd D. Hubert, *The Cutting Edge of Reading: Artists' Books* (New York: Granary Press, 1999), 10.

24. Gilles Deleuze and Félix Guattari, *A Thousand Plateaus*, trans. Brian Massumi (Minneapolis: University of Minnesota Press, 1987), 17.

25. Deleuze and Guattari, *A Thousand Plateaus*, 4.

26. Roland Barthes, "From Work to Text," in *Image, Music, Text*, trans. Stephen Heath (New York: Hill and Wang, 1978), 159.

27. Barthes, "From Work to Text," 157.

28. Hayles, "Print Is Flat," 68.

29. O'Gorman, *E-Crit*, 9.

30. Gregory Ulmer, *Heuretics: The Logic of Invention* (Baltimore: Johns Hopkins University Press, 1994), 21.

31. O'Gorman, *E-Crit*, xv.

32. O'Gorman, *E-Crit*, 7; Ulmer, *Heuretics*, xii.

33. Ulmer, *Heuretics*, 48.

34. Ulmer, *Heuretics*, xi.

35. Deleuze and Guattari, *A Thousand Plateaus*, 8.

36. Jean-Jacques Lecercle, *The Violence of Language* (London: Routledge, 1990), 4.

37. Lecercle, *Violence*, 19.

38. Lecercle, *Violence*, 30.

39. Lecercle, *Violence*, 40.

40. Lecercle, *Violence*, 57.

41. Jerome McGann, *The Textual Condition* (Princeton: Princeton University Press, 1991), 13.

42. Charles Bernstein, "Close Listening: Poetry and the Performed Word," in *My Way: Speeches and Poems* (Chicago: University of Chicago Press, 2010), 281.

43. Bernstein, "Close Listening," 281.

44. McGann, *Textual Condition*, 14.

45. McGann, *Textual Condition*, 114.

46. Jerome McGann, "Composition as Explanation," in *A Book of the Book*, ed. Jerome Rothenberg and Steven Clay (New York: Granary Books, 2000), 242.

47. Michel Serres, *The Parasite*, trans. Lawrence R. Schehr (Minneapolis: University of Minnesota Press, 2007), 13.

48. Serres, *Parasite*, 27.

49. Lecercle, *Violence*, 42.

50. Lecercle, *Violence*, 58.

51. Stéphane Mallarmé, "The Book, Spiritual Instrument," trans. Michael Gibbs, in *The Book, Spiritual Instrument*, ed. Jerome Rothenberg and David M. Guss (New York: Granary Books, 1996), 14.

52. Mallarmé, "The Book, Spiritual Instrument," 20.

53. In the *Glas* chapter, I mention especially Derrida's "The Double Session" and "The Book to Come."

54. Artist Klaus Scherubel's *Mallarmé, The Book* produces the Book's cover according to Mallarmé's specifications, while the inside is a blank block of Styrofoam,

cleverly indicating both the Book's material deliberateness and the impossibility of its execution.

55. Maurice Blanchot, "The Book to Come," in *A Book of the Book*, ed. Jerome Rothenberg and Steven Clay (New York: Granary Books, 2000), 141.

56. Blanchot, "Book to Come," 141.

57. Richard Sieburth, "From Mallarmé's *Le livre*," in *A Book of the Book*, ed. Jerome Rothenberg and Steven Clay (New York: Granary Books, 2000), 133.

58. Anna Sigríður Arnar, *The Book as Instrument: Stéphane Mallarmé, The Artist's Book, and The Transformation of Print Culture* (Chicago: University of Chicago Press, 2011), 266.

59. Arnar, *Book as Instrument*, 266.

60. Arnar, *Book as Instrument*, 268.

61. G. E. M. Anscombe and G. H. von Wright, editors' introduction to *Zettel*, by Ludwig Wittgenstein, trans. G. E. M. Anscombe (Berkeley: University of California Press, 1970), v.

62. Anscombe and Wright, editors' introduction, vi.

63. Peter Krapp, *Déjà Vu: Aberrations of Cultural Memory* (Minneapolis: University of Minnesota Press, 2004), 360.

64. Walter Benjamin, *The Arcades Project*, trans. Howard Eiland and Kevin McLaughlin (Cambridge, MA: Harvard University Press, 1999), 460.

65. Richard Sieburth, "Benjamin the Scrivener," in *Benjamin: Philosophy, Aesthetics, History*, ed. Gary Smith (Chicago: University of Chicago Press, 1989), 28, quoted in Marjorie Perloff, *Unoriginal Genius: Poetry by Other Means in the New Century* (Chicago: University of Chicago Press, 2002), 27.

66. Perloff, *Unoriginal Genius*, 27–28.

67. Paul Stephens, *The Poetics of Information Overload* (Minneapolis: University of Minnesota Press, 2015), xi.

68. Stephens, *Poetics*, xv.

69. Craig Dworkin, Simon Morris, and Nick Thurston, *Do or DIY* (York: Information as material, 2012), 15. In private correspondence, Dworkin indicates that "search and destroy" directly references the Bay Area zine of the same name, which eventually became the underground DIY publisher RE/Search.

70. "About," *ON Contemporary Practice*, accessed 23 October 2018, on-contemporary practice.squarespace.com/about. Bataille's influence slyly appears again in Cross's

blog *The Disinhabitor*, where a neon Acéphale figure by artist Cerith Wyn Evans can be discerned in the page's background.

71. Aaron Cohick, *The New Manifesto of the NewLights Press* (Colorado Springs, CO / Baltimore, MD: NewLights Press, 2013), n.p.

72. John Sturrock, "The Book Is Dead, Long Live the Book!," review of *Glas*, by Jacques Derrida, *New York Times*, September 13, 1987, http://nytimes.com/1987/09 /13/books/the-book-is-dead-long-live-the-book.html.

73. Sturrock, "The Book Is Dead."

74. Sturrock, "The Book Is Dead."

75. Robert Coover, "Reach Out and Disturb Someone," review of *The Telephone Book*, by Avital Ronell, *New York Times Book Review*, June 3, 1990, 15.

76. Coover, "Reach Out," 16.

77. Coover, "Reach Out," 16.

78. Mark C. Taylor, quoted in Thomas Rickert and David Blakesley, "An Interview with Mark C. Taylor," *JAC* 24, no. 4 (2004): 807, http://jstor.org/stable/20866657.

79. Rickert and Blakesley, "Interview," 807.

80. Georges Bataille, "Formless," in *Visions of Excess: Selected Writings, 1927–1939*, ed. and with an introduction by Allan Stoekl (Minneapolis: University of Minnesota Press, 1985), 31.

81. Yve-Alain Bois, "The Use Value of Formless," in *Formless: A User's Guide*, ed. Yve-Alain Bois and Rosalind Krauss (New York: Zone Books, 1997), 18.

82. Pierre-Henri Kleiber's *L'encyclopédie Da Costa (1947–1949)* (Lausanne: L'Âge d'Homme, 2014) is the definitive guide and also contains a full bibliography, most of which comprises scattered bibliographic mentions. Longer or more literary read-ings can be found in Alastair Brotchie's introduction to *Encyclopaedia Acephalica*, by Georges Bataille et al. (London: Atlas Press, 1997); as well as Christophe Lamiot's *Eau sur eau: Les dictionnaires de Mallarmé, Flaubert, Bataille, Michaux, Leiris et Ponge* (Amsterdam: Rodopi, 1997).

83. Jacques Derrida, "Between Brackets I," in *Points ... Interviews, 1974–1994*, ed. Eliz-abeth Weber and trans. Peggy Kamuf (Stanford: Stanford University Press, 1995), 17.

84. Avital Ronell, *The Telephone Book: Technology, Schizophrenia, Electric Speech* (Lin-coln: University of Nebraska Press, 1989), xv.

85. Mark C. Taylor, *Hiding* (Chicago: University of Chicago Press, 1997), 123.

86. Taylor, *Hiding*, 326.

87. Johanna Drucker, "Diagrammatic and Stochastic Writing and Poetics," *Iowa Review* 44, no. 3 (2014–2015): 123.

88. Cole Swensen, "Noise That Stays Noise," in *Noise That Stays Noise: Essays* (Ann Arbor: University of Michigan Press, 2011), 3, 6.

89. Swensen, "Noise," 3. Lotman's own use of the term "nonsemantics" indicates for him something much closer to "nonsemiotics," and should be distinguished from my materially oriented use of the term here.

Chapter 1

1. I am indebted to Pierre-Henri Kleiber's singular and indispensable *L'encyclopédie Da Costa* (Lausanne: L'Âge d'Homme, 2014). Note that the facsimiles of the three *Da Costa* fascicles maintain their page numbers in Kleiber, which does not paginate the facsimiles. All translations are my own. Thanks to Kevin Le Blévec for his assistance.

2. Georges Fragerolle, "Le fumisme" in *L'Hydropathe* (May 12, 1880), quoted in James Martin Harding, *Contours of the Theatrical Avant-Garde: Performance and Textuality* (Ann Arbor: University of Michigan Press, 2000), 18.

3. Alastair Brotchie, introduction to *Encyclopaedia Acephalica*, by Georges Bataille et al., ed. Alastair Brotchie (London: Atlas Press, 1997), 12. Compiled from work by Bataille, Michel Leiris, Marcel Griaule, Carl Einstein, and Robert Desnos, the *Encyclopaedia Acephalica* collects the first *Da Costa* fascicle and some works from the "Critical Dictionary" and elsewhere.

4. Kleiber, *L'encyclopédie*, 176. The second fascicle's first entry is "Anonymat," giving a name to the unnamable and describing the earlier work as "intransigent" and "insolent" or arrogant. Here, the second fascicle promises, signatures will be appended where necessary—although some of these signatures turned out to be false regardless; see Isabelle Waldberg, Robert Lebel, Marcel Duchamp, Maurice Baskine, Francis Bouvet, Henri Pastoureau, Pierre Mabille, and René Chenon, *Mémento universel Da Costa I*, reprinted in Kleiber, *L'encyclopédie*, 1.

5. Georges Bataille, *Inner Experience*, trans. and with an introduction by Stuart Kendall (Albany, NY: SUNY, 2014), 58.

6. Bataille, *Inner Experience*, 33.

7. Bataille, *Inner Experience*, 35.

8. Gwen Allen, *Artists' Magazines: An Alternative Space for Art* (Cambridge, MA: MIT Press, 2011), 1. There is some interpretive room between the terms "little magazine" and "artists' magazine"; here, I will stick to the latter as more appropriate.

9. Brotchie, introduction, 22.

10. Kleiber, *L'encyclopédie*, 89.

11. Cited in Kleiber, *L'encyclopédie*, 168.

12. Bataille et al., *Encyclopaedia Acephalica*, 155, 130; Waldberg et al., *Mémento universel Da Costa I*, reprinted in Kleiber, *L'encyclopédie*, 6.

13. Kleiber, *L'encyclopédie*, 113.

14. Kleiber, *L'encyclopédie*, 115.

15. Kleiber, *L'encyclopédie*, 174.

16. Allen, *Artists' Magazines*, 2.

17. Kleiber, *L'encyclopédie*, 331–335.

18. Kleiber, *L'encyclopédie*, 334–335.

19. Denis Diderot and Jean le Rond d'Alembert, "Preliminary Discourse," in *The Encyclopedia of Diderot and d'Alembert: Collaborative Translation Project*, University of Michigan, accessed October 24, 2018, https://quod.lib.umich.edu/d/did.

20. Christophe Lamiot, *Eau sur eau: Les dictionnaires de Mallarmé, Flaubert, Bataille, Michaux, Leiris et Ponge* (Amsterdam: Rodopi, 1997), 38.

21. Lamiot, *Eau sur eau*, 12.

22. Lamiot, *Eau sur eau*, 13.

23. Lamiot, *Eau sur eau*, 22.

24. Lamiot, *Eau sur eau*, 55.

25. Kleiber, *L'encyclopédie*, 231.

26. Kleiber, *L'encyclopédie*, 260.

27. Contemporary examples of what we might call lexicographical writing also abound, especially in avant-garde writing and Language or post-Language poetry; some of the more well-known might include writing by Vito Acconci, Bernadette Mayer, Harryette Mullen (e.g., *Sleeping with the Dictionary*), and Gertrude Stein (*Tender Buttons*).

28. Cited in Kleiber, *L'encyclopédie*, 167, 160–161.

29. Quoted in Kleiber, *L'encyclopédie*, 161.

30. Quoted in Kleiber, *L'encyclopédie*, 219.

31. Quoted in Kleiber, *L'encyclopédie*, 222.

32. Kleiber, *L'encyclopédie*, 162.

33. All quotations from the *Cadavre* issues are from the online archives of the Bibliothèque Nationale, Paris, accessed March 1, 2019, at https://catalogue.bnf.fr /ark:/12148/cb42690412r and https://catalogue.bnf.fr/ark:/12148/cb36275034h. (Translations are my own.)

34. Georges Bataille, "The Psychological Structure of Fascism," in *Visions of Excess: Selected Writings, 1927–1939*, ed. and with an introduction by Allan Stoekl (Minneapolis: University of Minnesota Press, 1985), 140–141.

35. Bataille, "The Use Value of D. A. F. de Sade," in *Visions of Excess*, 96.

36. Brotchie, introduction, 22.

37. Kleiber, *L'encyclopédie*, 257–258.

38. Kleiber, *L'encyclopédie*, 93; Bataille et al., *Encyclopaedia Acephalica*, 148.

39. Bataille, *Inner Experience*, 24.

40. Bataille et al., *Encyclopaedia Acephalica*, 116.

41. Waldberg et al., *Mémento I*, reprinted in Kleiber, *L'encyclopédie*, 6.

42. Bataille et al., *Encyclopaedia Acephalica*, 140; Bataille, "Psychological Structure," 140.

43. Kleiber, *L'encyclopédie*, 184.

44. Bataille et al., *Encyclopaedia Acephalica*, 122.

45. I am grateful to Samuel Johnson's 1755 dictionary for this definition.

46. Stéphane Mallarmé, "The Book, Spiritual Instrument," trans. Michael Gibbs, in *The Book, Spiritual Instrument*, ed. Jerome Rothenberg and David M. Guss (New York: Granary Books, 1996), 20.

47. Mallarmé, "The Book, Spiritual Instrument," 20.

48. Mallarmé, "The Book, Spiritual Instrument," 20.

49. Bataille, "Formless," 31.

50. Bataille, "Formless," 31; Bataille et al., *Encyclopaedia Acephalica*, 51.

51. Bataille, "Formless," 31.

52. Bataille et al., *Encyclopaedia Acephalica*, 124.

53. Bataille et al., *Encyclopaedia Acephalica*, 122.

54. "For the fly fallen in ink, the universe is a fly fallen in ink, but, for the universe, the fly is the absence of the universe, a small cavity deaf to the universe and in

which the universe is lost to itself" (Georges Bataille, "The Absence of God," in *The Unfinished System of Nonknowledge*, ed. and with an introduction by Stuart Kendall [Minneapolis: University of Minnesota Press, 2001], 104).

55. Michel Serres and Bruno Latour, *Conversations on Science, Culture, and Time*, trans. Roxanne Lapidus (Ann Arbor: University of Michigan Press, 1995), 65.

56. Serres and Latour, *Conversations*, 65.

57. Bataille et al., *Encyclopaedia Acephalica*, 116–119.

58. Bataille et al., *Encyclopaedia Acephalica*, 147, 25.

59. Bataille et al., *Encyclopaedia Acephalica*, 170 n61.

60. Bataille et al., *Encyclopaedia Acephalica*, 114.

61. Bataille et al., *Encyclopaedia Acephalica*, 128.

62. Bataille et al., *Encyclopaedia Acephalica*, 146.

63. Bataille et al., *Encyclopaedia Acephalica*, 114.

64. Bataille et al., *Encyclopaedia Acephalica*, 114–115.

65. Bataille et al., *Encyclopaedia Acephalica*, 137.

66. Bataille et al., *Encyclopaedia Acephalica*, 115.

67. Bataille et al., *Encyclopaedia Acephalica*, 141.

68. Bataille et al., *Encyclopaedia Acephalica*, 141.

69. Bataille et al., *Encyclopaedia Acephalica*, 150.

70. Bataille et al., *Encyclopaedia Acephalica*, 113.

71. Isabelle Waldberg, Robert Lebel, Marcel Duchamp, Maurice Baskine, Gabriel-Louis Pringué, Jacob Böhme, Yvonne Voyron, J.-M. Charcot, and V. Magnan, *Mémento universel Da Costa II*, reprinted in Kleiber, *L'encyclopédie*, 8.

72. Bataille et al., *Encyclopaedia Acephalica*, 116.

73. Bataille et al., *Encyclopaedia Acephalica*, 110.

74. Georges Bataille, *L'apprenti sorcier: Textes, correspondances et documents* (Paris: Éditions de la Différence, 1999), 517, quoted in Kleiber, *L'encyclopédie*, 117.

75. Bataille et al., *Encyclopaedia Acephalica*, 129.

76. Bataille et al., *Encyclopaedia Acephalica*, 129.

77. Bataille et al., *Encyclopaedia Acephalica*, 129.

78. See "George Auriol et l'écriture typographique," accessed January 8, 2019, http://histoire.typographie.org/auriol/george-auriol.html. I am grateful to Amelia Hugill-Fontanel for help identifying this typeface.

79. Kleiber, *L'encyclopédie*, 167; Brotchie, introduction, 19. Brotchie also quotes Édouard Jaguer telling a different version with the same punchline, 27 n41.

80. See Bonnie Jean Garner's fascinating "Duchamp Bottles Belle Greene: Just Desserts for His Canning," *Tout Fait: The Marcel Duchamp Studies Online Journal* (May 2000), http://toutfait.com/issues/issue_2/News/garner.html. Garner, in turn, references Stephen Jay Gould's suppositions about the wordplay (more slipping signifiers and remainders!) that links Greene and Rrose.

81. Kleiber, *L'encyclopédie*, 237.

82. Bataille et al., *Encyclopaedia Acephalica*, 123.

83. Emanuel Mendes da Costa, preface to *Elements of Conchology, or, An Introduction to the Knowledge of Shells* (London: Benjamin White, 1776), iv, https://www.biodiversitylibrary.org/page/12926446.

84. Bataille et al., *Encyclopaedia Acephalica*, 109.

85. Bataille, *Inner Experience*, 42.

86. Bataille, *Inner Experience*, 227.

87. Bataille et al., *Encyclopaedia Acephalica*, 109.

88. In correspondence with the author, professor Howard Horwitz points out that Duchamp's "impossible problem" isn't actually impossible but is technically a draw.

89. Bataille et al., *Encyclopaedia Acephalica*, 100, 110.

90. Bataille et al., *Encyclopaedia Acephalica*, 113.

91. Kleiber, *L'encyclopédie*, 177.

92. Kleiber, *L'encyclopédie*, 184.

93. Kleiber, *L'encyclopédie*, 225.

94. Bataille et al., *Encyclopaedia Acephalica*, 87.

95. See, e.g., David Hopkins's "Duchamp, Childhood, Work and Play: The Vernissage for *First Papers of Surrealism*, New York, 1942," *Tate Papers* 22 (autumn 2014), n.p.

96. Bataille et al., *Encyclopaedia Acephalica*, 124.

97. Bataille et al., *Encyclopaedia Acephalica*, 112.

98. Bataille et al., *Encyclopaedia Acephalica*, 112.

99. Bataille et al., *Encyclopaedia Acephalica*, 113.

100. Bataille, *Inner Experience*, 47.

101. Waldberg et al., *Mémento II*, reprinted in Kleiber, *L'encyclopédie*, 2.

102. Waldberg et al., *Mémento II*, reprinted in Kleiber, *L'encyclopédie*, 3.

103. Waldberg et al., *Mémento II*, reprinted in Kleiber, *L'encyclopédie*, 8.

104. Waldberg et al., *Mémento II*, reprinted in Kleiber, *L'encyclopédie*, 9.

105. Waldberg et al., *Mémento II*, reprinted in Kleiber, *L'encyclopédie*, 11.

106. Waldberg et al., *Mémento II*, reprinted in Kleiber, *L'encyclopédie*, 7–8.

107. Bataille, *Inner Experience*, 57.

108. Waldberg et al., *Mémento II*, reprinted in Kleiber, *L'encyclopédie*, 11.

109. Bataille, *Inner Experience*, 57, 24.

110. Waldberg et al., *Mémento II*, reprinted in Kleiber, *L'encyclopédie*, 11.

111. Brotchie, introduction, 16.

112. Friedrich Nietzsche, *Beyond Good and Evil*, trans. Walter Kaufmann (New York: Vintage, 1966), sec. 268, quoted in Bataille, *Inner Experience*, xxi n37.

113. Bataille, *Inner Experience*, 31.

114. Bataille, *Inner Experience*, 31.

115. Georges Bataille, *Oeuvres complètes*, vol. 5 (Paris: Gallimard: 1973), 483, quoted in Bataille, *Unfinished System of Nonknowledge*, xl.

116. Stuart Kendall, introduction to *Inner Experience*, xxxix, xli.

117. Kendall, introduction, xviii.

118. Brotchie, introduction, 22.

119. Bataille, "Socratic College," in *Unfinished System of Nonknowledge*, 17.

Chapter 2

1. See *Remembering Richard: Richard Eckersley as Remembered by His Friends and Colleagues*, a posthumous tribute curated by Richard Hendel in 2006 and published at the University of Nebraska–Lincoln, for more on Eckersley's life and (considerable) work, especially his role in bringing distinction to the University of Nebraska Press.

2. John P. Leavey, Jr., "This (then) will not have been a book ... ," in *Glossary* (Lincoln: University of Nebraska Press, 1986), 32.

3. Gayatri Chakravorty Spivak, "*Glas*-Piece: A *Compte Rendu*," *Diacritics* 7, no. 3 (1977): 22–43.

4. Spivak, "*Glas*-Piece," 25.

5. Peter Krapp, *Déjà Vu: Aberrations of Cultural Memory* (Minneapolis: University of Minnesota Press, 2004), 122.

6. Jacques Derrida, "Between Brackets I," in *Points ... Interviews, 1974–1994*, ed. Elizabeth Weber and trans. Peggy Kamuf (Stanford: Stanford University Press, 1995), 17.

7. Jacques Derrida, *Glas*, trans. John P. Leavey, Jr., and Richard Rand (Lincoln: University of Nebraska Press, 1986), 43b. I follow convention in using *a* and *b* to denote, respectively, left-hand and right-hand columns. All subsequent references are to this edition unless noted otherwise.

8. Stéphane Mallarmé, preface to "*Un coup de dés*," reprinted in *Collected Poems*, translated and with a commentary by Henry Weinfield (Berkeley: University of California Press, 1994), 121.

9. Marcel O'Gorman, *E-Crit: Digital Media, Critical Theory, and the Humanities* (Toronto: University of Toronto Press, 2006), 9.

10. O'Gorman, *E-Crit*, 11.

11. Geoffrey H. Hartman, *Saving the Text* (Baltimore: Johns Hopkins University Press, 1982), 16.

12. "Le bon plaisir" broadcast on France-Culture, quoted in Benoît Peeters, *Derrida: A Biography*, trans. Andrew Brown (Cambridge, UK: Polity, 2013), 257.

13. Krapp, *Déjà Vu*, 124.

14. Krapp, *Déjà Vu*, 200 n37.

15. Peeters, *Derrida*, 258. Peeters also notes that the original manuscript has been lost, which takes on an odd significance given *Glas*'s fascination with the empty tabernacle (256).

16. Krapp, *Déjà Vu*, 122.

17. Differentiation is a critical question here: according to Leavey, Eckersley even considered printing one or both books in two overlaid colors (red and blue), which would have required the reader to wear 3D glasses to disentangle. See John P. Leavey, "Translation/Citation: An Interview with John P. Leavey, Jr.," by Dawne McCance, *Mosaic* 35 no. 1 (2002): 9.

18. Leavey, "Translation/Citation," 9.

19. Leavey, *Glossary*, 34.

20. These two columns maintain their allegiance to their subjects, with one exception, where Hegel intrudes into Genet's column with a quotation from the *Critique of Judgment* on art and freedom (Derrida, *Glas*, 218b). This is set as a short (less than a page) judas.

21. Derrida, *Glas*, 1b.

22. Leavey, *Glossary*, 33–42.

23. Johanna Drucker, *Diagrammatic Writing* (Banff Art Centre: Creative Commons, 2013), 15–17.

24. Drucker, *Diagrammatic Writing*, 20.

25. Derrida, *Glas*, 6a.

26. Leavey, *Glossary*, 37.

27. Leavey, "Translation/Citation," 8.

28. Freud is implicit, especially, in the discussion on circumcision and castration (*Glas* 41a onward); Saussure in *Glas*, 90b–97b, and also present in the "SA" that obsesses the text, a (Hegelian) signature of *savoir absolu*, "absolute knowledge."

29. Derrida, *Glas*, 149b–160b.

30. Derrida, *Glas*, 188a.

31. Derrida, *Glas*, 220b–221b. Excrement is constantly referred to in the text. Genet "shits" at the shifting signifier of his name, e.g., 36b. Another moment describes the prisoners around the can of shit in *Miracle of the Rose*: "the glory of solid excrement raised in the incorporeal song" (38b). The song's incorporeality suggests the ring of the *glas*.

32. Derrida, *Glas*, 15b; Georges Bataille, "Formless," in *Visions of Excess: Selected Writings, 1927–1939*, trans. and ed. Allan Stoekl (Minneapolis: University of Minnesota, 1985), 31.

33. Derrida, *Glas*, 71b.

34. Derrida, *Glas*, 219b.

35. Derrida, *Glas*, 219b.

36. Derrida, *Glas*, 62b.

37. Derrida, *Glas*, 63b.

38. Derrida, *Glas*, 69b.

39. Derrida, *Glas*, 105a.

40. Derrida, *Glas*, 191b.

41. Derrida, *Glas*, 72a.

42. Derrida, *Glas*, 125b–126b.

43. "What does the band say? The following: BOUND/TO TAKE OFF." (Jacques Derrida, *Signéponge / Signsponge*, trans. Richard Rand [New York: Columbia University Press, 1984], 148.)

44. Derrida, *Glas*, 23b.

45. Derrida, *Glas*, 22b.

46. "All of philosophy has no other goal: it is a matter of giving a frock coat to what is, a mathematical frock coat," Bataille complains in "Formless," 31.

47. Derrida, *Glas*, 192b.

48. Derrida, *Glas*, 1a–1b.

49. Derrida, *Glas*, 1b.

50. Derrida, *Glas*, 49b–52b. Derrida derives this specific moment from the Littré, which takes the form of a judas.

51. Derrida, *Glas*, 28b.

52. Derrida, *Glas*, 32b.

53. Krapp, *Déjà Vu*, 125.

54. Derrida, *Glas*, 23b.

55. Derrida himself was also published by *Tel Quel* around this time, in an issue that contains an essay on Bataille. Wilson notes that Derrida was part of the group angling to publish Genet's "Ce qui est resté." See Sarah Wilson, "Rembrandt / Genet / Derrida," in *Portraiture: Facing the Subject*, ed. Joanna Woodall (Manchester: Manchester University Press, 1997), 203–216.

56. Derrida, *Glas*, 43b.

57. Derrida, *Glas*, 190b.

58. Derrida, *Glas*, 4b.

59. Derrida, *Glas*, 4b.

60. See also Leavey's "The Name of the Father" section in "This (then) … ," 51–57.

61. Derrida, *Glas*, 185b.

62. Spivak, "*Glas*-Piece," 25.

63. Derrida, *Glas*, 79b.

64. Derrida, *Glas*, 79b.

65. Derrida, *Glas*, 41b. Derrida later mentions Saussure's approach to proper names in *Anagrams*, which "starts their decomposition, destroys their singular integrity as proper names," as "superior" to Saussure's usual practice (95b).

66. Derrida mentions Genet's *L'Atelier d'Alberto Giacometti* (particularly, *Glas*, 80b). Also see Wilson's "Rembrandt / Genet / Derrida" for more on the intersection of Genet, Giacometti, and *Glas*.

67. Derrida, *Glas*, 2a.

68. Derrida, *Glas*, 3a–3b.

69. Derrida, *Glas*, 3b.

70. Derrida, *Glas*, 11b.

71. Derrida, *Glas*, 75b.

72. Derrida, *Glas*, 210b.

73. As mentioned, the French original and the English translation are nearly identical; the front matter discussed here is specific to the UNL edition, however.

74. Derrida, *Glas*, 140b.

75. Derrida, *Glas*, 141b.

76. Edmond Jabès, "Letter to Jacques Derrida on the Question of the Book," in *The Book of Margins*, trans. Rosmarie Waldrop (Chicago: University of Chicago Press, 1993), 43.

77. Edmond Jabès, "Extract from a Speech (Given on April 21, 1982, in Paris, at the Foundation for French Judaism)," in *The Book of Margins*, 174.

78. Jean-Bernard Moraly, "Ce qui est resté d'un Rembrandt déchiré en petits carrés bien reguliers et foutu aux chiottes, ou La critique selon Genet," in "Littérature et enseignment," special issue of *Le Francais dans le monde* (February–March 1988): 109 n10, as quoted in Wilson, "Rembrandt / Genet / Derrida," 212. The layout also suggests a medieval manuscript with marginalia, or a polyglot text, even a polyglot Bible that incorporates Hebrew and Latin or Greek. "While keeping an eye on the corner column (the contraband), read this as a new testament," Derrida suggests (*Glas*, 113b).

79. Derrida, *Glas*, 49a.

80. Derrida, *Glas*, 49a.

81. Derrida, *Glas*, 84a.

82. "Edmond Jabès and the Question of the Book" in Jacques Derrida, *Writing and Difference*, trans. Alan Bass (London: Routledge, 1978), 92.

83. "Cleaving" also recalls Imre Hermann and his idea of "clinging to," on which (and on whom) Derrida focuses in "Between Brackets I."

84. Derrida, "Edmond Jabès and the Question of the Book," 81.

85. Maurice Blanchot, "The Absence of the Book," in *The Station Hill Blanchot Reader: Fiction and Literary Essays*, ed. and trans. Lydia Davis (Barrytown, NY: Station Hill, 1999), 481.

86. Derrida, "Edmond Jabès," 81.

87. Derrida, "Edmond Jabès," 87.

88. There is an echo of Derrida in Hegel's reading of Egyptian pyramids, for him the epitome of symbolic art: "The sign—the monument-of-life-in-death, the monument-of-death-in-life ... the hard text of stones covered with inscriptions—is the *pyramid*." (Derrida, *Margins of Philosophy*, trans. Alan Bass [Chicago: University of Chicago Press, 1982], 83.)

89. Derrida, *Glas*, 43b.

90. Derrida, *Glas* (Paris: Denoël/Gonthier, 1981), vol. 1, 189.

91. Catherine Clément, "Le sauvage," *L'Arc* 54 (1973): 1.

92. Clément, "Le sauvage," 2.

93. Clément, "Le sauvage," 2.

94. Clément, "Le sauvage," 2. See also note 88 in this chapter on "the hard text of stones."

95. Derrida, "Glas," *L'Arc* 54 (1973): 11.

96. Derrida, "Glas," *L'Arc*, 13; Derrida, *Glas*, 14b.

97. Derrida, *Glas*, 118b–120b.

98. Derrida, *Glas*, 121b–123b.

99. Renée Riese Hubert, "Derrida, Dupin, Adami: 'Il faut être plusieurs pour écrire,'" *Yale French Studies* 84 (1994): 255–257.

100. Jacques Derrida, "+R (Into the Bargain)," in *The Truth in Painting*, trans. Geoff Bennington and Ian McLeod (Chicago: University of Chicago Press, 1987), 181, 150.

101. Also see Derrida, "+R," 167.

102. Derrida, "+R," 157, 161.

103. Derrida, "+R," 167–168. This statement is not technically true, if you consider "(PARANTHESIS)" [sic], *Glas*, 124.

104. Drucker, *Diagrammatic Writing*, 19.

105. Derrida, "+R," 168.

106. Hubert, "Derrida," 242.

107. Hubert, "Derrida," 243.

108. Hubert, "Derrida," 257.

109. Jacques Derrida, "The Book to Come," in *Paper Machine*, trans. Rachel Bowlby (Stanford: Stanford University Press, 2005), 15.

110. Aaron Cohick, *The New Manifesto of the NewLights Press* (Colorado Springs, CO / Baltimore, MD: NewLights Press, 2013), n.p.

111. Norbert Bolz, "The Deluge of Sense," 1993, accessed February 26, 2019, http:// museum.doorsofperception.com/doors1/transcripts/bolz/bolz.html.

112. J. Hillis Miller, "Literary Theory, Telecommunications, and the Making of History," in *Scholarship and Technology in the Humanities*, ed. May Katzen (London: British Library, 1991), 11–20, quoted at http://hydra.humanities.uci.edu/derrida/blurbs .html.

113. George Landow, "What's a Critic to Do? Critical Theory in the Age of Hypertext," in *Hyper/Text/Theory*, ed. Landow (Baltimore: Johns Hopkins University Press, 1994).

114. Gregory Ulmer, *Applied Grammatology: Post(e)-Pedagogy from Jacques Derrida to Joseph Beuys* (Baltimore: Johns Hopkins University Press, 1984), 303.

115. Starre is citing Landow's argument in George Landow, *Hypertext 3.0: Critical Theory and New Media in an Era of Globalization* (Baltimore: Johns Hopkins University Press, 2006), 66; in Alexander Starre, *Metamedia: American Book Fictions and Literary Print Culture after Digitization* (Iowa City: University of Iowa Press, 2015), 11.

116. Derrida, "Paper or Me, You Know … ," in Derrida, *Paper Machine*, trans. Rachel Bowlby (Stanford: Stanford University Press, 2005), 47.

117. Mark Poster, *The Mode of Information: Poststructuralism and Social Context* (Chicago: University of Chicago Press, 1990), 100.

118. Poster, *Mode of Information*, 110.

119. Krapp is quoting Michael Ryan; Krapp, *Déjà Vu*, 130. This latter perspective in fact is the focus of Krapp's entire chapter, which, taking *Glas* as case study, considers our tendency to read new media either as completely inaccessible and intangible or as a recapitulation of old media.

120. Krapp, *Déjà Vu*, 128.

121. Geoffrey Bennington, *Jacques Derrida* (Chicago: University of Chicago Press, 1993), 14.

122. Peter Krapp, "Colophon," Hydra, University of California–Irvine, last modified February 19, 2009, http://hydra.humanities.uci.edu/colophon.html.

123. Geoffrey Bennington, "Expositioning Hypertextuality," Derridabase, University of California–Irvine, last modified February 13, 2009, http://hydra.humanities.uci .edu/derrida/base.html.

Chapter 3

1. Avital Ronell, *The Telephone Book: Technology, Schizophrenia, Electric Speech* (Lincoln: University of Nebraska Press, 1989), 11.

2. Ronell, *Telephone Book*, 353.

3. Ronell, *Telephone Book*, 350.

4. Ronell, *Telephone Book*, 351.

5. Ronell, *Telephone Book*, 351.

6. Laurence A. Rickels, "Take Me to Your Reader," in *Reading Ronell*, ed. Diane Davis (Urbana: University of Illinois Press, 2009), 63.

7. Michel Serres, *The Parasite*, trans. Lawrence R. Schehr (Minneapolis: University of Minnesota Press, 2007), 10.

8. Serres, *Parasite*, 15–16.

9. Serres appears only once, as a ghostly presence in *The Telephone Book*'s endnotes. See Ronell, *Telephone Book*, 438 n108.

10. Martin Heidegger, "The Question Concerning Technology," trans. William Lovitt, in *Basic Writings*, ed. David Farrell Krell, rev. ed. (San Francisco: HarperCollins, 1993), 325.

11. Heidegger, "Question Concerning Technology," 323.

12. Martin Heidegger, "The Origin of the Work of Art," trans. Albert Hofstadter, in Krell, *Basic Writings*, 147.

13. Ronell, *Telephone Book*, 208–209.

14. Ronell, *Telephone Book*, 207.

15. Ronell, *Telephone Book*, 213.

16. Serres, *Parasite*, 79.

17. Anne Waldschmidt, "Disability Goes Cultural: The Cultural Model of Disability as an Analytical Tool," in *Culture—Theory—Disability: Encounters Between Disability Studies and Cultural Studies*, ed. Anne Waldschmidt, Hanjo Berressem, and Moritz Ingwersen, Disability Studies (Bielefeld: Transcript Verlag, 2017), 24.

18. Waldschmidt, "Disability," 25.

19. David Mitchell and Sharon L. Snyder, *Narrative Prosthesis: Disability and the Dependencies of Discourse* (Ann Arbor: University of Michigan Press, 2000), 160.

20. Mitchell and Snyder, *Narrative Prosthesis*, 3.

21. Mitchell and Snyder, *Narrative Prosthesis*, 6.

22. Ronell, *Telephone Book*, 3.

23. Richard Eckersley, memo via Carolyn Einspahr to Joan Sampson, December 8, 1988, University of Nebraska, composition and repro specifications for one new title, THE TELEPHONE BOOK by Ronell. In the Richard Eckersley Archives, University of Nebraska–Lincoln.

24. Ronell, *Telephone Book*, 61, 255, 81.

25. Michael Jon Jensen, "About the Making of *The Telephone Book*," in *Remembering Richard: Richard Eckersley as Remembered by His Friends and Colleagues*, ed. Richard Hendel (Lincoln: University of Nebraska Press, 2006), 29.

26. Ronell, "Conversations," in *Remembering Richard*, 23.

27. For pilcrows, see the third call in the chapter "Priority Call #1." The tiny black boxes are used throughout the chapters "Derrida to Freud: The Return Call," "The Case of Miss St.," and "Birth of a Telephone: Watson—Dead Cats." Eckersley refers to these black boxes as "typographic representations of circuits" (quoted in Jensen, "About the Making," 34). Space in the middle of a line marks paragraphs in the latter half of the chapter "Delay Call Forwarding." Highlighted and italicized text does the same throughout "The Televisual Metaphysics." Lines extending in from the left margin are used in "The Tuning Fork."

28. Ronell, *Telephone Book*, 84.

29. Ronell, *Telephone Book*, 95.

30. Ronell, *Telephone Book*, 97.

31. Ronell, *Telephone Book*, 103.

32. Ronell, *Telephone Book*, 98.

33. Ronell, *Telephone Book*, 109.

34. Ronell, *Telephone Book*, 109.

35. Ronell, *Telephone Book*, 109–110.

36. Ronell, *Telephone Book*, 111–115.

37. Ronell, *Telephone Book*, 111.

38. Ronell, *Telephone Book*, 111.

39. Ronell, *Telephone Book*, 34–35.

40. Ronell, *Telephone Book*, 122.

41. Ronell, *Telephone Book*, 123.

42. Ronell, *Telephone Book*, 125.

43. Ronell, *Telephone Book*, 228.

44. Ronell, *Telephone Book*, 231.

45. Ronell, *Telephone Book*, 237.

46. Ronell, *Telephone Book*, 239.

47. Ronell, *Telephone Book*, 241.

48. Ronell's figure of the poet links R. D. Laing's schizophrenic Julie and Heidegger's Trakl. For the poet, like the schizophrenic operator, listening precedes speaking. Listening here implies the voice of an absent friend, speaking from beyond (the grave). See the chapter "The Call of the Colon" in *Telephone Book*.

49. Ronell, *Telephone Book*, 226.

50. Ronell, *Telephone Book*, 252.

51. Ronell, *Telephone Book*, 228.

52. For the original transcription, see *Alexander Graham Bell Laboratory Notebook, 1875–1876*, World Digital Library, accessed November 28, 2017, www.wdl.org/en /item/11375/.

53. Ronell, *Telephone Book*, 251. Jensen relates his "delight" at producing a "little program" to create this effect for the book (Jensen, "About," 31).

54. Ronell, *Telephone Book*, 259.

55. Ronell, *Telephone Book*, 276.

56. Ronell, *Telephone Book*, 302.

57. Ronell, *Telephone Book*, 309.

58. Ronell, *Telephone Book*, 331.

59. Ronell, *Telephone Book*, 315.

60. Ronell, *Telephone Book*, 316.

61. Ronell, *Telephone Book*, 328.

62. Ronell, *Telephone Book*, 328–329.

63. Ronell, *Telephone Book*, 331.

64. Ronell, *Telephone Book*, 335.

65. Ronell, *Telephone Book*, 334–335.

66. Ronell, *Telephone Book*, 337.

67. Ronell, *Telephone Book*, 340.

68. Ronell, *Telephone Book*, 340.

69. Ronell, *Telephone Book*, 340.

70. Jerome McGann, "From Text to Work: Digital Tools and the Emergence of the Social Text," *Romanticism on the Net*, nos. 41–42 (2006), www.erudit.org/revue/ron/2006/v/n41-42/013153ar.html.

71. Graham P. Collins, "Claude E. Shannon: Founder of Information Theory," *Scientific American*, October 14, 2002, www.scientificamerican.com/article/claude-e-shannon-founder.

72. Warren Weaver, introduction to Claude E. Shannon and Warren Weaver, *The Mathematical Theory of Communication* (Urbana: University of Illinois Press, 1964), 8.

73. Jerome McGann, *The Textual Condition* (Princeton: Princeton University Press, 1991), 11.

74. McGann, *Textual Condition*, 14.

75. Friedrich Kittler, "The History of Communication Media," *CTheory* (1996), www.ctheory.net/articles.aspx?id=45.

76. Ronell mentions Kittler three times in *The Telephone Book*'s endnotes. The most robust of these references appears in the note mentioning Serres: Ronell focuses on a paragraph in *Gramophone, Film, Typewriter* in which Kittler ties Nietzsche to "white noise," another moment revealing her own preoccupation with noise. See Ronell, *Telephone Book*, 436 n108.

77. Geoffrey Winthrop-Young and Michael Wutz, translators' introduction to *Gramophone, Film, Typewriter*, by Friedrich A. Kittler (Stanford: Stanford University Press, 1999), xxxix.

78. Winthrop-Young and Wutz, translators' introduction, xx.

79. Kittler, *Gramophone, Film, Typewriter*, 96.

80. Kittler, *Gramophone, Film, Typewriter*, 10.

81. Kittler, *Gramophone, Film, Typewriter*, 13.

82. Kittler, *Gramophone, Film, Typewriter*, 184.

83. Jussi Parikka, "Archival Memory Theory: An Introduction to Wolfgang Ernst's Media Archaeology," in *Digital Memory and the Archive*, by Wolfgang Ernst, ed. Jussi Parikka (Minneapolis: University of Minnesota Press, 2013), 19.

84. Parikka, "Archival Memory Theory," 9.

85. Wolfgang Ernst, "Toward a Media Archaeology of Sonic Articulation," in Ernst, *Digital Memory*, 172.

86. Ernst, "Toward a Media Archaeology," 174–175.

87. Ernst, "Toward a Media Archaeology," 183.

88. Mary Flanagan and Austin Booth, introduction to *Reload: Rethinking Women and Cyberculture*, ed. Flanagan and Booth (Cambridge, MA: MIT Press, 2002), 588.

89. Donna Haraway, "A Cyborg Manifesto: Science, Technology, and Socialist-Feminism in the Late Twentieth Century," in *Simians, Cyborgs, and Women: The Reinvention of Nature* (New York: Routledge, 1991), 150.

90. Flanagan and Booth, introduction, 12.

91. Haraway, "Cyborg Manifesto," 176.

92. Lisa Gitelman, *Always Already New: Media, History, and the Data of Culture* (Cambridge, MA: MIT Press, 2006), 2.

93. Eva Horn, "There Are No Media," *Grey Room* no. 29 (Fall 2007): 8.

94. Bruno Latour, *Reassembling the Social: An Introduction to Actor-Network Theory* (Oxford: Oxford University Press, 2005), 5, 114.

95. Serres, *Parasite*, xxi.

96. Latour, *Reassembling the Social*, 100.

97. Latour, *Reassembling the Social*, 5.

98. Other accounts directly discuss feminism in ANT. Rosalind Gill and Keith Grint write, "Singling out actor network research, feminists have argued that in an important sense women are simply not seen as actors at all." See Rosalind Gill and Keith Grint, introduction to *The Gender-Technology Relation: Contemporary Theory and Research*, ed. Grint and Gill (London: Taylor & Francis, 1995), 18. In the same volume, Susan Ormrod addresses this idea in a technological context: "Although gender is not highlighted in most examples of the actor-network approach, it does enable us to demonstrate the construction of gender relations as a crucial element

in constructing a new technology." See Susan Ormrod, "Feminist Sociology and Methodology: Leaky Black Boxes in Gender/Technology Relations," in Grint and Gill, *Gender-Technology Relation*, 39.

99. Matthew G. Kirschenbaum, *Mechanisms: New Media and the Forensic Imagination* (Cambridge, MA: MIT Press, 2007), 17 n31; Parikka, "Archival Memory Theory," 7.

100. Gitelman, *Always Already New*, 7.

101. Latour, *Reassembling the Social*, 11.

102. Latour, *Reassembling the Social*, 124.

Chapter 4

1. Mark C. Taylor, *Hiding* (Chicago: University of Chicago Press, 1997).

2. Michael Rock and Susan Sellers, "The Typographer Called Out of Hiding," on the website "*Hiding* by Mark C. Taylor / *The Réal, Las Vegas, Nevada* by Mark C. Taylor and José Márquez," University of Chicago Press, 1998, accessed October 24, 2018, http://press.uchicago.edu/Misc/Chicago/791599.html. While all artistic arguments are materially specific, *Hiding*'s nonsemantics pose particular difficulties for digital translation: the Google Books version loses a massive amount of content.

3. Gilles Deleuze and Félix Guattari, *A Thousand Plateaus*, trans. Brian Massumi (Minneapolis: University of Minnesota Press, 1987), 4.

4. Deleuze and Guattari, *A Thousand Plateaus*, 8.

5. Deleuze and Guattari, *A Thousand Plateaus*, 4.

6. Taylor, *Hiding*, 326.

7. Deleuze and Guattari, *A Thousand Plateaus*, 4.

8. Taylor, *Hiding*, 13.

9. Michel Serres, *The Five Senses*, trans. Margaret Sankey and Peter Cowley (New York: Continuum, 2009), 23.

10. Serres, *Five Senses*, 81.

11. Andrew Piper, *Book Was There* (Chicago: University of Chicago Press, 2012), 3.

12. Brian Massumi, *Parables for the Virtual: Movement, Affect, Sensation* (Durham: Duke University Press, 2002), 90.

13. Matthew G. Kirschenbaum makes a similar argument in *Mechanisms* in the context of digital files, which are subject to entropic processes at minute levels. See Kirschenbaum, *Mechanisms: New Media and the Forensic Imagination* (Cambridge, MA: MIT Press, 2007).

14. Quoted in Thomas Rickert and David Blakesley, "An Interview with Mark C. Taylor," *JAC* 24, no. 4 (2004): 808, http://jstor.org/stable/20866657.

15. Mark C. Taylor and Esa Saarinen, *Imagologies: Media Philosophy* (London: Routledge, 1994), 3.

16. "Electrotecture: Architecture and the Electronic Future," *ANY: Architecture New York* 3 (November–December 1993). Avital Ronell also appears in this issue.

17. Rock and Sellers, "Typographer."

18. Rock and Sellers, "Typographer."

19. Jack Miles, foreword to Taylor, *Hiding*, 1.

20. Taylor, *Hiding*, 251.

21. Taylor, *Hiding*, 247.

22. Taylor, *Hiding*, 337.

23. Taylor, *Hiding*, 25.

24. Taylor, *Hiding*, 23.

25. See Whitney Trettien, *"Tristram Shandy* and the Art of Black Mourning Pages," *Diapsalmata* (blog), September 17, 2012, at http://blog.whitneyannetrettien.com /2012/09/tristram-shandy-art-of-black-mourning.html.

26. Auster's novel, in which Peter Stillman's steps form letters on New York City streets, itself describes a mingling or interfacing of land, skin, and text.

27. Serres, *Five Senses*, 25.

28. Taylor, *Hiding*, 83.

29. Rock and Sellers, "Typographer."

30. Taylor, *Hiding*, 76.

31. Taylor, *Hiding*, 12.

32. Taylor, *Hiding*, 105.

33. Taylor, *Hiding*, 107.

34. Serres, *Five Senses*, 32.

35. Taylor, *Hiding*, 131.

36. Fakir Musafar, quoted in Taylor, *Hiding*, 133.

37. Taylor, *Hiding*, 133.

38. Deleuze and Guattari, *A Thousand Plateaus*, 152.

39. Serres, *Five Senses*, 21.

40. Serres, *Five Senses*, 19.

41. Massumi, *Parables*, 89.

42. Massumi, *Parables*, 89–90.

43. Stelarc, *Obsolete Body / Suspension / Stelarc*, ed. James D. Paffrath (Davis, CA: JP Publications, 1984), 24, quoted in Taylor, *Hiding*, 135–137.

44. Taylor, *Hiding*, 133.

45. Alicia Imperiale, "Seminal Space: Getting under the Digital Skin," in *Re: skin*, ed. Mary Flanagan and Austin Booth (Cambridge, MA: MIT, 2006), 265, 283.

46. Paul Virilio, "The Vision Machine" (Bloomington: Indiana University Press, 1994), 62, quoted in Taylor, *Hiding*, 266.

47. Rachael Sullivan, "Making Contact: Touch Screens and Antimaterialism," *Delirium Waltz* (blog), March 24, 2014, http://www.rachaelsullivan.com/deliriumwaltz/2014/03/24/making-contact/.

48. Taylor, *Hiding*, 256–257.

49. Taylor, *Hiding*, 266.

50. Rock and Sellers, "Typographer."

51. Taylor, *Hiding*, 278–279, 284–285, 291–292, 320–321, 322–323.

52. Chris Langton, quoted in Taylor, *Hiding*, 306–308.

53. Taylor, *Hiding*, 312.

54. Taylor, *Hiding*, 315, 318–319.

55. Taylor, *Hiding*, 319.

56. Taylor, *Hiding*, 326.

57. Taylor, *Hiding*, 326.

58. N. Katherine Hayles, "Print Is Flat, Code Is Deep: The Importance of Media-Specific Analysis," *Poetics Today* 25, no. 1 (2004): 74.

59. Hayles, "Print Is Flat," 76.

60. Hayles, "Print Is Flat," 78.

61. Taylor, *Hiding*, 303.

62. Hayles, "Print Is Flat," 79.

63. Taylor, *Hiding*, 83.

64. Márquez continued explorations of hybridity and reality with his "South to the Future" (STTF) website, which combined fact and fiction as news in the late 1990s. Of their stories, Márquez and collaborator Becky Bond note that "Hybridity, like that of the mule, serves only to make them stronger, heartier, more durable." Provocatively, they also term this work "noise news." See Becky Bond and José Márquez, "South to the Future's World Wide Wire Service," *Style in the Media Age* 33, no. 2 (Summer 1999): 309. In a further conflation or erasure of the line separating real from digital, an STTF-fabricated story about "energy beers" that were "viewed as a public menace" later became true when California and other states took action against Anheuser-Busch for selling actual "caffeine-spiked beer products" in 2008; see "2000 SF Weekly Satire Has Come to Fruition," Association of Alternative Newsmedia, July 25, 2008, http://www.altweeklies.com/aan/2000-sf-weekly-satire-has-come-to-fruition/Article?oid=426009.

65. Mark C. Taylor and José Márquez, "Motel Réal / Las Vegas," interview on *Talk of the Nation*, NPR, December 29, 1997, http://npr.org/programs/talk-of-the-nation/1997/12/29/12931607/.

66. Sometimes the coins simply disappear as you mouse over them. In the NPR interview, Márquez reveals that this was a solution to a technical problem: the game did not have enough memory. The perceived ephemerality of Vegas finds a nice resonance, at metaphorical and literal levels, in this detail. Taylor and Márquez, "Motel Réal / Las Vegas."

67. *The Singing Detective* (television series), directed by Dennis Potter (BBC, 1986), quoted in Taylor, *Hiding*, 60–61.

68. Taylor and Márquez, "Motel Réal / Las Vegas."

69. Cigars are another example of the inside-outside dichotomy breaking down, as well as appearing as "the object of a pure and luxurious consumption," as Derrida notes in *Given Time: I. Counterfeit Money*, trans. Peggy Kamuf (Chicago: University of Chicago Press, 1992), 107.

70. Taylor, *Hiding*, 143.

71. Taylor and Márquéz, "Motel Réal / Las Vegas."

72. Taylor, *Hiding*, 64.

73. Taylor, *Hiding*, 65.

74. Mark C. Taylor, "Unending Strokes," in *Theology at the End of the Century*, ed. Robert Scharlemann (Charlottesville: University of Virginia Press, 1990), 146.

75. Taylor, "Unending Strokes," 147. Perhaps a line by John Cage is apropos here, "I have nothing to say and I am saying it," but in the register of a lament. Cage's "What we require is silence, but what silence requires is that I go on talking" also reverberates with the logic of noise.

76. Taylor, "Unending Strokes," 146.

77. Jacques Derrida, *Glas*, trans. John P. Leavey, Jr., and Richard Rand (Lincoln: University of Nebraska Press, 1986), 49a.

78. Taylor, *Hiding*, 239.

79. Taylor, *Hiding*, 12; Berkeley Art Museum and Pacific Film Archive, "Shelley Jackson: Skin," YouTube video, 10:01, March 7, 2011, http://youtube.com/watch?v=viF-xuLrGvA.

80. The hidden becomes an actual mystery at this point: in personal correspondence around 2016, some of the "words" confessed they had not yet received their copy of the story, despite fulfilling the requirements, thus sparking curiosity about the existence of the story in the first place.

81. Shelley Jackson, "Skin Guidelines," on "Ineradicable Stain," accessed October 24, 2018, https://ineradicablestain.com/skindex.html.

82. Jackson, "Skin Guidelines."

83. Robert Smithson, "A Provisional Theory of Non-sites" (1968), in *Robert Smithson: The Collected Writings*, ed. Jack D. Flam (Berkeley: University of California Press, 1996), 364.

84. Massumi, *Parables*, 135.

85. Taylor, *Hiding*, 123.

86. Jackson, "Call for Participants," on "Ineradicable Stain."

87. I am grateful to Scott Black for the idea that time concurrently affects literary language and land art.

88. Jack D. Flam, introduction to *Robert Smithson: The Collected Writings*, ed. Jack D. Flam (Berkeley: University of California Press, 1996), xix.

89. Robert Smithson, "Entropy and the New Monuments" (1966), in *Smithson: The Collected Writings*, 11.

90. Taylor, *Hiding*, 230.

91. Kazimir Malevich, quoted in Smithson, "Entropy," 14.

92. Smithson, "Entropy," 14.

93. Smithson, "Entropy," 15.

94. Taylor, *Hiding*, 12.

95. Smithson, "Provisional Theory," 364.

Conclusion

1. Georges Bataille, "Formless," in *Visions of Excess: Selected Writings, 1927–1939*, ed. and with an introduction by Allan Stoekl (Minneapolis: University of Minnesota Press, 1985), 31; Mark C. Taylor, *Hiding* (Chicago: University of Chicago Press, 1997), 326.

2. Jerome McGann, "Texts in N-Dimensions and Interpretation in a New Key," *Text Technology* 12, no. 2 (2003): 1.

3. McGann, "Texts in N-Dimensions," 15.

4. Gilles Deleuze and Félix Guattari, *A Thousand Plateaus*, trans. Brian Massumi (Minneapolis: University of Minnesota Press, 1987), 9.

5. Michel Serres, *The Parasite*, trans. Lawrence R. Schehr (Minneapolis: University of Minnesota Press, 2007), 20.

6. Manuel Portela, *Scripting Reading Motions: The Codex and the Computer as Self-Reflexive Machines* (Cambridge, MA: MIT Press, 2013), 86. The original term is from Drucker herself. Portela discusses this technique in his chapter on Drucker's earlier artist's books.

7. Johanna Drucker, "Diagrammatic and Stochastic Writing and Poetics," *Iowa Review* 44, no. 3 (2014–2015): 127.

8. Johanna Drucker, *Stochastic Poetics* (New York: Granary Books/Druckwerk, 2012), 27, 40. The piece is unpaginated; I follow the Ubuweb PDF's implied pagination for convenience. The PDF can be downloaded from ubu.com/vp/Drucker.html.

9. From the work's information page: "*Stochastic Poetics* by Johanna Drucker," Granary Books online, accessed January 25, 2019, www.granarybooks.com/product_view/1162/.

10. Tia Ghose, "Ultra-Precise Quantum-Logic Clock Trumps Old Atomic Clock," *Wired*, February 5, 2010, http://www.wired.com/2010/02/quantum-logic-atomic-clock.

11. Drucker, "Diagrammatic and Stochastic," 123–124.

12. Drucker, "Diagrammatic and Stochastic," 131.

13. Craig Dworkin, "The Stutter of Form," in *The Sound of Poetry / The Poetry of Sound*, ed. Marjorie Perloff and Craig Dworkin (Chicago: University of Chicago Press, 2009), 178.

14. Drucker, *Stochastic Poetics*, 10. *The Telephone Book* also begins with a similar stutter effect, in which the letters of the title are spread out across its several opening pages.

15. Drucker, *Stochastic Poetics*, 16.

16. Drucker, *Stochastic Poetics*, 53.

17. The link between stutter and tongue might recall *The Word Made Flesh*: its large expanded "TTTTTHEWORDMADEFLESH," as well as the beginning: "The tongue LIES ON THE TABLE." (Johanna Drucker, *The Word Made Flesh* [New York: Druckwerk, 1989].)

18. Johanna Drucker, *SpecLab: Digital Aesthetics and Projects in Speculative Computing* (Chicago: University of Chicago Press, 2009), 25.

19. Drucker, *Stochastic Poetics*, 27, 53.

20. Drucker, *Stochastic Poetics*, 8, 12.

21. Drucker, *Stochastic Poetics*, 27.

22. Dworkin, "Stutter," 182.

23. Drucker, *Stochastic Poetics*, 30. I use brackets to signify a moment of space.

24. Drucker, "Diagrammatic and Stochastic," 122.

25. David Foster Wallace, "Deciderization 2007—a Special Report," *Best American Essays 2007*, ed. David Foster Wallace and Robert Atwan (New York: Mariner Books, 2007), 1.

26. Drucker, *Stochastic Poetics*, 15, 27, 25.

27. Drucker, *Stochastic Poetics*, 26.

28. Drucker, *Stochastic Poetics*, 14, 17, 20.

29. Drucker, *Stochastic Poetics*, 19.

30. "Poetics" is used in Drucker, *Stochastic Poetics*, e.g., 8–11, 20; "poetix" appears, e.g., 6, 17, 21.

31. Drucker, *Stochastic Poetics*, 29. Another "sex" cluster appears on 31.

32. Drucker, *Stochastic Poetics*, 30. Through sex, noise is also tied up with power dynamics: "A dominatrix, passing the night politics of / Alphabetical soup" (34).

33. Susan Howe, "An Interview with Susan Howe," by Lynn Keller, *Contemporary Literature* 36, no. 1 (1995), http://yaleunion.org/susan-howe/.

34. "An Interview," Keller.

35. "An Interview," Keller.

36. Catherine Halley, "Detective Work: An Interview with Susan Howe," Poetry Foundation, January 14, 2015, http://poetryfoundation.org/features/articles/detail /70196.

37. Richard Flood, "An Artist and His Doppelgangers," *Walker Reader*, September 1, 2005, http://walkerart.org/magazine/2005/an-artist-and-his-doppelgangers.

38. Susan Howe, *Spontaneous Particulars: The Telepathy of Archives* (New York: New Directions, 2014), 17.

39. Howe, *Spontaneous Particulars*, 21.

40. "Susan Howe: The Art of Poetry No. 97," an interview by Maureen N. McLane, *Paris Review*, no. 203 (2012), http://theparisreview.org/interviews/6189/susan-howe-the-art-of-poetry-no-97-susan-howe.

41. Marjorie Perloff, "Spectral Telepathy: The Late Style of Susan Howe," *Transatlantica*, no. 1 (2016), transatlantica.revues.org/8146.

42. Drucker, *SpecLab*, 26.

43. Serres, *Parasite*, 66.

44. Drucker, *SpecLab*, 28.

45. Johanna Drucker, *Diagrammatic Writing* (Banff Art Centre: Creative Commons, 2013), 26.

46. Dennis Overbye, "A Scientist Takes on Gravity," *New York Times*, July 12, 2010, http://nytimes.com/2010/07/13/science/13gravity.html.

47. Drucker, *Stochastic Poetics*, 33.

48. Drucker, *Stochastic Poetics*, 36.

49. Drucker, *Stochastic Poetics*, 38.

50. Drucker, *SpecLab*, 27.

51. Drucker, *Stochastic Poetics*, 7.

52. E.g., Drucker, *Stochastic Poetics*, 25, 27.

53. Drucker, *Stochastic Poetics*, 36.

54. Overbye, "A Scientist Takes on Gravity."

55. Drucker, *Stochastic Poetics*, 52.

56. "Delightenment" also occurs as a goal in Drucker, *SpecLab*, 30.

57. Drucker, *Stochastic Poetics*, 49.

58. For a more detailed explanation of how entropy and thermodynamics relate to Serres's communication theory, see Serres, "The Origin of Language: Biology, Information Theory, and Thermodynamics," in Serres, *Hermes: Literature, Science,*

Philosophy, ed. Josue V. Harari and David F. Bell (Baltimore: Johns Hopkins University Press, 1982).

59. Drucker, "Diagrammatic and Stochastic," 126.

60. Thanks to Leslie Miller at Grenfell Press for confirming this fact.

61. Drucker, *Stochastic Poetics*, 19.

62. Drucker, "Diagrammatic and Stochastic," 131.

63. "Glossary of Terms," Hollander's website, accessed October 24, 2018, https://www.hollanders.com/a-to-z.

64. Howe, *Spontaneous Particulars*, 59.

65. Howe, *Spontaneous Particulars*, 9.

66. Dworkin, "The Stutter of Form," 168.

67. Perloff, "Spectral Telepathy," 27.

68. Perloff, "Spectral Telepathy," 31.

69. Drucker, "Diagrammatic and Stochastic," 122–123.

70. Jean-Jacques Lecercle, *The Violence of Language* (London: Routledge, 1990), 57.

71. Dworkin, "The Stutter of Form," 167.

Bibliography

"About." *ON Contemporary Practice*. Accessed October 23, 2018. http://on-contem porarypractice.squarespace.com/about.

Allen, Gwen. *Artists' Magazines: An Alternative Space for Art*. Cambridge, MA: MIT Press, 2011.

Anscombe, G. E. M., and G. H. von Wright. Editors' introduction to *Zettel*, by Ludwig Wittgenstein, v–vi. Translated by G. E. M. Anscombe. Berkeley: University of California Press, 1970.

Arnar, Anna Sigríður. *The Book as Instrument: Stéphane Mallarmé, The Artist's Book, and The Transformation of Print Culture*. Chicago: University of Chicago Press, 2011.

Barthes, Roland. "From Work to Text." In *Image, Music, Text*, 155–164. Translated by Stephen Heath. New York: Hill and Wang, 1978.

Barthes, Roland. *The Pleasure of the Text*. Translated by Richard Miller. New York: Hill and Wang, 1975.

Bataille, Georges. "Formless." In *Visions of Excess: Selected Writings, 1927–1939*, 31. Edited and with an introduction by Allan Stoekl. Minneapolis: University of Minnesota Press, 1985.

Bataille, Georges. *Inner Experience*. Translated and with an introduction by Stuart Kendall. Albany, NY: SUNY Press, 2014.

Bataille, Georges. "The Psychological Structure of Fascism." In *Visions of Excess: Selected Writings, 1927–1939*, 137–160. Edited and with an introduction by Allan Stoekl. Minneapolis: University of Minnesota Press, 1985.

Bataille, Georges. *The Unfinished System of Nonknowledge*. Edited and with an introduction by Stuart Kendall. Minneapolis: University of Minnesota Press, 2001.

Bataille, Georges. "The Use Value of D. A. F. de Sade." In *Visions of Excess: Selected Writings, 1927–1939*, 91–102. Edited and with an introduction by Allan Stoekl. Minneapolis: University of Minnesota Press, 1985.

Bataille, Georges, Michel Leiris, Marcel Griaule, Carl Einstein, and Robert Desnos. *Encyclopaedia Acephalica*. Edited and with an introduction by Alastair Brotchie. London: Atlas Press, 1997.

Benjamin, Walter. *The Arcades Project*. Translated by Howard Eiland and Kevin McLaughlin. Cambridge, MA: Harvard University Press, 1999.

Bennington, Geoffrey. *Jacques Derrida*. Chicago: University of Chicago Press, 1993.

Berkeley Art Museum and Pacific Film Archive. "Shelley Jackson: Skin." YouTube video, 10:01. March 7, 2011. http://youtube.com/watch?v=viF-xuLrGvA.

Bernstein, Charles. "Close Listening: Poetry and the Performed Word." In *My Way: Speeches and Poems*, 279–301. Chicago: University of Chicago Press, 2010.

Blanchot, Maurice. "The Absence of the Book." In *The Station Hill Blanchot Reader: Fiction and Literary Essays*, 471–486. Edited and translated by Lydia Davis. Barrytown, NY: Station Hill, 1999.

Blanchot, Maurice. "The Book to Come." In *A Book of the Book*, edited by Jerome Rothenberg and Steven Clay, 141–159. New York: Granary Books, 2000.

Bois, Yve-Alain. "The Use Value of Formless." In *Formless: A User's Guide*, edited by Yve-Alain Bois and Rosalind Krauss, 13–40. New York: Zone Books, 1997.

Bright, Betty. *No Longer Innocent: Book Art in America 1960–1980*. New York: Granary Books, 2005.

Brotchie, Alastair. Introduction to *Encyclopaedia Acephalica*, by Georges Bataille et al., 9–28. Edited and with an introduction by Alastair Brotchie. London: Atlas Press, 1997.

Clément, Catherine. "Le Sauvage." *L'Arc* 54 (1973): 1–2.

Cohick, Aaron. *The New Manifesto of the NewLights Press*. Colorado Springs, CO / Baltimore, MD: NewLights Press, 2013.

Collins, Graham P. "Claude E. Shannon: Founder of Information Theory." *Scientific American*, October 14, 2002. www.scientificamerican.com/article/claude-e-shannon -founder.

Coover, Robert. "Reach Out and Disturb Someone." Review of *The Telephone Book*, by Avital Ronell. *New York Times Book Review*, June 3, 1990, 15–16.

Deleuze, Gilles, and Félix Guattari. *A Thousand Plateaus*. Translated by Brian Massumi. Minneapolis: University of Minnesota Press, 1987.

Derrida, Jacques. "Between Brackets I." In *Points … Interviews, 1974–1994*. Edited by Elizabeth Weber. Translated by Peggy Kamuf. Stanford: Stanford University Press, 1995.

Derrida, Jacques. "The Book to Come." In *Paper Machine*. Translated by Rachel Bowlby. Stanford: Stanford University Press, 2005.

Derrida, Jacques. "The Double Session." In *Dissemination*. Translated by Barbara Johnson. Chicago: University of Chicago Press, 1983.

Derrida, Jacques. "Edmond Jabès and the Question of the Book." In *Writing and Difference*. Translated by Alan Bass. London: Routledge, 1978.

Derrida, Jacques. "Glas." *L'Arc* 54 (1973): 4–15.

Derrida, Jacques. *Glas*. Paris: Galilée, 1974.

Derrida, Jacques. *Glas*. Paris: Denoël/Gonthier, 1981.

Derrida, Jacques. *Glas*. Translated by John P. Leavey, Jr., and Richard Rand. Lincoln: University of Nebraska Press, 1986.

Derrida, Jacques. *Margins of Philosophy*. Translated by Alan Bass. Chicago: University of Chicago Press, 1982.

Derrida, Jacques. "+R (Into the Bargain)." In *The Truth in Painting*. Translated by Geoff Bennington and Ian McLeod. Chicago: University of Chicago Press, 1987.

Diderot, Denis, and Jean le Rond d'Alembert. "Preliminary Discourse." In *The Encyclopedia of Diderot and d'Alembert: Collaborative Translation Project*. University of Michigan. Accessed October 24, 2018. https://quod.lib.umich.edu/d/did.

Drucker, Johanna. *The Century of Artists' Books*. New York: Granary Books, 1995.

Drucker, Johanna. "Diagrammatic and Stochastic Writing and Poetics." *Iowa Review* 44, no. 3 (2014–2015): 122–132.

Drucker, Johanna. *Diagrammatic Writing*. Banff Art Centre: Creative Commons, 2013.

Drucker, Johanna. "The Self-Conscious Codex: Artists' Books and Electronic Media." *SubStance* 82 (1997): 93–112.

Drucker, Johanna. *SpecLab: Digital Aesthetics and Projects in Speculative Computing*. Chicago: University of Chicago Press, 2009.

Drucker, Johanna. *Stochastic Poetics*. New York: Granary Books, 2012.

Drucker, Johanna. *The Word Made Flesh*. New York: Druckwerk, 1989.

Dworkin, Craig. *No Medium*. Cambridge, MA: MIT Press, 2013.

Dworkin, Craig. "The Stutter of Form." In *The Sound of Poetry / The Poetry of Sound*, 166–183. Edited by Marjorie Perloff and Craig Dworkin. Chicago: University of Chicago Press, 2009.

Dworkin, Craig, Simon Morris, and Nick Thurston. *Do or DIY*. York, UK: Information as material, 2012.

Eckersley, Richard. "Composition and Repro Specifications for One New Title, THE TELEPHONE BOOK by Ronell." Memo via Carolyn Einspahr to Joan Sampson, University of Nebraska, December 8, 1988. Richard Eckersley Archives, University of Nebraska–Lincoln.

Electronic Literature Organization. Accessed October 23, 2018. https://eliterature .org/about.

"Electrotecture: Architecture and the Electronic Future." *ANY: Architecture New York* 3 (November–December 1993).

Emerson, Lori. *Reading Writing Interfaces: From the Digital to the Bookbound*. Minneapolis: University of Minnesota Press, 2014.

Ernst, Wolfgang. "Toward a Media Archaeology of Sonic Articulation." In *Digital Memory and the Archive*, 172–183. Edited by Jussi Parikka. Minneapolis: University of Minnesota Press, 2013.

Flam, Jack D. Introduction to *Robert Smithson: The Collected Writings*, viii–xxv. Edited by Jack D. Flam. Berkeley: University of California Press, 1996.

Flanagan, Mary, and Austin Booth. Introduction to *Reload: Rethinking Women and Cyberculture*, edited by Mary Flanagan and Austin Booth, 1–24. Cambridge, MA: MIT Press, 2002.

Flood, Richard. "An Artist and His Doppelgangers." *Walker Reader*, September 1, 2005. http://walkerart.org/magazine/2005/an-artist-and-his-doppelgangers.

Garner, Bonnie Jean. "Duchamp Bottles Belle Greene: Just Desserts for His Canning." *Tout Fait: The Marcel Duchamp Studies Online Journal* (May 2000). http://toutfait.com /issues/issue_2/News/garner.html.

Ghose, Tia. "Ultra-Precise Quantum-Logic Clock Trumps Old Atomic Clock." *Wired*, February 5, 2010. http://www.wired.com/2010/02/quantum-logic-atomic-clock.

Gill, Rosalind, and Keith Grint, editors. *The Gender-Technology Relation: Contemporary Theory and Research*. London: Taylor & Francis, 1995.

Gitelman, Lisa. *Always Already New: Media, History, and the Data of Culture*. Cambridge, MA: MIT Press, 2006.

Halley, Catherine. "Detective Work: An Interview with Susan Howe." *Poetry Foundation*, January 14, 2015. http://poetryfoundation.org/features/articles/detail/70196.

Haraway, Donna. "A Cyborg Manifesto: Science, Technology, and Socialist Feminism in the Late Twentieth Century." In *Simians, Cyborgs, and Women: The Reinvention of Nature*, 149–181. London: Routledge, 1991.

Harding, James Martin. *Contours of the Theatrical Avant-Garde: Performance and Textuality*. Ann Arbor: University of Michigan Press, 2000.

Hartman, Geoffrey H. "How Creative Should Literary Criticism Be?" *New York Times*, April 5, 1981. http://nytimes.com/1981/04/05/books/how-creative-should-literary-criticism-be.html.

Hartman, Geoffrey H. *Saving the Text*. Baltimore: Johns Hopkins University Press, 1982.

Hayles, N. Katherine. "Print Is Flat, Code Is Deep: The Importance of Media-Specific Analysis." *Poetics Today* 25, no. 1 (2004): 67–90.

Heidegger, Martin. "The Origin of the Work of Art." Translated by Albert Hofstadter. In *Basic Writings*. Edited by David Farrell Krell. San Francisco: HarperSanFrancisco, 1993.

Heidegger, Martin. "The Question Concerning Technology." Translated by William Lovitt. In *Basic Writings*, 308–341. Edited by David Farrell Krell. San Francisco: HarperSanFrancisco, 1993.

Helms, Jason. *Rhizcomics: Rhetoric, Technology, and New Media Composition*. Ann Arbor: University of Michigan, 2017. http://digitalrhetoriccollaborative.org/rhizcomics.

Higgins, Dick. *Foew&ombwhnw: a grammar of the mind and a phenomenology of love and a science of the arts as seen by a stalker of the wild mushroom*. Vermont: Something Else Press, 1969.

Hollander's online. Accessed October 24, 2018. https://www.hollanders.com/a-to-z.

Hopkins, David. "Duchamp, Childhood, Work and Play: The Vernissage for *First Papers of Surrealism*, New York, 1942." *Tate Papers* 22 (autumn 2014). https://www.tate.org.uk/research/publications/tate-papers/22/duchamp-childhood-work-and-play-the-vernissage-for-first-papers-of-surrealism-new-york-1942/.

Horn, Eva. "There Are No Media." *Grey Room*, no. 29 (2007): 6–13.

Howe, Susan. "An Interview with Susan Howe." By Lynn Keller. *Contemporary Literature* 36, no. 1 (1995). http://yaleunion.org/susan-howe/.

Howe, Susan. *Spontaneous Particulars: The Telepathy of Archives*. New York: New Directions, 2014.

Howe, Susan. "Susan Howe: The Art of Poetry No. 97." An interview by Maureen N. McLane. *Paris Review*, no. 203 (2012). http://theparisreview.org/interviews/6189/susan-howe-the-art-of-poetry-no-97-susan-howe.

Howe, Susan. *Tom Tit Tot*. New York: Museum of Modern Art, 2014.

Howe, Susan, and David Grubbs. *WOODSLIPPERCOUNTERCLATTER*. LP/CD. Drag City, 2015.

Hubert, Renée Riese. "Derrida, Dupin, Adami: 'Il faut être plusieurs pour écrire.'" *Yale French Studies* 84 (1994): 242–264.

Hubert, Renée Riese, and Judd D. Hubert. *The Cutting Edge of Reading: Artists' Books.* New York: Granary Books, 1999.

Imperiale, Alicia. "Seminal Space: Getting under the Digital Skin." In *Re: skin.* Edited by Mary Flanagan and Austin Booth, 265–291. Cambridge, MA: MIT Press, 2006.

Jabès, Edmond. "Extract from a Speech (Given on April 21, 1982, in Paris, at the Foundation for French Judaism)." In *The Book of Margins.* Translated by Rosmarie Waldrop. Chicago: University of Chicago Press, 1993.

Jabès, Edmond. "Letter to Jacques Derrida on the Question of the Book." In *The Book of Margins.* Translated by Rosmarie Waldrop. Chicago: University of Chicago Press, 1993.

Jackson, Shelley. "Ineradicable Stain." Accessed October 24, 2018. https://ineradicable stain.com/skindex.html.

Jensen, Michael Jon. "About the Making of *The Telephone Book.*" In *Remembering Richard: Richard Eckersley as Remembered by His Friends and Colleagues*, edited by Richard Hendel, 27–40. Lincoln: University of Nebraska Press, 2006.

Johns, Adrian. *The Nature of the Book.* Chicago: University of Chicago Press, 1998.

Kirschenbaum, Matthew G. *Mechanisms: New Media and the Forensic Imagination.* Cambridge, MA: MIT Press, 2007.

Kittler, Friedrich A. *Gramophone, Film, Typewriter.* Stanford: Stanford University Press, 1999.

Kittler, Friedrich A. "The History of Communication Media." *CTheory*, July 30, 1996. http://ctheory.net/articles.aspx?id=45.

Kleiber, Pierre-Henri. *L'encyclopédie Da Costa (1947–1949).* Lausanne: L'Âge d'Homme, 2014.

Krapp, Peter. *Déjà Vu: Aberrations of Cultural Memory.* Minneapolis: University of Minnesota Press, 2004.

Lamiot, Christophe. *Eau sur eau: Les dictionnaires de Mallarmé, Flaubert, Bataille, Michaux, Leiris et Ponge.* Amsterdam: Rodopi, 1997.

Landow, George. "What's a Critic to Do? Critical Theory in the Age of Hypertext." In *Hyper/Text/Theory*, edited by George Landow, 1–48. Baltimore: Johns Hopkins University Press, 1994.

Latour, Bruno. *Reassembling the Social: An Introduction to Actor-Network Theory.* Oxford: Oxford University Press, 2005.

Leavey, John P., Jr. "This (then) will not have been a book …" In *Glassary*, 22–128. Lincoln: University of Nebraska Press, 1986.

Leavey, John P., Jr. "Translation/Citation: An Interview with John P. Leavey, Jr." By Dawne McCance. *Mosaic* 35, no. 1 (2002): 1–20.

Lecercle, Jean-Jacques. *The Violence of Language*. London: Routledge, 1990.

Lippard, Lucy. "The Artist's Book Goes Public." 1977. In *Artists' Books: A Critical Anthology and Sourcebook*, edited by Joan Lyons, 45–48. Rochester, NY: VSW Press, 1985.

Mallarmé, Stéphane. "The Book, Spiritual Instrument." Translated by Michael Gibbs. In *The Book, Spiritual Instrument*, edited by Jerome Rothenberg and David M. Guss, 14–20. New York: Granary Books, 1996.

Mallarmé, Stéphane. *Collected Poems*. Translated and with a commentary by Henry Weinfield. Berkeley: University of California Press, 1994.

Massumi, Brian. *Parables for the Virtual: Movement, Affect, Sensation*. Durham: Duke University Press, 2002.

McGann, Jerome. "Composition as Explanation." In *A Book of the Book*, edited by Jerome Rothenberg and Steven Clay, 228–245. New York: Granary Books, 2000.

McGann, Jerome. "From Text to Work: Digital Tools and the Emergence of the Social Text." *Romanticism on the Net*, nos. 41–42 (2006). http://erudit.org/revue/ron/2006/v/n41-42/013153ar.html.

McGann, Jerome. "Texts in N-Dimensions and Interpretation in a New Key." *Text Technology* 12, no. 2 (2003): 1–18.

McGann, Jerome. *The Textual Condition*. Princeton: Princeton University Press, 1991.

Mitchell, David, and Sharon L. Snyder. *Narrative Prosthesis: Disability and the Dependencies of Discourse*. Ann Arbor: University of Michigan Press, 2000.

O'Gorman, Marcel. *E-Crit: Digital Media, Critical Theory, and the Humanities*. Toronto: University of Toronto Press, 2006.

Overbye, Dennis. "A Scientist Takes on Gravity." *New York Times*, July 12, 2010. http://nytimes.com/2010/07/13/science/13gravity.html.

Parikka, Jussi. "Archival Memory Theory: An Introduction to Wolfgang Ernst's Media Archaeology." In *Digital Memory and the Archive*, by Wolfgang Ernst, 1–22. Minneapolis: University of Minnesota Press, 2013.

Peeters, Benoît. *Derrida: A Biography*. Translated by Andrew Brown. Cambridge, UK: Polity, 2013.

Perloff, Marjorie. "Spectral Telepathy: The Late Style of Susan Howe." *Transatlantica*, no. 1 (2016). transatlantica.revues.org/8146.

Perloff, Marjorie. *Unoriginal Genius: Poetry by Other Means in the New Century*. Chicago: University of Chicago Press, 2002.

Phillpot, Clive. "Some Contemporary Artists and Their Books." In *Artists' Books: A Critical Anthology and Sourcebook*, edited by Joan Lyons, 97–132. Rochester, NY: VSW Press, 1985.

Piper, Andrew. *Book Was There*. Chicago: University of Chicago Press, 2012.

Portela, Manuel. *Scripting Reading Motions: The Codex and the Computer as Self-Reflexive Machines*. Cambridge, MA: MIT Press, 2013.

Poster, Mark. *The Mode of Information: Poststructuralism and Social Context*. Chicago: University of Chicago Press, 1990.

Rickels, Laurence A. "Take Me to Your Reader." In *Reading Ronell*, edited by Diane Davis, 60–73. Urbana: University of Illinois Press, 2009.

Rickert, Thomas, and David Blakesley. "An Interview with Mark C. Taylor." *JAC* 24, no. 4 (2004): 805–819. http://jstor.org/stable/20866657.

Rock, Michael, and Susan Sellers. "The Typographer Called Out of Hiding." "*Hiding* by Mark C. Taylor / *The Réal, Las Vegas, Nevada* by Mark C. Taylor and José Márquez." Website. University of Chicago Press. 1998. Accessed October 24, 2018. http://press.uchicago.edu/Misc/Chicago/791599.html.

Ronell, Avital. "Conversations with Eckersley." In *Remembering Richard: Richard Eckersley as Remembered by His Friends and Colleagues*, edited by Richard Hendel, 20–26. Lincoln: University of Nebraska Press, 2006.

Ronell, Avital. *The Telephone Book: Technology, Schizophrenia, Electric Speech*. Lincoln: University of Nebraska Press, 1989.

Rose, Jonathan. "From Book History to Book Studies." American Printing History Association. Accessed October 23, 2017. https://printinghistory.org/awards/page/8.

Serres, Michel. *The Five Senses*. Translated by Margaret Sankey and Peter Cowley. New York: Continuum, 2009.

Serres, Michel. *The Parasite*. Translated by Lawrence R. Schehr. Minneapolis: University of Minnesota Press, 2007.

Serres, Michel, and Bruno Latour. *Conversations on Science, Culture, and Time*. Translated by Roxanne Lapidus. Ann Arbor: University of Michigan Press, 1995.

Shannon, Claude E., and Warren Weaver. *The Mathematical Theory of Communication*. 1949. Reprint, Urbana: University of Illinois Press, 1964.

Shaw, Tate. *Blurred Library: Essays on Artists' Books*. Victoria, TX: Cuneiform Press, 2016.

Sherman, Levi. "Book Thinking." *Book Art Theory* (blog). College Book Art Association. December 31, 2015. https://collegebookart.org/bookarttheory/3722798.

Sieburth, Richard. "From Mallarmé's *Le livre.*" In *A Book of the Book*, edited by Jerome Rothenberg and Steven Clay, 132–140. New York: Granary Books, 2000.

Smith, Keith. *Structure of the Visual Book.* Rochester, NY: Keith Smith Books, 1984.

Smith, Keith. *Text in the Book Format.* Rochester, NY: Keith Smith Books, 1989.

Smithson, Robert. "Entropy and the New Monuments." 1966. In *Robert Smithson: The Collected Writings.* Edited by Jack D. Flam. Berkeley: University of California Press, 1996.

Smithson, Robert. "A Provisional Theory of Non-sites." 1968. In *Robert Smithson: The Collected Writings.* Edited by Jack D. Flam. Berkeley: University of California Press, 1996.

Spivak, Gayatri Chakravorty. "*Glas*-Piece: A *Compte Rendu.*" *Diacritics* 7, no. 3 (1977): 22–43.

Starre, Alexander. *Metamedia: American Book Fictions and Literary Print Culture after Digitization.* Iowa City: University of Iowa Press, 2015.

Stephens, Paul. *The Poetics of Information Overload.* Minneapolis: University of Minnesota Press, 2015.

Stewart, Garrett. *Bookwork: Medium to Object to Concept to Art.* Chicago: University of Chicago Press, 2011.

"Stochastic Poetics" by Johanna Drucker. Granary Books website. Accessed October 24, 2018. http://granarybooks.com/product_view/1162.

Sturrock, John. "The Book Is Dead, Long Live the Book!" Review of *Glas*, by Jacques Derrida. *New York Times*, September 13, 1987. https://nytimes.com/1987/09/13/books/the-book-is-dead-long-live-the-book.html.

Sullivan, Rachael. "Making Contact: Touch Screens and Antimaterialism." *Delirium Waltz* (blog). March 24, 2014. http://rachaelsullivan.com/deliriumwaltz/2014/03/24/making-contact.

Swensen, Cole. "Noise That Stays Noise." In *Noise That Stays Noise: Essays.* Ann Arbor: University of Michigan Press, 2011.

Taylor, Mark C. *Hiding.* Chicago: University of Chicago Press, 1997.

Taylor, Mark C. "Unending Strokes." In *Theology at the End of the Century*, edited by Robert Scharlemann, 136–148. Charlottesville: University of Virginia Press, 1990.

Taylor, Mark C., and José Márquez. "Motel Réal / Las Vegas." Interview on NPR's *Talk of the Nation.* December 29, 1997. http://npr.org/programs/talk-of-the-nation/1997/12/29/12931607/.

Taylor, Mark C., and José Márquez. *The Réal, Las Vegas, NV.* Windows 95 and Mac OS 7. Williamstown, MA: Williams College Museum of Art / North Adams, MA: Massachusetts Museum of Contemporary Art, 1997.

Taylor, Mark C., and Esa Saarinen. *Imagologies: Media Philosophy.* London: Routledge, 1994.

Triple Canopy. Accessed October 24, 2018. http://canopycanopycanopy.com.

Ulmer, Gregory. *Applied Grammatology: Post(e)-Pedagogy from Jacques Derrida to Joseph Beuys.* Baltimore: Johns Hopkins University Press, 1984.

Ulmer, Gregory. *Heuretics: The Logic of Invention.* Baltimore: Johns Hopkins University Press, 1994.

Viguers, Susan. "Does Text-To-Be-Read Belong in the Artist's Book?" *Book Art Theory* (blog). College Book Art Association. September 30, 2015. https://collegebookart.org /bookarttheory/3426333.

Visconti, Amanda. *Infinite Ulysses.* Accessed October 24, 2018. http://infiniteulysses .com.

Waldschmidt, Anne. "Disability Goes Cultural: The Cultural Model of Disability as an Analytical Tool." In *Culture—Theory—Disability: Encounters Between Disability Studies and Cultural Studies*, edited by Anne Waldschmidt, Hanjo Berressem, and Moritz Ingwersen, 19–27. Disability Studies. Bielefeld: Transcript Verlag, 2017.

Wallace, David Foster. "Deciderization 2007—a Special Report." In *Best American Essays 2007*, edited by David Foster Wallace and Robert Atwan, 1–8. New York: Mariner Books, 2007.

Wilson, Sarah. "Rembrandt / Genet / Derrida." In *Portraiture: Facing the Subject*, edited by Joanna Woodall, 203–216. Manchester: Manchester University Press, 1997.

Winthrop-Young, Geoffrey, and Michael Wutz. Translators' introduction to *Gramophone, Film, Typewriter*, by Friedrich A. Kittler, xi–xxxviii. Stanford: Stanford University Press, 1999.

Index

The letter *f* following a page number denotes a figure.

Haraway, Donna, 86, 105, 106
Hardware-fetishism, 105
Hartman, Geoffrey H., 13, 63
Hayles, N. Katherine, 4, 5, 10–11, 15,
 24, 122, 123
Hegel, Georg Wilhelm Friedrich, 29, 31,
 63, 65, 66, 69, 70, 71, 72, 75, 77, 78,
 114, 117
Heidegger, Martin, 14, 90, 93, 96,
 97, 107
Hejinian, Lyn, 22–23
Helms, Jason, 24
Helvetica (typeface), 93, 97
Helvetica Bold (typeface), 95, 96
Helvetica Condensed (typeface), 97
Herald, The, 43, 46
Heterogeneity
 of *Encyclopedia Da Costa*, 28–29,
 45–50, 52
 foundation for, 14–15
 in *Hiding*, 30
 noise and, 45–46
 in *The Réal: Las Vegas, NV*, 30
 in *Skin*, 30
Heteroglossia, 137, 139–140
Heuretics, 15
Hiding (Taylor)
 autobiographical section, 116
 creating, 12
 death in, 116, 127–129, 132
 "Dermagraphics," 116–117, 120
 "De-/sign/ing," 115
 "Drawing," 117
 front matter, 109, 114
 in *Glas*, 30
 "Ground Zero," 114, 119
 "Interfacing," 119–121, 120*f*
 layout, 109–110, 111, 113–114,
 116–117, 120, 135
 materiality, 3, 31, 114
 noise in, 19
 psoriasis in, 116–117
 reading, 111–112, 114, 117

release, 110, 123, 127
sensory knowledge, exploration of, 122
significations of color, 114–116, 120
"Skinsc(r)apes," 115–116, 115*f*
texts of skin, 6, 30–31, 110, 113–121
from text to hypertext, 121–129
typography, 109–110, 114, 121, 123
white space, 109
writing, 114
Higgins, Dick
 Foew&ombwhnw, 7
Historical method, 105
Hölderlin, Friedrich, 20
Horn, Eva, 106–107
Howe, Susan, 32, 143–144, 146, 152,
 153. *See also Tom Tit Tot*
Huamour, 47, 56–58
Hubert, Judd D., 13
Hubert, Renée Riese, 13, 79–80
Human-machine interface, 95,
 105–106, 120
Humour noir, 57
Huysmans, Joris-Karl, 50
Hybridity, 16
Hydropathes literary club, 35
Hypericonomy, 15
Hypermedia, 15
Hypertext, 12, 21, 29, 61, 81–83,
 121–129, 157
Imagology, 15–16, 113–114
Immediacy, 39–40, 54–55, 59
Imperiale, Alicia, 119
In-between-ness, 106–107
Incohérents, 34
Incunabula, digital, 24
Index, 50
Infection, 51
Inflexions, 24
Information, 60, 102
Information as Material (iam,
 publisher), 23
Information overload, 22
Information theory, 102